ADVANCE PRAISE FOR

THE *Arts*, Education, and Social Change

"In this book, educators describe their journeys with the arts and provide a glowing and clear-eyed testimony to the uniqueness of the teaching experience. As we travel from Bedford Hills Women's Prison to a small town in Thailand and then return to more familiar learning communities, it is apparent that aesthetic experiences enable both students and teachers to gain new access to their emotional and cognitive selves. Readers of The Arts, Education, and Social Change will not only sink taps into their own artfulness but recognize the ways in which the arts can provide a deeper understanding of glaring social issues. Despite the current climate of standardization, these chapters in their beautiful honesty offer many moments of consolation."

Karel Rose, Professor of Education,
Brooklyn College, CUNY Graduate Center

"The Arts, Education and Social Change celebrates the unique power of the arts to communicate, understand and transform our most complex personal problems and aspirations. This wonderful selection of essays— ranging from dancing our dreams of a better community to furthering cultural pride through storytelling, to transforming conflict through art— vividly demonstrates how artistic activity has always offered the most inspiring, personal, and reliable ways of expressing our different viewpoints. Our deep diversity is conveyed in this book, showing the resilient drive to create that unites us all."

Shaun McNiff, Professor, Lesley University, Cambridge, Massachusetts
Author of Creating with Others: The Practice of Imagination in Life

THE *Arts*, Education, and Social Change

Series
in Arts
& Education

Elijah Mirochnik
General Editor

Vol. 9

PETER LANG
New York • Washington, D.C./Baltimore • Bern
Frankfurt am Main • Berlin • Brussels • Vienna • Oxford

THE

Education, and

Social Change

Little Signs of Hope

EDITED BY
Mary Clare Powell
& Vivien Marcow Speiser

PETER LANG
New York • Washington, D.C./Baltimore • Bern
Frankfurt am Main • Berlin • Brussels • Vienna • Oxford

KH

Library of Congress Cataloging-in-Publication Data

The Arts, education, and social change /
edited by Mary Clare Powell, Vivien Marcow Speiser.
p. cm. — (Lesley University series in arts and education; vol. 9)
Includes bibliographical references.
1. Arts and society. 2. Arts—Study and teaching.
I. Marcow Speiser, Vivien. II. Title.
III. Series: Lesley University series in arts & education; v. 9.
NX180.S6P68 700'.71—dc22 2004006756
ISBN 0-8204-6302-7
ISSN 1524-0177

Bibliographic information published by **Die Deutsche Bibliothek**.
Die Deutsche Bibliothek lists this publication in the "Deutsche
Nationalbibliografie"; detailed bibliographic data is available
on the Internet at http://dnb.ddb.de/.

Cover photo by Angela Rackstraw
Cover design by Lisa Barfield

The paper in this book meets the guidelines for permanence and durability
of the Committee on Production Guidelines for Book Longevity
of the Council of Library Resources.

8/21/05

Thanks

Producing a book is a collective effort,
and we acknowledge with thanks:

all the authors who contributed to this book,

all the people, students and artists
whose work is described in these pages,

Lesley University for supporting us in producing the book,

Mia for typesetting, and the Peter Lang staff for their
substantial support in production.

We are grateful.

Mary Clare Powell
Vivien Marcow Speiser
Editors

CONTENTS

FOREWORD

In this ninth volume in the Lesley University Series in Arts and Education, Professors Vivien Marcow Speiser and Mary Clare Powell bring new insight to the critical role of the arts in educating for social change. The editors have brought together artists, educators, and therapists around the globe to describe the theory and practice of their transformative work in and through the arts. The authors describe, often through moving stories, their real world experiences in working with children and adults to transform lives through greater understanding of the individuals and their roles in society.

While the critical role of the arts in expressing the uniqueness of the individual and his or her culture has long been acknowledged, the importance of the arts as a vehicle for crossing social and cultural boundaries and moving society to action and social change is less well documented. The authors of this volume describe their experiences in working with the arts to transform lives. Building on Lesley University's philosophy of the critical role of the arts in human development, the editors provide us, in this volume, with various approaches for transforming our teaching through a better understanding of the "healing power of creating in the arts."

It is fitting that Professors, Marcow Speiser and Powell should edit this volume since their teaching in and through the arts has always focused on the use of the arts for social change. In addition to their teaching, both faculty members oversee programs designed to integrate the arts in education and therapy to train

others in the transformational role of the arts. As director of international and collaborative programs, Professor Marcow Speiser oversees Lesley University's extension in Israel, which offers programs in Expressive Therapies, Creative Arts in Learning, and Interdisciplinary Studies, where the arts as healing are central to each student's program of study. Professor Powell is director of the Creative Arts in Learning Program, the largest in the university, in which over a thousand teachers a year are being trained to integrate the arts across the curriculum to meet the needs of each child.

For more than two decades I have had the privilege of observing the transformative teaching and leadership of Professors Marcow Speiser and Powell. I am pleased that their work, and that of the other authors they have identified, will now reach a broader audience. *The Arts, Education and Social Change* provides arts educators, teachers, and therapists with extraordinary examples of how the arts can transform the lives of individuals and move society to a more equitable and just place.

Martha McKenna
Provost, Lesley University

INTRODUCTION

Mary Clare Powell
Vivien Marcow Speiser

Yes, they are little signs, but they are still signs of hope—that precious commodity. Hope seems a little wimpy compared to something sturdy like faith or love, yet hope is there at the bottom when it looks as if wars will never end and as if oppression will always be our human condition. Hope grows and always grows up. Why little signs? Because the work of the people in this book is local, where the real work gets done. Because in the great scheme of things, perhaps these results don't show up, at least not yet. But the artist-educators in this book are all over the globe, where, in many separate countries, they are convinced that their work is important.

Stories

Here you will read stories about 8th grade girls in Newton, Massachusetts, using dance to undermine racism and Bedouin women living in tents in Israel who use drawing to empower themselves. There are stories of Saudi-Arabian students teaching their teachers about the possible misuse of the arts, and immigrants in Vancouver producing plays with a Chilean director to confront the pain of severance and transplantation. Ghanaian village women use theater to become equal partners in the transformation of their village life, and an arts center in North Carolina rebuilds itself by really reaching out to its roots in the community. We have women in a prison in New York State and women imprisoned by poverty and homelessness in urban Boston who are finding ways out through the arts.

Children in Thailand and kids in Massachusetts use storytelling to learn about and value their cultures, to see from new vantage points. Dancers in a New Jersey university learn to really see each other; elementary teachers-to-be and kids on opposite coasts of the United States connect through the arts. South African children use drawing to be heard, to reconnect with themselves, to learn to speak, and find their voices. Adolescents use theater to explore theirs. One artist tells the lifelong story of involvement in social change, and another uses collage to help teachers-to-be "unhinge" linear frames of thinking and dominant ideologies and practice that often go unchallenged in the classroom. A Jewish professor reflects on her work with Israeli teachers in a time of war and comes to understand positionality in a new way. Conflicts are resolved using the arts.

Mary Clare Powell's Story

All my adult life I have been telling stories like these about the power of the arts. One group in particular stands out in my memory—the low-income women of Chicopee, Massachusetts, who wrote their way out of poverty, who moved from breakdown to breakthrough, simply by beginning to write their stories. Led by Pat Schneider and myself, they came to believe they were writers; they began to explore their lives, write their lives, and heal their lives. As they wrote, they began to assume that they had something to say and the power to say it. Evelyn wrote about her Polish family, Teresa wrote dark pieces about drugs and sex and her son fishing in the river. Enid explored her childhood as a brown Puerto Rican girl in a white world. Maryann described how she made wallets all day at a factory and raised her granddaughter. Robin mourned her mother's death with the group. These women, week by week, liberated themselves and each other; they mined diamonds in stories and poems; they generated freedom. They broke their own silence, risked telling the truth about their lives, turning into, not away from the pain, neglect, failures, severe limits, abuse, poverty, discrimination, fears, and dangers of their lives. Most of the original group of eight women went to college, some got master's degrees, and they began to lead writing workshops for their neighbors and their neighbors' kids to pass along the healing power of creating in the arts.

I learned an enormous amount from these women, but mostly I learned about the power of making words and making people. This experience forms the heart of my deep belief in the arts and education, which supports my belief in how social change can come about.

Vivien Marcow Speiser's Story

My story is a multicultural one. Born in South Africa, I was exposed from an early age to social injustice and inequality, and as an adult living in both Israel and the United States, I have witnessed the often-devastating results of such historical injustices. I have never given up hope that I can do something to impact the situation.

As an artist-educator, arts therapist, arts administrator, and performer, I have learned that the arts can create form from formlessness and from feeling. Suzanne Langer (1962) writes that, "There is an important part of reality that is quite inaccessible to the formative influence of language: that is the realm of so called inner experience, the life of feeling and emotion." The arts can be a way of expressing that which is otherwise inexpressible. Many of the authors in this book touch on unique ways of working with this inner reality within a social context.

The South African poet, Breyten Breytenbach (1980) speaks to the issue of creating form from formlessness when he writes:

> To dance as one should
> You must be blind and groping
> With as your audience
> (A Season in Paradise, p. 250)

I know from my own engagement with the creative process that something will emerge even from the bleakest darkness. I have made dances about the Holocaust, about war and about peace, about the most painful moments of the human experience. I have photographed the fires raging in Wyoming and Montana and lamented over these and other conflagrations. I have hoped even when all hope seems gone. I have curated art shows such as *After/Before: Artistic Encounters Following September 11th,* and arts events such as *Seeing Both Sides of the Israeli-Palestinian Context.*

Like many of the authors in this book, I believe the arts are a call to action, to education, and to empowerment. The arts, as Neale Donald Walsh says, "help us search again not only for the meaning of life but also the purpose of our individual and collective experience...for ways we might re-create ourselves anew as a human species, so that we may end at last the cycle of violence that has marred our history." (p. 17) I see the little offerings I make through my art forms and through my teaching as the manifestation of that hope. I see the contributions of the writers in this book as exemplars of that hope.

Artist-Educators

The contributors to this book offer to others what they themselves have experienced—the opportunity to create. They value authenticity more than perfection of execution, so they offer art making that heals. Teaching grows organically from their lives as artists, often impelled by a social or political vision. Often their work grows out of a community or out of their own experience of liberation. Suzi Gablick writes, "The capacity to move beyond the old art-and-life polarities is precisely...the starting point for new modes of relatedness, in which the paradigm of social conscience replaces that of the creative genius." (1989, p. 76)

The teacher/artist couples her knowledge of people and groups and all the skills of working with them with the knowledge and experience of the arts—which they know have the power to transform. Lori Wynters, one of our contributors, describes her work with women in prisons as transformational, where "art making has the potential to open the heart, liberate the individual, social groups, social processes and even liberate societal institutions."

We have educators acting in small and local ways, working with discrete groups of individuals. That's the way artists always work—small. And they work in the faith that it matters how you work. How can poets stop a war by gathering on the street corners? We don't know, but still we gather, in hope.

In this book, we see education in the truest sense—transformative education. *Educere* (from the Latin) means to draw forth, to evoke that which is within. And it is this process we see happening in the work of these artist-teachers. When you couple the process of evoking what is within with the creative process, which helps people find their words and images and believe in their power to put them out into the world, the result is social change—not always monumental, but real social change from the inside out.

In her work with children in a post-apartheid South Africa, Angela Rackstraw, whose chapter has given us our title for this volume, knows that even though there is little real chance that the living situations of the children she is working with will change, still there are "small bright moments" that engagement with the arts brings to them: "What we can offer the children is a space where they will be heard and listened to, a space where they will hopefully reconnect with themselves, learn to speak, and find their voices."

Arts

The arts help people find what Tillie Olsen calls "the will, the measureless store of belief in oneself to be able to come to, cleave to, find the form for one's own

life comprehensions." (1965, p. 27) Chicana writer Gloria Anzaldua says she writes to discover herself, to preserve herself, to make herself, to achieve self-autonomy... "To convince myself that I am worthy....The act of writing is the act of making soul...alchemy. It is the quest for the self, for the center of the self." (1981, p. 168–69)

In the minds of these teacher/artists, creativity is linked to wholeness, to the well being of persons. M.C. Richards writes, "Why does the human being long to work artistically? Why are the art programs in the public schools and communities so popular? Because there is a natural enthusiasm for creative activity built into our bodies. There is an essential connection between artistic activity and human nature...[The arts} are the ground of our intuitive understanding of ourselves and the world around us." (1980, p. 94)

The arts, writes Maxine Greene, professor at Columbia University Teachers College, raise awareness and open clearings. "To move into those spaces or clearings requires a willingness to resist the forces that press people into passivity and bland acquiescence, a refusal of 'normalization.'"(p. 27-28) "One of the functions of the arts is to subvert our thoughtlessness and complacencies, our certainties even about art itself." (p. 33) This is how the arts enable true education ... "to feel oneself *en route,* to feel oneself in a place where there are always the possibilities of clearing, of new opening: this is what we hope to communicate to the young...."(p. 37)

Social Change

It happens as the people in this book do their creative work with others. Often they don't really know much about the impact of their work, or its scope. They simply do it in hope. From time to time they see how limits are transcended, how the word gets out, how hope is generated far more broadly than they anticipated. They are doing nothing less than changing the world, one small group at a time. As Margaret Mead asked, what other way of changing the world is there?

This is social change one person at a time. Slow but lifelong and lasting. This social change is really about developing an inner sense of confidence—faith in what is potential in oneself. This is the same definition of creativity for Erich Fromm who writes that being original means that one experiences himself as the true center of his [or her] world and the true originator of his [or her] acts." (1959, p. 63)

Maryat Lee, founder of Ecotheater in West Virginia, challenges us all, "What if people are endowed with extraordinary gifts, but all access to them is mis-educated out of them? What if it is now the calling of artists...to draw their fellows

into the dance instead of leaving them to sit stuffed on the sidelines in their end-less misery with glassy admiring eyes? The sense of connectedness and equality with humankind which we all need, are deeply missing. It once was possible through artists…"(Letter, March 20, 1987)

And it still is. Beverly Naidus, in this book, says, "I remain optimistic that more of us will use the arts to provoke dialogue, empower the invisible and alien-ated, raise questions about things we take for granted, educate the uninformed, heal rifts in polarized communities and within individuals wounded by society's ills, and provide a vision for a future where people can live in greater harmony with each other and the natural world."

It is our hope, and not a little one, that you will be inspired by the work of the women and men described here, and that it will encourage you to find ways to pull those around you into the dance, helping them become participants, to see themselves as they truly are, to envision new possibilities for their lives, and to change their worlds. As Vivien and Phillip Speiser write, "The arts mobilize passion and will power in the service of our common survival."

References

Anzaldua, G. and Moraga, C. (eds.). (1981). with *This Bridge Called My Back.* New York: Kitchen Table: Women of Color.

Breytenbach, B. (1980). *A Season in Paradise,* London: Faber and Faber.

Fromm, E. (1959). The creative attitude, in Anderson, H., Ed. *Creativity and Its Cultivation.* New York: Harper and Row.

Gablik, S. (1989). Making art as if the world mattered: Some models of creative partnership, in *Utne Reader,* July/August 1989.

Greene, M. Texts and margins, in *Harvard Educational Review,* Vol. 61, 1, Feb. 1991.

Langer, S. (1962). *Philosophical Sketches.* Baltimore: The Johns Hopkins University Press.

Lee, Maryat. *Ecotheater* (private correspondence).

Olsen, T. (1965). *Silences.* New York: Dell.

Richards, M.C. (1980). *Toward Wholeness.* Middletown, CT: Wesleyan University Press.

Walsh, N.D. (2001). What is the proper response to hatred and violence? in *From the Ashes: A Spiritual Response to the Attack on America,* New York: St. Martin's, Rodale, and Beliefnet.

CHAPTER ONE

Dance the Dream: Reflections on an Eighth Grade Dance Class

Nancy Beardall

"Ms. Beardall, Ms. Beardall, something terrible has happened to Roberta! Two white boys told her she was a 'f_____, black, b_____whore'! A crowd of kids are on the field." I felt a knife pierce my heart. Roberta had been in my dance class for the last two years. During this time I watched this vibrant, yet volatile, middle-school girl focus her energy as she matured into a strong, grounded adolescent. This single spring morning event, which was publicly reported, forced us as a school community to examine the underlying racial tensions that existed in our city. For me, this event triggered my commitment and sense of responsibility as an active role model and ally of students to understand and address racism in our school.

As a dance and comprehensive health teacher and a dance/movement therapist, I have always supported students in their social, emotional, and relational development. This racial incident provided me and the school community with many questions as to how to encourage understanding, dialogue, and healing. I needed to examine my own racial identity development and to ask myself how might we heal after this latest incident.

The following year, as I was looking at my eighth grade dance class in the late fall and feeling proud of them, it struck me that this group was more diverse than ever. We had five African American students, four deaf and hard-of-hearing students, three ESL (English as a second language) students from Italy, Ecuador, and Brazil, and six Euro-American students. At that moment, I wanted to give everyone the opportunity to look at our differences in order to come to a better understanding of each other.

I had recently started working with Steve Bergman and Janet Surrey from the Gender Relations Project at the Stone Center, Wellesley College, and realized that their method of looking at differences between the genders to achieve a better mutual understanding, or relational connection, could be applied to diversity issues. Using the Shem/Berman/Surrey (1998) gender dialogue model, I decided that my diverse group of students could be guided to talk about their racial, ethnic, or cultural differences as a way of learning about, accepting, and supporting each other.

The "Relational Model" (Jordan, et al. 1991), on which the gender dialogue is based, focuses on connections that foster growth. Jean Baker Miller (as cited in Tatum and Ayvazian, 1994) has written about the constructive power of relational connections and the potentially destructive force of relational disconnections and violations. By helping the girls to become more conscious of and to talk about friendships, greater communication and understanding could be fostered in addition to establishing a connection among the girls in the group. This process has been described as follows: "What happens when our experience is validated by another in a mutually empathic relationship? We feel a strong sense of connection" (Tatum and Ayvazian, 1994, p. 1). The intention was to help each girl in her own identity development process as well. What was learned would be used to create a dance that would be shared with the community.

The first step was to speak to my students and to get their approval for the project. After a lengthy discussion on why we should work on understanding our differences in a dance class—and fielding many good questions and concerns from students—the group gave their support. One of the students, however, felt strongly that there should be no affinity groups. She said "I think that the dance should be about unity." I assured her and the group that that was our ultimate goal, and that by speaking of differences, we could possibly get to feeling connected in a more authentic way. I also shared with them that I had not done this before, and I was unsure of what exactly lay ahead, but that I trusted we would all learn from our experience.

The project began by dividing the class into affinity groups. Psychologist Beverly Tatum's (1997) idea of affinity groups for students of color to discuss their academic achievement and those issues unique to their racial identity was applied to the cultural differences experienced by each group in the class. The goal was clear—to support each affinity group through this process.

Next, I needed help in leading each affinity group. I asked two African American colleagues, an ESL teacher, and an American Sign Language inter-

preter to be part of the project. I was already supervising two Lesley University graduate interns who worked with us on this project. We asked the girls to list the strengths of girls' friendships and to list the things they didn't like about such friendships. The entire class then came together to engage in a dialogue across groups. After the first session, it was clear that the questions were too general. Cultural differences and similarities among girls were not being adequately elicited.

The adult leader of the African American affinity group reported that, although the African American students spoke about differences between their friendships with one another as opposed to those with girls outside their own group, none of those conversations came up in the large-group discussion. A second series of questions was developed. The collaboration with my African American colleagues was crucial to the process. Their view and mentorship were essential to me, as well as to the students. The second series of questions was as follows:

- Do you think there is a difference between the friendships among your (deaf and hard-of-hearing, African American, ESL, Euro-American) friends as compared with other groups?
- How do you feel when you are asked the above question about differences?
- Can you make friends outside your immediate group?

A third series of questions was as follows:

- How might you like to be understood or treated?
- What would you like others to know about you?

In addition to writing out their thoughts, the students were also given the opportunity to include a picture, story, poem, or song.

During the large-group dialogue sessions, the African American students and the deaf and hard-of-hearing students tended to speak the most. A deaf student said, through the interpreter, that she felt people had treated her as if she were invisible at the school she attended prior to Day Middle School. They would ignore her at best, make fun and be cruel to her at worst. An African American student asked her whether she wast treated that same way at Day. "Not really," she responded, but went on to say that people didn't try very hard to communicate. She told how friendships within the deaf group are "tight," and yet friends argue because they are like sisters, always together.

One of the African American students responded with, "I'm the boss of my table at lunch and you and your friends can always sit with us." Another

African American student said, "It makes me feel bad that you were treated that way" and began to cry. A deaf student began to cry. The group was silent. I asked everyone to stand in a circle and hold hands. I spoke to the girls about the pain involved in feeling isolated, discriminated against, left out. Another student spoke of fear and anger. I said we were all here to support one another. We could share what we learned here by creating a dance to perform for the school.

The ESL students said little in the beginning. We needed to hear from everyone, so we asked all of the students to try and contribute some of their thoughts. No one was left out. One student began to speak of feeling different—being too embarrassed to have kids come over to her house because her family had different customs. Although the ESL students were from Italy, Brazil, and Ecuador, they spoke about religious holidays they had in common and the fact that they were not part of the dominant culture.

The Euro-American students said little, and much of what was said in their small group was left unsaid in the larger group. They did say in the small affinity group that they sometimes felt intimidated by the African American students. They also said it was difficult to communicate with the deaf and hard-of-hearing students and ESL students. One student said she had been asked by the African American students to be in their dance piece but had refused because she was afraid they would make fun of her if she could not do the steps. She felt that if she had participated in these dialogues before, she would have joined in their dance. It was an important moment for the group, students began to recognize that dialoguing could bring one to a more trusting and understanding connection. The Euro-American students intimated that they had be enenculturated not to speak of racial differences and were, therefore, hesitant to connect in this way.

Active antiracism education in which white privilege (McIntosh, 1989) and history from multiple perspectives of culture and race (Banks, 1996) are discussed is currently being integrated into the core subjects. This focus will lead students to learn more about true cross-cultural dialogue. Historically, multicultural education has been about heroes and holidays, not about students' responsibility and role in connecting. Active antiracism education provides more effective strategies for giving students the ability to dialogue honestly about their racial and cultural identity.

At the group's third meeting, two students, an African American and an ESL student, refused to enter the room. Both said what the class was doing was "too

hard." In the last session, when two students had cried, there was a great deal of pain shared. The students realized that building connection across affinity groups was difficult, both individually and collectively, and was painful as well as healing. I assured each of them that it was safe for them. In the end, each came in separately and sat down. Liz Lerman (1993) writes about learning about Christian art from her Jewish perspective and speaks about what she calls "colliding truths" and how the moment of discomfort must be waited out: "I feel that this moment of discomfort is actually the next stop beyond connections" (p. 7).

The third session followed a format similar to the one used in the first two meetings, small affinity groups followed by a meeting with the entire class. The discussion focused on how students would like to be understood and treated by others and on ideas for the dance. The dialogues flowed easily. There was respect and support. The group had shifted. It had not been easy, but by talking about differences, students found they could connect, build relationships, share what we learned, and DANCE.

After the dialogue sessions, I put together a number of quotes from the students' spoken and written statements. The quotes were typed and placed on the stage floor. Students were asked to go around and choose a quote they wanted to say at the beginning of the dance as a way to shape the underlying movement theme. The girls were given the chance to pick whatever statement spoke to them, their own or another's. Most of the girls choose another student's words. At this stage in adolescence it can often be intimidating to speak one's own truth and easier to feel passionately about what a friend may say. The power of the dialogue gave all the students the opportunity to be seen, heard, reflected, and held in the reality of their own experience as developing adolescent girls. By choosing to read somebody else's statement they could speak their mind, their worries and needs, and still feel safe and protected. This experience further fostered connection and growth. The students wrote:

- "May you thrive with grace and strength."
- "Change the cycle of negative thoughts."
- "Feelings and thoughts from others that do not set bounds."
- "I can say something too."
- "Understand, I try my best."
- "We all need to have more patience with each other."
- "The wish, a deeper understanding among us."
- "See me as I am."

- "You don't know what it's like until you've been there."
- "Treat me with respect."
- "Watch and listen carefully."
- "There are no differences on the inside; people see the differences on the outside."
- "With respect, you begin to bring forth the true you."
- "People treat me as if I'm not there."
- "Sometimes I want to be mean to others just so they will know what it feels like."
- "If we had talked before and understood, we could have worked together. We need to talk more."
- "It feels good when people ask me about my differences because then, POW, it's out there."
- "It's sometimes intimidating."
- "When you know, you act and dance the dream."

Each girl said the phrase she had chosen into the microphone and then-walked to her place on the stage. At the end, everyone applauded and hugged. Students were sharing their words. Trust and mutuality was being established. The group had something to share.

Speaking the phrases was a way to move forward from the dialogue sessions to planning and choreographing the dance. Everyone was listened to, and we began incorporating the ideas with the movements. The process was slow and sometimes frustrating. The group members worried there would not be enough time. However, everyone steadily worked through it all. Students volunteered to come in after school. Everyone worked hard and was present right there in the moment.

One day a parachute was brought in for the students to play and dance with. The results were incredible. The students were so exuberant and playful with each other. This was how the dance needed to end, sharing the joy of simply being, working, connecting, and dancing together. This is the beauty of dance and how it unifies.

On a group level, movement speaks and connects us to each other in the dance, but the dialogue helped to make this process more conscious and, there-fore, helped each student feel in her body a sense of differences, of understanding, and connection. Each of the students came to understand her individual contribution and her relationship to the group. As such, the dance evolved and flowed, the process of choreographing reflected the process in the dialogue. The

dance evolved into expressive movement, body, and space and mirrored the dialogue. The group divided into triads, which represented each of the affinity groups from the dialogue. These triads were not actually divided along affinity group lines but served to symbolize those groupings. Each member of the triad choreographed a single movement, which they taught to the other two members. The triad's movement phrase thus came from the combination of the three individual movements. The triads then taught their movement phrase to the rest of the group, as each affinity group had done with the larger group in the dialogue. They then joined with another triad and became a group of six.

As the groups of six came together they formed an s-shape on the stage. In this formation, each dancer performed her own movement and passed the momentum along to the next dancer in line, who did her own movement. The girls wanted to have their own individual dance phrase, which led us to performing a succession of individual movement phrases in the s-shape, creating a sense of individuals in community and a further sharing of movement and connection. The end of the dance, everyone agreed, needed to convey the joy of dancing and sharing together as experienced when we played with the parachute.

Working on choreography encourages listening, problem-solving skills, and collaboration. There is a give and take, a sharing, a compromising that leads to team building and a sense of community. We looked at each dancer's individual movements and sense of alignment using Bartenieff and Lewis's (1980) body fundamental connections, Laban and Lawrence's (1947) effort qualities and their increased movement repertoire, in addition to Laban's (1966) use of space. The dance followed the dialogue process. Each student had her own movement patterns and collaborated on creating group phrasing in different configurations, leading to each expressing her own unique signature before ending in a playful spiral of joy and celebration.

The name of the dance became "Dance the Dream." A quote from the Lesley intern involved in the project eloquently described the experience. She said, "What I finally said to the class was how touched I was with how mature they were, as a class, and at the same time how young and purely innocent. The dance that we all created from this process expresses that so beautifully. Not only does it capture their unity within the differences; it also captures their child like energy. As Kia said, 'When you know, you act and dance the dream.' I've discovered that the dream is not only coming together and connecting as a diverse group. It is also finding a middle ground between the graceful, mature young lady and the happy, skipping little girl."

Newton's METCO (Metropolitan Council for Educational Opportunity) counselor said, "The students of color don't get the opportunity to discuss differences." She mentioned how "at middle school many of her students feel different because of their race." Here was an opportunity for them to meet in their own group and discuss how they felt and also to discuss and share among the diverse group of students in the dance class about the similarities of girls' friendships whether they be about strengths or difficulties."

The guidance counselor who had taken part in the project wanted all future dance students to learn the dance. The learning, however, was the process that became the dance. Could the dance be taught to other students and have them bond and feel as these students did? The group did not believe so; however, Dance the Dream became a model for dialoguing about diversity and building connections in school.

The eighth-grade creative dance program at Day Middle School is an art elective that meets twice a week for the entire year and addresses the challenges that many adolescent girls face. Adolescent girls need to define who they are, feel good about who they are, and work together in community, where they can maintain a sense of their own body and self while connecting to the group. Through their identity development, they must resist becoming a stereotype in a society that surrounds them with stereotypical images of girls and women, while affirming themselves and finding their voices. Dance that is used as a tool for children to consciously connect to their bodies, accept their bodies, and creatively express themselves is empowering. According to Russell (1958), "Dance involves the whole person in an extraordinarily balanced way...no other activity demands so equally the use of the intellect, the body, the emotions and the intuition" (p. 13). The Dance the Dream project provided the opportunity for collaborating on the dialogue questions with colleagues, collecting the data from the students in the dialogues, and applying what we learned to the creative process of choreographing the dance. The dance became part of our individual and collective racial and cultural awareness. Performing and sharing the dance with parents and their middle-school peers, as well as traveling to two elementary schools in the city, allowed the students to communicate beyond themselves a message that they felt connected to. Martha Eddy (1998) says "Performance affords an opportunity to contribute to the wider community, increasing the sphere of relationship (and, hence, hopefully extending the range of behavioral accountability) and supporting the development of confidence and pride" (p. 335).

The following valuable insights were leaned from Dance the Dream:

- The group's experience during the affinity groupings, dialogue, and creation of the dance embodied the body-mind experience based on the shared consciousness of all the students. Miller and Stiver's (1997) qualities of connection and growth—respect, engagement, zest, attention, empathy, authenticity, diversity, mutuality, empowerment, and mutual empowerment (pp. 25-41)—were observed throughout this process.
- In active antiracism and diversity work, there needs to be a diverse group of people sharing their perspectives. One cannot begin to know what another racial or cultural group is feeling. Fear can hold individuals back from asking difficult questions. One can't get answers from questions that have not been asked. The project's leaders came up with some difficult questions that needed to be put before the group. Once the leaders had permission to ask these questions, it became easier to talk about differences and for the students to dialogue about them.
- Affinity groups were successful, but it was important to bring that learning into the larger class group so that everyone could understand what the people in that group were feeling.
- Having role models in active antiracism and diversity work is important for students. This work is challenging, and students need to see adult teachers, counselors, staff, and peers as allies and role models.

Instead of feeling the project was completed, one felt as if it were just a beginning in the use of affinity groups, the dialogue, and the creative process in adolescent identity development and respect for differences in the middle school. The challenge was how to apply what was learned to other subject areas.

The gift of Dance the Dream was the chance for individual students to move from not knowing each other and even being intimidated and afraid of each other to dancing together in community. By doing so, each student came to recognize her authentic voice and her movement voice, which allowed her to trust herself enough to be true to who she was and open to the possibility of connection and partnering in a creative dance that expressed a relational model of community and support.

The following year I sent my former dance students, now freshmen at Newton North High School, a questionnaire asking them to reflect on their experiences of the Dance the Dream process and what, if anything, they were

able to take with them to the high school. Here are a few of the responses.

- "I learned that I loved expressing myself through the art of dance."
- "When we had group discussions, our feelings just poured out, and even now, it affects us, because we still say 'hi' to each other and make a point of smiling when we see each other, because we had bonded during that experience."
- "I found the diversity and individuality very welcoming. I didn't have to act a certain way anymore. I could be myself."
- "Everyone stayed helpful. We would help each other out any time."
- "All people want the same thing. I learned we all want to be supported."
- "It became easier to talk to people of a different race or culture."
- "Well, for me, I was always afraid to even look at a deaf person because I thought they would think I was ignorant. That has changed—I talk and listen to each person."

The students had connected to themselves, to each other, and to the community. Dance the Dream was part of our community's healing reaction to a racial incident. The journey, the process, the dance, the students' contributions, my own growth in trusting myself, my students, my colleagues, and the creative art process itself were additional affirmations and examples of the healing and transforming powers of dance.

References

Banks, J. (1996). *Teaching Strategies for Ethnic Studies.* New York: Allyn and Bacon.

Bartenieff, I. and Lewis, D. (1980). *Body Movement: Coping with the Environment.* New York: Gordon and Breach Science.

Eddy, M. H. (1998). The role of physical activity in educational violence programs for youth. Unpublished dissertation. ColumbiaUniversity.

Hervey, L.H. (2000. *Artistic Inquiry in Dance/Movement Therapy.* Springfield, Illinois: Charles C. Thomas.

Jordan J., Kaplan A., Miller J., Stiver I. and Surrey J. (1991). *Women's Growth in Connection.* New York: Gulford.

Laban, R. (1966). *Choreutics.* Lisa Ullmann, Ed. London: Macdonald and Evans.

Laban, R. and Lawrence, F. (1947). *Effort.* London: Macdonald and Evans.

Maletic, V. (1987). *Body, Space, Expression: The Development of Rudolf Laban's Movement and Dance Concepts.* Berlin: Mouton de Gruyter.

McIntosh, P. (1988). *White privilege and male privilege: a personal account of coming to see correspondences through work in women's studies.*

Miller, J.B. and Stiver, I. (1997). *The Healing Connection: How Women Form Relationships in Therapy and in Life.* Boston: Beacon.

Preston-Dunlap, V. (1998). *Rudolph Laban: An Extraordinary Life.* London: Dance.

Russell, J. (1958). *Modern Dance in Education.* London: Macdonald and Evans.

Shem, S., Berman, S., Surrey, J. (1998). *We Have to Talk: Healing Dialogues Between Women and Men.* New York: Basic.

Tatum, B.D. (1997). *Why Are All the Black Kids Sitting Together in the Cafeteria?* New York: Basic.

Tatum, B.D. and Ayvazian A. (1994). Women race and racism: A dialogue in black and white. Work in progress. Stone Center paper No. 68, Wellesley College.

Engendering Cultural Pride through Storytelling

Margaret Read MacDonald and Wajuppa Tossa

In Northeastern Thailand (Isaan), use of the local dialects is discouraged. Standard Bangkok Thai is required in schools and is used in movies, magazines, and on television. In an effort to engender pride in local languages and cultures, Wajuppa Tossa has begun a storytelling project. University students are trained to perform for children in the 19 provinces of Isaan, while teachers are taught to help children perform the stories they bring into the classroom from home in the local dialects. Through university education, teacher conferences, children's storytelling camps, and storytelling tours, Wajuppa is making a difference in the way local culture and language is viewed in Isaan.

In 1995 and 1996, Margaret Read MacDonald was invited to join Wajuppa in Mahasarakham to help train students and teachers throughout rural Isaan in storytelling techniques, an amazing opportunity for a folklorist and professional storyteller. Elderly folks shared stories, which they added to their troupe's repertoire. Teachers were eager to learn storytelling techniques for classroom use everywhere they went. Together they developed a tandem-telling translation technique that allowed MacDonald to teach and perform. She has now used this technique throughout the world and has taught it to bilingual teams from several countries.

Wajuppa quickly learned these story-teaching methods and continues to train a core of students each year. Her enthusiasm for story-teaching has prompted her to take her students throughout Thailand, Laos, and Singapore to share

their skills with teachers in regions outside of Isaan. They continue to inundate Isaan with story today.

Isaan consists of the large Korat plateau, a flat, dry area, in which only one crop of rice can be grown annually. A low mountain range lies at the plain's edges, and the Mekong River loops around the eastern and northern edges of the region. Wajuppa was born and raised in the small town of Tat Phanom on the banks of the Mekong River. She grew up swimming in the Mekong and worshipping at the sparkling white stupa of the Tat Phanom Buddhist wat. Buddha himself is said to have visited this place, making the wat a particularly sacred spot.

Wajuppa grew up speaking Lao. The people of this area are ethnically Lao like their neighbors across the river and most of the residents of the entire Isaan region. Those in the south, near the Cambodian border, are Khmer. Pockets of speakers of minority languages like Phu Thai and Suey are sprinkled throughout Isaan. In Wajuppa's youth, everyone spoke their local dialect, but gradually Bangkok Thai displaced the local speech.

Today, radio, television, magazines, and all school instruction are in Bangkok Thai. The speaking of local dialects in schools is discouraged and in some cases forbidden. When Isaan folk visit Bangkok to find work or to do business, they are looked down on as country bumpkins. If they speak in their rural dialects, they are scorned. Due to these factors, upwardly mobile families in Isaan do not allow their children to use dialect.

Wajuppa was shocked by this practice when she saw it firsthand at a relative's party one day. She was teasing her cousin's two young twins in her Lao dialect when she was sharply told that they did not allow anyone to speak to the children in that dialect. These children would grow up speaking proper Bangkok Thai.

While a doctoral candidate at Drew University, Wajuppa spent several years translating lengthy Isaan folk epics. These amazing pieces of folk literature have been preserved on palm-leaf manuscripts in the wats of Isaan. To study these, Wajuppa had to train herself to recognize many archaic words that are obsolete in the Isaan-Lao language. Today, only monks are able to read these texts. Suddenly Wajuppa realized that not only was the ancient language being lost, but the very lifeblood of her own childhood was being forsaken. With this loss of language, local cultures would be lost as well.

In 1993, Wajuppa conducted a survey of children at the Teachers' College in Mahasarakham, which stands adjacent to Mahasarakham University, where she

teaches in the Western Language Department. She discovered that 50 percent of the students surveyed did not understand the Isaan dialect. Less than 20 percent could recognize titles of traditional Isaan folktales.

In an effort to slow this cultural decline, Wajuppa devised a three-year storytelling project. She applied for a Fulbright Scholarship to teach storytelling techniques to students in her university. She applied for a grant from the James Thompson Foundation for travel expenses as she took her storytellers throughout Isaan to perform in schools. She badgered Mahasarakham University to provide vans to take her students to schools throughout a 19-province area.

In 1995, MacDonald, a folklorist, storyteller, and children's literature specialist, arrived as a Fulbright Scholar to assist in Wajuppa's project. The task was daunting. First, university students needed to be trained in storytelling techniques. Wajuppa and MacDonald developed a method of tandem-telling that allowed for rapid-fire, line-for-line translation and performance. The second challenge was to find suitable tales in Isaan folk literature for the students to tell.

To find these tales, MacDonald scavenged at the university library and engaged a graduate student, Uraiwan Prabipu, to translate those stories most likely to play well before large audiences of children. Uraiwan translated them into English, while MacDonald typed them up. Then MacDonald adapted the stories into a format that would be easy to perform, and Wajuppa translated the stories back into Lao, correcting any cultural errors MacDonald might have unwittingly inserted. Then they taught the stories to the class via tandem-telling. The students rehearsed them in small groups, and MacDonald coached the students in their final performances. Wajuppa sought to involve students who could speak Khmer, Khorat, and other minority dialects, as well as the much-used Lao. Though the stories were taught in Lao, the students rehearsed the stories with others from their own language group.

One of the most amazing stories we worked with was the story of Chet Huat Chet Hai, a boy who eats seven pots of rice and seven jars of fish sauce at each meal. His father takes him off to the forest in an attempt to get rid of him, but strong Chet Huat Chet Hai carries home the tree meant to fall on him and rides home on a tiger meant to eat him. Later, he sets off on an adventure and picks up several extraordinary traveling companions: one can cut 100 bamboos at a time, one can chop with his hard head, and one can pull 100 carts.

When she came to this point in her re-telling of the story, MacDonald made a cultural gaffe. In her version, Chet Huat Chet Hai greeted each traveler with a hardy, "Hi! I'm Chet Huat Chet Hai! Who are you?" This kind of confronta-

tional behavior is considered extremely rude in Thai society even if it is intended to be friendly. One chats for a while and facts gradually emerge. In light of this, Wajuppa had to soften the re-telling.

Following the meeting of the travelers, the friends travel along and defeat a witch and a giant. This story (Stith Thompson Motif F601 Extraordinary Companions), has variants in many countries, but this one differs from others in its unusual details. For example, in this version a giant cockroach is pulled from its hole.

Her troupe told the Chet Huat Chet Hai story for a year as a traditional folktale. One day, a listener asked if they had ever been to the Chet Huat Chet Hai Temple. This set them off on a search through several wats, and they finally found the place. To their amazement, they found the grounds of the temple covered with Chet Huat Chet Hai statuary. The monk of this temple was keeper of an ancient palm-leaf manuscript bearing the story. In the forest near the temple could be seen the actual spot where, according to the story, the giant cockroach was pulled from its hole. Thus, the simple foktale now took on the added meaning of a belief legend and a place legend. It is multi layered stories like this that Wajuppa explores in her studies of Isaan folk literature.

In 1996, MacDonald returned, and the Mahasarakham Storytelling Troupe toured 19 school districts. At each school, Wajuppa administered tests to first graders, examining their attitudes toward their local dialects and their knowledge of local folk literature. Storytelling assemblies were held, at which the students gave high-energy folktale performances in Lao. In some areas, tales were also told in Khmer or other dialects. The students used tandem-telling, audience-participation, and story-theater techniques to engage these large audience—often 600 or more children in a dusty, windy open-air space using a scratchy microphone. After school, MacDonald and Wajuppa held a workshop for the teachers, in which a few simple stories were taught for use in their classrooms. The participants were also encouraged to teach local culture units to their children. It was hoped that they would ask their students to bring in folktales from their own families and share these in their own dialects.

Wajuppa explains what followed:

> We believe that if a dying language and culture are to be maintained and revitalized, everyone must take part. Thus, we tried to get both parents and teachers involved, not only the children. At the performance, we told three or four short folktales in tandem and one in story-theater format. Then we encouraged the children to collect stories from home to share with us next time. We also encouraged teachers to help us follow up by asking the children every one or two weeks which stories they had learned from home.

If the children wanted to tell stories, the teachers would help them rehearse. In this way, everyone would be involved in preserving Isaan folk literature that might otherwise be forgotten. The children might feel that these stories were important. If they liked the stories and the way that we told the stories in dialect, they might have better attitudes toward local dialects and literature.

Although we tried to involve everyone in the process of preserving local languages and cultures, our focus was on the children. Thus, in our second visit we asked students to volunteer to tell their stories to us. We left for about a year before we returned to the schools to do the same activities and to listen to representative children tell their stories to us. We hoped that the children would choose to tell the stories that they learned from home and to do so in local dialects. We were delighted to find 129 young storytellers among the 4,933 [total children told to in first year of project]. Among these children, 81.6 percent told folktales that they learned from home, and 75.96 percent told stories in local dialects. The stories that the children told were unique, such as the "Golden Conch Shell," which is similar to the "Golden Turtle Prince." Some stories were so tellable that we adapted them from the children's tellings and added them to our troupe's repertoire. These included "When Xiangmiang Is Outwitted," "Three Animals" and "The Miser Bird" ("Nok Khee Thi"). These stories are now being shared all over Isaan, thanks to these children who learned the stories from their communities.

In the final year of her project, Wajuppa again surveyed the students. Now they were in second grade. She was pleased with some of the results.

	1st Survey	2nd Survey
Proud to speak local dialect	76.5%	86.18%
Agree that Thai people should speak a dialect as well as standard Thai	75.66%	81.13%
Embarrassed to speak dialect	53.61%	51.50%
Thai people should speak only standard Thai	38.41%	23.40%
Should know at least one local folktale	74.91%	84.13%
Like to ask elders for stories	85.36%	95.07%
Think stories can teach moral lessons	90.77%	97.53%
Think local folktales and storytelling are old fashioned	31.74%	21.63%
Think local folktales and storytelling are of no value	29.59%	21.58%

In order to encourage the continuation of this work, Wajuppa holds an annual storytelling conference for teachers and librarians. Participants have come to Mahasarakham from all over Thailand to participate. Many go home encouraged to carry on storytelling work in their own communities. The Mahasarakham Storytelling Troupe has traveled to Chiang Mai, Bangkok, Hat Yai, and other regions to share tales and promote the project. Wajuppa has twice brought storytelling troupe members to the United States to perform, and she has traveled to Australia and Singapore to speak about her project and share Isaan stories. Each November, the Mahasarakham storytelling troupe sponsors a "Tellabration," the worldwide storytelling event encouraged by the National Storytelling Network in Jonesborough, Tennessee.

Wajuppa offers a storytelling camp each year for children and their parents. She continues to bring in storytelling and theater specialists to work with her students, and each year she recruits and trains another batch of Mahasarakham storytellers. Perhaps one of the most important results of this work will be that many former storytellers later go out into their communities. Many of these are now continuing her storytelling project in their own rural schools. And one of her students, Prasong Saihong, is now studying for a master's in cultural anthropology at Northern Illinois University. His master's thesis involves collecting stories from rural tellers in Isaan.

Endnote

1. For more information on the Mahasarakham Storytelling Troupe or Wajuppa Tossa's project, contact Margaret Read MacDonald at mrm@margaretreadmacdonald.com or at www.margaretreadmacdonald.com or Wajuppa Tossa at wajuppa.t@mail.msu.ac.th.

Sister Travelers:
Sara, Antigone, Lilith, and Me

Eleanor Roffman

Introduction: Self and Context

During the last six summers I have packed my bags and books for a trip to Israel to teach the Psychology of Women course in the Women's Studies Division of Lesley University's Graduate Summer School Extension. This is a journey that challenges me on every level. I am crossing borders, boundaries, and conflicts within myself as well as outside my daily reality.

The long hot days of summer school take the students away from their everyday lives for five days, eight hours a day. This is not a vacation for the students, but it is a time away from the bulletins of suicide bombers and the Israeli occupation and retaliation within the Palestine territories. The relief is illusory because they are only a cell phone call away from the latest tragedy. They must still board buses or drive themselves back and forth from school, and they still fear for their families' safety. Still, it is a respite. Being in Israel has required of me a heightened sense of awareness, both for my well-being and for my sense of identity.

Not unlike many American Jews, I was inculcated in my youth with a loyalty and a defensive posture toward Israel. As an adult I have challenged that posture and think differently about being Jewish and about my relationship to Israel. These shifts and changes have created great churning within me. I bring all of this to Israel when I go.

Worldview and Positionality

As a child, my worldview was shaped by the international community's general indifference to Jewish suffering in World War II and to the burgeoning Zionist movement. As a feminist committed to combating racism, sexism, and hetero-sexism, the work I do would be worth little if I remained indifferent to my perception of the state-supported Israeli offenses against Palestinians or to the killing of Israelis through retaliatory attacks. I believe that what has often been labeled terrorism is the desperate means of a poor and outgunned people fighting illegal occupation. In our post-September 11th context, there is little empathy for and analysis of the situations labeled terrorism.

Initially, I thought that my feminist politics, cultural connection, and knowledge about their country would position me in relationship to the Israeli students in a way that would encourage their welcoming of me. I was wrong. The only people who responded to me at the beginning in a receptive way were the radicals and the American emigrants, each for different reasons. The radicals responded because of our political bond and the Americans because of the cultural familiarity.

In the Israeli classroom, it has been difficult not to feel like an interloper. In the American classroom, I can speak knowledgeably about the American experience. In the Israeli classroom, I needed to listen differently to what the students were telling me about their experiences. Perhaps, unconsciously, I brought my American position to the Israeli classroom. Understandably, I was met with resistance.

How I was seen and how I see myself were in conflict. In the United States, I am on the margin. My queer feminist left-wing politics place me on the edge of the dominant culture. In Israel, I represent the dominant American culture. The students were resisting because I was an American feminist and represented the power structure. To the Israeli students, I was someone from the middle, not from the edge. I represented the center of power in our world, the United States of America. I was an American Jew who, they assumed, was somewhat critical of their politics yet tainted by the power held by the government of the United States, as well as what they perceived to be the privileges of being an American.

The resistance in the classroom and the suspicion directed toward me bothered me until I could figure it out. I want to thank the Israeli students for teaching me an important lesson about resistance from a new stance. My presence, what I brought with me, and what I represented were the objects of their resistance. My worldview and self-perception initially made this difficult for me to

comprehend. I am a woman, a teacher, and a leftist lesbian from a working-class background. I have always been the resistor, not the one representing power. I have been comfortable with being on the margin, on the edge of the mainstream. This teaching experience has taught me so much about myself, my notions of resistance, and how positionality changes with context.

Another important aspect of understanding the impact of context was not only how the students conceptualized who I was but also how my presence affected their relationships. In the classroom, the students had a shared Israeli cultural experience. Within it, I felt as if they were united (against the interloper) in ways that were not always possible in their lives outside this context. I needed to address this, and I did so by being direct (a quality familiar to the Israelis), acknowledging what I sensed within the classroom, and opening a discussion about their feelings toward me. I used the experience to teach about membership, the importance of context, the fluidity and dynamics of identity, positionality, and the role of those on the margins.

Political Context

The majority of Israelis perceive their society to be democratic, yet they have an occupying and authoritative relationship with the Palestinians. This creates contradictions and a host of defensive postures within Israeli society. Many in the world perceive the Israelis as a militaristic nation that controls another people and the Palestinian struggle as a just one, a fight for self-determination against an oppressive force. There are others who believe Israel is the only democracy in the Mideast and should be supported because of that. There are positions that fall between these poles, but the world press and global opinion tend to support this dichotomous framing. Although the Israeli army is generally considered to be a major military power, Jews, in world opinion, have not, until the establishment of the state of Israel, been considered a bellicose and militarily aggressive people. The state of Israel has changed the image of the Jew in the world and among Jews as well.

War is an aspect of daily life in Israel; it is a normalized part of the culture. It exists within an ideology that perceives war as way to solve problems. Women in this society are praised when they follow the dichotomized social roles dictated by militarism, and as a group, they have, for the most part, uncritically accepted their roles as reproducers and caretakers (Sharoni, 1995).

Militarization and Gender

Since militarization is native to Israeli culture, I have found it useful for my work to view this militarization from a feminist lens, one that focuses on the role of gendered power. Women play specific roles in wartime cultures (Enloe, 1993). They play a role in the maintenance of militarization. In Israel, there is a people's army. Conscription is for everyone, except the ultra-Orthodox. Women enter the army after secondary school. For Israeli women, this gendered role is expressed most clearly in how they are treated in the army. Women often suppress experiences of harassment in the army and remain silent about reporting abuse. (Mazali, 2002)

This silence continues as women prepare their own children to enter the army. Questioning the military preparation that is part of every Israeli child's development is considered marginal and socially deviant. Children are taught to expect military service as part of their social development. In Israel, there is less confusion about gender roles than in the United States because of the constant state of crisis, war, and militarism (Hareven in Feldman, 1999, p. 124). Gender, class, and race issues are ancillary. Sacrifice, for the good of the state, generally means that those on the margins are sacrificed.

Prior to my connecting militarism, gender, feminism, and war, I perceived the resistance I felt in the classroom as directed toward me. Now, I see it not so much as directed toward the course or me personally. I understand it differently. It is also about the survival instincts of the students and their denial of the role militarism plays in the construction of their national psyche and identity. It is this denial that feeds and protects the resistance to seeing themselves as powerful and colluding in the control of another people. Denial contributes to an atmosphere of silence.

Cognitive Dissonance

The theory of cognitive dissonance (Festinger, 1957) suggests that the possession of cognitive elements of knowledge, which have psychologically opposite implications, generate an unpleasant state of tension or dissonance. An individual is motivated to attempt to reduce this dissonance by altering cognition. The more a person is committed to an action or belief, the more resistant that person is to information that threatens that belief. (Roffman, 1975)

Since the Israelis are living within a crisis situation, one that threatens their safety and well-being, they are struggling with notions of morality and truth.

Cognitive dissonance theory can aid us in understanding that struggle. For example, if the Israelis see themselves as living in a democracy and democratic life as a positive way of being, that perception will push to the background the perception that they are military occupiers and the oppressors of another people. The Israelis see themselves as victims, subject to random acts of violence perpetrated upon them by a group of people who do not want them to be there. Perceiving Israelis as victims of attacks creates less dissonance than would the perception of the Israelis as occupiers. The role that the Israelis take in relationship to the Palestinians demands that they maintain a military state in order to keep the balance of power as it is.

Militarization is the way of life in Israel. They live in a state of war. It may not be the choice of the people, but it is the reality of their lives. Included in this narrative is the long history of persecution that the Jewish people have experienced. The past has informed the present in a way that promotes the contradictory roles of both oppressors and oppressed. Even though the Israelis are occupying Palestine, they see themselves as being persecuted by the Palestinians. The impact of this perception on individual and national character perception is pervasive.

Feminist Pedagogy

My early thinking about teaching has been influenced by the feminist thinking of the Euro-American women's movement. As I have become more culturally aware, I have looked beyond this perspective but realize that the foundation of my thinking is still centered within this framework. Even though the Israelis are open to things American, they also, like nationals of other countries, have considered the U.S. women's movement to be a movement that prioritizes the needs and interests of the Euro-American middle class. I share this perspective. Within my own increasing global awareness, I have been motivated to think internationally, find international references—ones that reflect a more global view—and connect gender with social, psychological, and international political issues of power.

Feminist theories of development focus on the centrality of relationships in our lives and the quality of these relationships as we live them within our realities. A feminist pedagogy embraces the notion that as teachers and learners we become more self-aware as we go about the process of learning and teaching. The boundaries in a feminist classroom can be seen as meeting places where women can interact and inquire of each other in nonoppressive ways.

Since the majority of the students in the Women's Studies programs are prac-

titioners of some sort of social service delivery, I emphasize the relationship between theory, practice, and action within the classroom setting. I create a parallel mirroring process reflective of the basic tenets of feminist theorizing. This process values the telling of personal narrative, making connections between personal experience and social norms and values, and deconstructing social values that dictate the lives of women (Gilligan, 1982). Thinking like this creates opportunities to explore the relationship of theory to everyday life, to examine our learning processes, and to transfer and apply what we learn to personal and social change.

In order to bring to the classroom a feminist model that works, especially on an international level, I need to bring to the situation an understanding of the power dynamics of the culture, the setting, and the topic. The challenge is to create a framework that examines the power dynamics and the relationships between the dominant and the subordinate. This framework challenges dichotomous thinking and creates a more inclusive way of viewing the issues. When we move from dichotomous thinking, we are able to enter the realm of relational intersubjectivity. Relational intersubjectivity is the connection between the "knower," the perception of "truth," and the communication of that truth within the classroom setting. This approach promotes learning from people's stories, applying that learning to other peoples' experiences and truths, and creating an extension of one's perspective to include the narratives and knowledge of others (Belenky, et al., 1986).

Mythology

I have chosen mythology as a medium to create understanding and foster change. With students, I begin the investigation of mythology and its relevance to women by exploring archetypes. In doing so we are exploring long-held views of the human condition. By exploring mythology, individuals can interpret, evaluate, and stretch their inner knowing. Students can engage in an exploration of the current status of social conditions as well as create new ways for dealing with these conditions.

I search for myths and legends that offer new ways of looking at creation, power, and survival. I encourage the process of new myth-making based on the notion that we can continually be in a process of reframing and re-narrating the myths that shape our lives. These new myths give us hope, resilience, and greater understanding of the psycho-cultural dynamics within society. The strongest way to combat negative and untrue myths is to create new ones (Feldman, 1999, p. 171).

I have worked with three important myths in Western society. They are the biblical story of Isaac, the Greek myth of Antigone, and the Jewish fable of Lilith. These myths represent conflicts within kinship relationships and the aberrations that occur within these relationships, especially when they involve conflict with a higher authority.

Isaac and Sara

The myth of Isaac is about his potential death at the behest of God and at his father's hand. Abraham struggles with God's dictate to end his son's life. Yael Feldman (1999) suggests that this myth presents an archetype of the Israeli nation. If it does, one can provide a positive or negative spin on the situation. Either the fathers are initiating the violence brought upon the sons (and daughters), or talking things through and providing resistance can thwart violence. (Feldman 1999, p. 171) What if Sara, Isaac's mother, was approached by God to bring her son to the altar to be sacrificed? How would the story change? I have asked women in the Psychology of Women class to write their responses to this question. In one class, I asked the women to hold their responses and not reveal their thinking until we explored another issue.

I then asked the students to explore where their notions of motherhood came from? Did they think they are biologically driven to be mothers (an essentialist perspective)? Or did they think that the way they thought about mothering was socially created (a constructivist perspective)? Most of the students did not think their beliefs were shaped by the larger society but by their individualistic relationship, to the external world.

We explored the pitfalls of dichotomies; we even created a space in the room for women to take a stand between the two polarities of essentialist and constructivist thought. Women walked around the room, giving thought to where they would place themselves. Many of the students had so many exceptions to taking a position to either pole that they clustered themselves mostly in the middle. Not only did we address a core issue of women's lives, mothering, but also we created a way for women to claim their space. They put their bodies where their thinking directed them. Having people use their bodies as a barometer of expression is a very powerful way to connect the physical with the intellectual. I find that there is a qualitative difference in the way people can own their positions if their bodies are symbolizing their stance. While still in their posture, I asked them to think about what influences their thinking about bearing children and how their external environment may affect this. In one class I found that the

students were able to make a very interesting distinction. Although many of them did not see the state as influencing them as to whether they should have children, they did see the state's influence in terms of the number of children they should have. The support for this position was strong. In deconstructing this conversation, I encouraged them to explore what the relationship was between mothering and nationalism. Had I constructed the discussion by beginning with that framing, I do not think that the students would have been able to explore the origins of their thinking in quite the same way.

The movement, the focus on their own struggles and experiences, prepared them to discuss another vulnerable topic, how they feel about compulsory conscription into the army. Most of the women had deep mixed feelings. Going into the army is a core aspect of Israeli culture. Children are taught to expect military service to be part of their development. To question military service is the anomaly and is pathologized within the culture. Parents reinforce the expectation of doing military service. However, as more and more young people question the military, more and more parents are opening themselves to the same inquiry.

The women in this class had a relationship to the military, which reflected a shift in the adherence to obeying authority without questioning. One woman told a story in which her child reported harassment in the army. Her response was to call the commanding officer and demand that the behavior cease. Another woman in the class supported her behavior. The mother who told this story felt proud of her intervention and saw it as an act of enfranchisement.

We then returned to the myth of Abraham and Isaac or the reframing of Sara and Isaac. When they discussed the concept of infanticide from the perspective of mythology, they were able to take a more strident posture regarding how they may protect their children from state authority. They spoke about the role of violence in their culture. At times, the conversation was somewhat muted. I interpreted this to mean that they could not fully break their silence on the subject. As women, their role was to prepare their children for the military, not to question the underlying mythology and ideology that supports the military and militarization. However, I do think the prior conversation about motherhood provided a link to a discussion of violence in the culture.

Yael Feldman in her book, *No Room of Their Own* (1999), suggests that Israeli literature provides evidence that the psychological defense of repression is reflected in the image of the "stiff-upper-lipped sabra (native)" and the cultural preoccupation with "soft emotions." I sense from the students' reporting that they are questioning resistance to the normative cultural feelings.

Antigone

Sophocles wrote Antigone around 442 B.C. Antigone's birth is the result of incest. Her mother is also her grandmother, and her father is also her brother. Confusion about roles and the threat of that confusion for the characters are deep and complex. Positions are unclear; the role of the father is questioned; the mothers are struggling with their feelings; and the children are the recipients of the damage and trauma that results from family and societal power struggles.

Families struggle to survive in the tumultuous times in which we live. Whether through displacement, poverty, natural disaster, or shifting social norms, today's family is not an easy kinship unit to maintain and nourish. What is interesting to note in a course on women's psychological development is that it is the woman (Antigone) who dies because she speaks up, and it is the man (Abraham) who survives, as does his son, because he speaks up. These two myths create opportunities to explore the relationship between voice and power.

Ellen Kaschak (1992) provides an insightful view of the role of Antigone as the pleasing and subordinate daughter. Antigone is the daughter and sister of Oedipus. As a guide for her father and as a dutiful sister, she finds herself in danger. Her betrothed, Haemon, pleads for her life with his father, Creon, whom she has disobeyed. The tragedy ends with both Antigone and Haemon found hanging from trees. Her ending is similar to that of her mother, Jocasta, who ended by hanging herself.

Kaschak (1992) discusses the Antigone phase of female development as one in which the focus of the female's life is to please and obey men. Kaschak goes on to describe the resolution of the Antigonal phase as one in which women turn their focus from men and pleasing men to one in which they address their own concerns and relations with other women.

Judith Butler (2000) presents Antigone in yet another way, as one defiant of state authority and one who claims responsibility for her acts. According to Butler, Antigone's predicament addresses the concerns of kinship. Her life was painful because she was the product of incest, and the acts of her life led to her death. She defied the silence imposed on her and publicly defied the king's orders. Butler points out that it is not incest that interrupts this family but war. Antigone puts the needs of her family ahead of the needs of the state, and for this she is punished.

Both these feminist thinkers present divergent views of the same story. Each one's focus is different. Kaschuk is interested in examining the story of Antigone as reflecting a developmental stage in which women resolve their issues with

pleasing male authority. Butler, through the story of Antigone, is interested in exploring kinship relationships, their clashes with state rule, and their impact on ethical development. In the class, women are asked to connect the implications of the two divergent interpretations of Antigone to their discussion of motherhood, nationalism, and empowerment. The writing of both the stories of Isaac and Antigone are attributed to men. Yet, it is the feminist and women-centered telling of the story that creates material for women to connect with their daily lives.

Lilith

The students listen to the reframing of the story of Lilith. Just as Kaschak and Butler have examined the role of Antigone, I have addressed the story of Lilith. Lilith is not in the Bible and only referenced in medieval Jewish folklore as the wife of Adam prior to Eve. She is referred to as a witch, a menacer, and kidnapper of young children. In Jewish tradition, the hand of Lilith is placed above a baby's cradle to keep away this goddess of the night, who is reputed to enter nurseries in the dark and escape with an infant in hand.

How can we see this story differently? This is the question I bring to class. It matters less what my or any other individual's interpretation of the myth may be, what matters is that students are being given the opportunity to question how we may see a myth differently than its intended meaning.

This is only one of many myths that present women as evil and jealous. Equally represented is the sad fate of women who seek to gain knowledge or sate their curiosity, e.g., Pandora, and, of course, Eve. In folklore and biblical mythology, women are punished for wanting to know, for wanting to satisfy their desire for knowledge.

The reframing of gender dichotomies is central to a reconceptualization of women. Although there is not a generic woman, there are gender struggles that are defined by the sociopolitical and racial composition of the societies in which women live.

Engaging with gender dichotomies and contradictions makes for rich meaning when we can explore the role that power plays in either keeping the dichotomies and contradictions or deconstructing them.

Conclusion

These classroom examples are from several years of teaching experience. Although initially resistant, the women mostly appreciated the opportunity to

talk about their concerns about gender. The risks I took in opening up the discussion to militarism changed the atmosphere in the classroom. When the connection was made between violence, militarism, and the secondary status of women, I found that they became more engaged with the subject, in part due to the opportunity to connect to the subject on a personal and expressive level. They could link the narratives created with their internal, individual, and collective knowledge of themselves.

The opportunity to engage in myth-making created a creative moment for the women to think from inside and from outside their experience. These activities provided them opportunities for movement and for a release of energy that could be directed toward making the mind/body connection.

I feel gifted by the students. They taught me how to put into practice in the classroom setting my belief that resistance is healthy, purposeful, and necessary for social change. My goal was not to rip apart their resistant behaviors but to be able to provide a setting and tools to examine the sources and needs connected to their sense of resistance to examine critically their personal and social understandings.

Initially, I was the stranger who brought a view that is not usually made public in school settings. I hope that what I brought to the students was a new way to look at an ongoing situation that is deadlocked in conflicting narratives. In doing so, I like to think that I ceased to be a stranger and became a sister traveler.

References

Armstrong, M.(1992). *The Burning Times,* Direct Cinema Ltd. Bat shalom@net vision.net.il (Internet, August 22, 2002, email communication.

Aronson, E. (1972). *The Social Animal.* San Francisco: W. H. Freeman.

Belenky, Mary F., Clinch, Blythe M., Goldberger, Nancy R., and Tarule, Jill M. (1986). *Women's Ways of Knowing: The Development of Self, Voice, and Mind.* New York: Basic Books.

Butler, J. (2000). *Antigone's Claim: Kinship Between Life and Death.* New York: Columbia University Press.

Enloe, Cynthia H. (1989). *Bananas, Beaches, and Bases: Making Feminist Sense of International Politics.* Berkeley: University of California Press.

_____ (1993). *The Morning After: Sexual Politics at the End of the Cold War.* Berkeley: University of California Press.

Feldman, Y. (1999). *No Room of Their Own, Gender and Nation in Israeli Women's Fiction.* New York: Columbia University Press.

Festinger, L. (1957). *A Theory of Cognitive Dissonance.* Stanford: Stanford University Press.

Gilligan, C. (1982). *In a Different Voice: Psychological Theory and Women's Development.* Cambridge: Harvard University Press.

Gilligan, C., Rogers, A., and Tolman, D., Eds. (1991). *Women, Girls and Psychotherapy: Reframing Resistance.* New York: Haworth.

Gilman, S. (1993). *Freud, Race, and Gender.* Princeton: Princeton University Press.

Hazelton, L. (1997). *Israeli Women: The Reality Behind the Myth.* New York: Simon and Schuster.

Kaschak, E. (1992). *Engendered Lives: A New Psychology of Women's Experience* New York: Basic Books.

Maher, Frances A., Tetreault, Mary Kay Thompson (1994). *The feminist classroom.* New York: Basic Books.

Mazali, R. (2002). Someone makes a killing off war: Militarization and occupation in Israel-Palestine, presentation at Jewish Unity for Just Peace Conference, Chicago, May 4–5.

Nash, S. (1996). *Character portrayal and cultural critique in Shulamit Harereven's work.* Modern Judaism 16, 215–218.

Nuhair, I. (2001). *Women and Militarization in Israel: Forgotten Letters in the Midst of Conflict, in Waller, Marguerite, and Rycenga, Jennifer, Frontline Feminisms, Women, War and Resistance.* New York: Routledge.

Reinharz, S. (1998). *The concept of voice,* Paper presented at meeting of Human Diversity, perspectives on people context. University of Maryland, College Park, as quoted in Fine, Michelle, 1992, *Disruptive Voices, the Possibilities of Feminist Research,* Ann Arbor: University of Michigan Press.

Roffman, E. (1975). Unpublished doctoral dissertation, A role playing work shop as a facilitator of change in attitudes toward women, Boston University.

Sharoni, Simona (1992). Every woman is an occupied territory: The politics of militarism and sexism and the Israeli-Palestinian conflict. *Journal of Gender Studies,* I, 4, 447–62.

_____ (1995). *Gender and the Israeli-Palestinian Conflict: The Politics of Women's Resistance.* Syracuse: Syracuse University Press.

Stone, Merlin (1984). *Ancient Mirrors of Womanhood.* Boston: Beacon.

CHAPTER FOUR

Rehearsing Life:
Exploring Alternatives and
Possibilities through Theater

Lisa Donovan

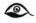

"If no one changes the world it will stay as it is, if no one changes the play it will come
to the same end as before."
—Augusto Boal, 1993, p. 20

The Intervention Theater Project

The Intervention Theater Project is a collaboration between Columbia-Greene
Community College and the Greene County Collaborative Community
Partnership for Youth in New York State, a coalition of social service agencies and
educational institutions striving to empower youth through a variety of pro-
grams. It began two years ago, produced with funding from the New York State
Department of Health and the Division of Child and Adolescent Health. This
coalition came together to introduce students and teachers to theater as a way to
magnify and examine complex social issues while exploring possibilities for social
change. "Intervention Theater" is an appropriate term because the project was
designed to empower teenagers to see, to act on, and to impact a situation of sig-
nificance in their lives. It provides a useful model for using the arts to understand
human interaction. The goal of this work is to activate adolescent voices and cre-
ate a dynamic dialogue about issues of concern to teenagers.

In a five-week progression during June 2000, I worked with high school stu-
dents and teachers in separate sessions exploring social issues through theater
techniques. Participants selected issues of significance in their own lives. These

issues became the subject of our theater work.

In the student section of the program, seven junior and senior year Cairo-Durham high school students and two coordinating teachers participated. Preliminary issues chosen for exploration by the students included:

- Being labeled by adults. In this case it was skateboarders fighting for the rights of their park, a real issue that students in the group had just been through with the town government.
- What it means to be "a geek" as opposed to being "cool." All of the participants in the group had either experienced being negatively labeled or had friends or family members who had dealt with this.

In the teachers' course, there were nine enthusiastic participants from several school districts in Greene County. The two issues chosen by this group were:

- The lack of respect among teachers in different disciplines. The scene explored the suggestion of a science teacher that their course take precedence over a music class.
- The demoralizing conversations that occur in the faculty room. Teachers shared experiences where lunchtime discussions about students were demoralizing and eroded the educational mission of schools.

Both sets of issues were emotionally charged and personally significant for the groups. While the teachers focused on learning new techniques and understanding how the exercises worked, students were more interested in the fun of doing theater and the exploration of issues that were significant to their lives. The theater exercises and intervention theater process sparked provocative discussions in both groups and allowed causes and solutions to be explored.

After this initial exploration of intervention theater techniques, the student project created and rehearsed an original theater piece to be performed for a student audience not involved in the project. Through participatory theater, the audience would actively engage with the issue presented.

The Power of Participatory Theater

> Theater is a form of knowledge; it should and can also be a means of transforming society (Boal, 1993, xxxi).

Theater, by its nature, has always provided the possibility for examining life's most complex issues. Brazilian artist and activist Augusto Boal (1993) suggests that we are all theater, that the dramatic pervades our lives.

The theatrical language is the most essential human language. Everything that actors do, we do throughout our lives, always and everywhere. Actors talk, move, dress to suit the setting, express ideas, reveal passions—just as we all do in our daily lives. The only difference is that actors are conscious that they are using the language of theatre, and thus are better able to turn it to their advantage, whereas the woman and man in the street do not know that they are speaking theatre (Boal, 1993).

Many theater artists use theater for social commentary or to spark action or awareness. Boal harnesses theater techniques to examine real-life issues. By presenting an issue of significance to the audience, then blurring the boundaries between performer and audience member, Boal activates the audience and moves them from the role of spectator to "spectactor" (1993). By allowing the voices and ideas of the audience to be brought into the action on stage, Boal creates an engaging dialogue through which a scene can take many forms and directions.

The dialogue process serves as a hands-on tool for exploring complex social issues and relationships and the nature of cause and effect. It provides individuals with the opportunity to "try on" different roles and courses of action in a safe setting, to see how role and personal choice affect circumstance. The goal of the work is not to achieve one right solution but rather to try many possible approaches to the problem being explored.

The techniques of what Boal calls the "Theater of the Oppressed" tease out the nuances of complex issues and make visible the tensions that underlie them. His approach gives power to the powerless by giving participants an understanding of the structures of power at work in their lives (Boal, 1985). Spry (1994) suggests that "Understanding these structures is a first step towards change" (pp. 174–175).

For me, the power of Boal's techniques lies in its ability to make internal and external voices visible. Our inner voice often reveals a different perspective than our outer voice. I use Boal's techniques to access true voice, to listen for what's not being said, and to listen for the changes in voice when scenarios are replayed with different actions and endings. Boal's activities develop the ability to become attuned to the subtleties of a situation and to the building blocks of a complex issue. Boal's techniques develop awareness about why choices are made and how power dynamics fuel conflict. Through the process, we recognize the power we have to change a situation. The work becomes, in essence, a rehearsal for imagining change (Boal, 1996).

In its most archaic sense, theater is the capacity possessed by human beings—and not by animals—to observe themselves in action. Humans are capable of seeing themselves in

the act of seeing, of thinking their emotions, of being moved by their thoughts. They can see themselves here and imagine themselves there; they can see themselves today and imagine themselves tomorrow (Boal, 1993).

Perhaps most powerfully, participatory theater allows students to change perspectives by playing the roles of characters very different from themselves. Viewing the world through someone else's eyes, students see their own point of view, values, and belief systems more clearly. They develop tolerance and an understanding that difficult situations are rarely as simple as right or wrong. This work has a powerful potential for delving into complex issues that trouble society.

> There is an extraordinary power in his foundational idea of transforming spectators into "spect-actors" who become active subjects in the theater rather than passive observers, thereby giving power, authority, and responsibility to the audience. Spect-actors are given the opportunity to rehearse active resistance to oppression in the theater, to "try out" different possibilities within the relative safety of the theater and evaluate the success of each. Through this process, spect-actors will be empowered, and better prepared, to deal with reality (Green, 2001, p. 47).

Boal calls his process "Theater of the Oppressed" because it transforms the existing model of oppression that occurs in many situations by changing the power structures in the situation. (Schutzman, 1994) suggests that "the power in many TO [Theater of the Oppressed] techniques is precisely to de-ritualize our lives, to crack something open and make us vulnerable" (p. 218).

Intervention Theater in Action

Students enter the auditorium greeted by music that sets the tone for the narratives that will follow, "This song is dedicated to every kid who ever got picked last in gym class, to every kid who never had a date to no school dance, to everyone who's ever been called a freak. This is for you!" (Good, 2000).

Four scenes unfold before the student audience, each detailing an individual teen's experience in being yoked with a label by others. The stories are designed to reflect the group dynamic when labeling occurs. Each scene is a composite of the stories told by participants during the development of the script. In each scenario, the protagonist initially appears powerless to change the outcome. Each scene presents a problem and asks an unspoken question about the nature of labeling. How does it feel to be the person labeling? How does it feel to be labeled? How does labeling happen? What power do we have to stop ourselves and others from being labeled? What alternatives do we have?

In the first scene, a young woman is labeled a "slut" after a photograph of her with a male friend at a party is misinterpreted, and a rumor gets spread around school. In the next scenario, a young woman is labeled "dirty" because she chooses not to shave her legs and armpits. In a third scene, a young woman who has dyed her hair pink on a whim is followed around and searched by store security because of how she looks. She is labeled a "freak." In the final scene, a group of teenagers are hanging out in front of a small grocery store. The owner comes out and orders the "punks" to leave because they are frightening his customers away.

The audience is challenged to consider how each scene might have ended in a different way. They are invited to ask "what if" in the face of these questions and invent alternative models of behavior. The goal is the exploration of possibility. I ask the students in the audience, "Do the scenes strike a chord? Are these moments similar to anything you've experienced in your lives?" "Yes," they acknowledge. I ask them to select a scene that resonates with them, a scene they would like to explore further.

After watching the stories, the students in the audience elect to explore the scene about the gang of kids hanging outside a store. I ask what the main character, in this case one of the teenagers who becomes an ad hoc spokesperson for the group, wants? Members of the audience suggest that what the protagonist wants is to be heard. Was he successful? No. Why not? Do they have other ideas about strategies that the character might try in order to change the outcome? They do.

Audience members describe a range of interesting alternatives for their counterparts on stage: the teens could move around the corner and hang out somewhere else to avoid conflict; or they could stand up for themselves, assert their power, and refuse to leave; or they could leave or wait until the owner walks away and then come back; or they could start a dialogue with the owner about why they have the right to stand there.

I invite someone from the audience to come up on stage and act in the role of our protagonist in order to try out one of the solutions they have proposed. I wait patiently. "I'll do it," says a courageous young man in the back. He climbs onto the stage as the audience of his peers cheers him on.

The scene begins with the young man performing one of the alternative strategies, which steers the scene in a new direction and we're off. From here, we try a variety of alternative choices in the scene, substituting new performers until we've explored the complexities of the scene to our satisfaction or until time runs

out. Each time the scene is replayed from the moment of conflict, at which point
different strategies are employed and then discussed. The flow of the action is
dictated by the audience as well as by the action on stage. After each new strate-
gy is tried, we stop and talk. Was it successful? Why or why not? What does each
alternative tell us about a particular issue? As audience members are invited to
become actors in an ever-changing drama, the rules and roles shift both for those
on stage as well as for those watching from their seats.

In the first few substitutions, the ideas tried are less than successful. If the
teenagers move away from the store, they feel they've given in. If they try to dis-
cuss why they have the right to stand there, the owner, played by one of teach-
ers in the group, becomes instantly defensive, and the tension in the scene esca-
lates. Undaunted, the students seem to grow more interested by the challenge of
the scene.

As a way to dig deeper into the unspoken messages and understand what is
happening, I invite the audience to ask questions of the characters to discover
and understand the motivating forces. They start the scene again, and I freeze the
action at different points in the scene to allow the spectators to interview the
characters and ask about the choices they are making and why, their motivation,
their background, etc. When the action is stopped mid-stream, participants can
examine the dynamics at work in the moment and talk about what they see.
Through the interview process, it quickly becomes apparent that the storeowner
does not see the group as individuals. He sees them as a "gang."

As far as the storeowner is concerned, the teenagers' efforts to make a case
for themselves fall on deaf and defensive ears. The teens, on the other hand, see
the storeowner as controlling and fail to see why he might be reacting this way.
Only through the process of questioning the storeowner, do the teens come to
understand that he is concerned about sales and making a living.

As a result of the new information, students decide to have the protagonist
go to the storeowner on his own as a representative of their teen-aged commu-
nity. The result is markedly different than other attempts. An authentic connec-
tion is made. A true dialogue can now take place in which both storeowner and
teenager hear each other. The owner begins to share his concerns about his busi-
ness. The teen talks about wanting a place to be with his friends. Something
important has shifted here, suggesting that labeling in this case, is a wielding of
power.

The actor playing the storeowner describes a shift in his response. He says he
feels able to listen to an individual plea because he is no longer nervous about
what the group will do and feels hopeful that the individual will also hear his

concerns. The audience and actors reflect on what we have discovered about the issue being explored. These are some of the thoughts that came up:

- There are always two sides to an issue.
- If you are not heard, there can be no progress.
- In order to come up with a solution, both sides must listen.
- Labeling is often about a power struggle.

These conclusions are learned in the context of a specific situation and can be tested, explored, and played with in order to illuminate the larger issue of labeling. In order to evoke a true dialogue, the audience needs to be an active part of the process.

The energy is high as the bell rings and the students file out. The actors are elated. The process of exploring and developing this improvisational piece has paid off. The work has sparked a dialogue on sensitive topics that lie at the heart of the adolescent experience. Perhaps the discussion here will spark students to be more aware and less accepting of labeling in their lives. It is, at least, a beginning.

> Can theater mobilize the sort of identification and irony that lets us get involved and recognize the means and meanings of that involvement? Can theater offer a place where we might yet be called upon to look, engage, step back, consider what we haven't already seen, scoffed or cried at, dismissed or acquiesced to? Can it be a place where we practice—to borrow a heartening phrase from the anti-prison movement—critical resistance? (Solomon, 2001, p. 10)

The Process

> Actors must employ lies in one sense, must create a fiction to illuminate a truth
> (Smith quoted in Kalb, 2001, p. 18).

The Intervention Theater Program incorporates Boal's theories and techniques and brings participants through several progressive layers: body and sensory awareness, imagination, voice, improvisation, scene work, role-playing, character development, the development of an original piece, and ultimately the use of Boal's technique of Forum Theater, which is the interactive working of a scene with an audience.

> The aim in all these workshops is to create a safe place where people feel free to exchange their stories and look for solutions to their collective problems (Spry, 1994, p. 179.)

Students develop improvisational dilemmas based on real life experiences. The scenes are acted out and alternatives explored. This provides an opportunity to imagine how different values, opinions, and ideas might be shaped. Theater games and exercises are explored to promote self-knowledge and awareness and to hone participants' senses so that they are increasingly able to see the subtleties of a situation. Improvisation allows students to play with ideas, to think in new directions, to break away from predictable responses and imagine possibilities.

The scenes are developed out of participants' real-life stories. I collect stories by doing a story circle in which each participant shares a personal story relating to a topic identified by the group. When themes emerge from the stories, they are noted and collected. A scene is developed that resonates with all of the stories but is not one person's specific circumstances. This prevents participants from becoming too emotionally identified with the situation, which can block the ability to see the dynamics within the scene.

> However little we may really be interested in anyone else, we do seem willing to listen to people's individual stories as possible keys to our own development (Kalb, 2001, p.16).

Story ideas are explored in improvised scenes in which the action and dialogue unfold in the moment. Improvising ideas for scenes can help participants to crystallize the issue they are dealing with. This work is not always comfortable, as the stakes get higher, and scenework often touches deep emotions. Often, the more uncomfortable a scene feels, the richer it is for exploration.

> When in an improvisational scene that requires us to be in an uncomfortable situation (within the fiction of the scene or because of the contrast between our views and our character's views) we want to respond as we do in uncomfortable situations in real life: We want to get out. In improv work, we are practicing to stay in those pretend situations so we can examine them and learn from them (Rohd, 1998, p. 89).

Once the stories are developed, they are rehearsed in a variety of styles, so that each actor fully understands the role, the character's intention, and how that character might react given the different twists played out in the forum. Boal recommends a variety of rehearsal techniques including the questioning of characters, playing the scene out with different pure emotions (hate, love, envy, etc.), and switching roles. (See Boal's Games for Actors and Non-Actors for more information about these techniques and others.) Each rehearsal technique allows the actors to discover the characters and the dynamics of the scene in new and deeper ways.

Part of the exploration in rehearsal must focus on intention. Intention is what a character needs or wants. This desire drives the action in a scene.

> The strength, clarity, and importance of a character's choice of intention determines the behavior and course of a character in a specific interaction. This includes the strategies and tactics the character uses to get what they want. Drama comes from conflicting intentions (Rohd, 1998, p. 82).

Intention informs our lives, but we are often unaware of it. Seeing the power it holds in scenework helps us to understand the role it plays in our own relationships.

The rehearsal process is a pivotal piece of intervention theater. Through a variety of techniques, the pieces are manipulated in every imaginable way to expose new knowledge about the issue being explored. Work is done on developing characters' belief systems and their underlying ideas and relationships. This gives the issue breadth and allows the performers to establish deeper connections to the piece. In creating original pieces, students are able to apply their own experiences. Theater serves to magnify an issue to facilitate exploration. Because the scene is an imaginary construct, it provides participants with the safety to play parts that could otherwise be offensive, overwhelming, or uncomfortable. The result is a lively dialogue with action between the spect-actors and the performers about the issue being explored.

The interactive performance of scenes (Boal calls it "Forum Theater") begins with a scene that presents a problem of interest to the audience. A facilitator coordinates the process, asks questions, guides interactions and invites the audience to be active participants in the action, encouraging them to jump into the scene as a substitute protagonist and address the problem however they see fit. Boal calls this role the "joker" because he or she acts as a wild card (Boal, 1985). The joker serves as the mediator between the world of the action on stage and the world of the audience. The scene is played several times with alternative approaches. Discussion is included; however, it is important to keep the action flowing so that new ideas can be observed in action.

Debriefing and releasing tension after each exploratory session is key, because even though the scenarios are imaginary, the experience feels real. Rohd cautions that "if we truly allow ourselves to experience the imaginary circumstance and everything else going on, our body has a real reaction (Rohd, 1998, p. 89). This allows a realistic exploration of the alternative solutions.

The scenes are set up as failures, what Boal calls the "anti-model" (1993). The scenes are presented to an audience of people who are part of the commu-

nity. They are then invited to jump in for the protagonist and try out alternative solutions. The goal is not to come up with one specific solution but, rather, to learn about the problem being explored. Each alternative solution sheds light on the issue from a different direction. Green talks about the opportunity in the forum to deconstruct the situation: "Through the shared experiences of people in a theatrical space, it is possible to deconstruct the self, to look at the self within a problem situation from multiple points of view, and then to put it all back together into an ability to take action (2001, p. 61). Once participants have "played" at taking action, they are more likely to try alternatives in their own lives. This sense of agency is at the heart of the work.

In Conclusion: A Rehearsal for Social Change

Atlas talks about theater's ability to consider possibility: "I believe it is theater's power to embrace multiple meanings and to resist, reframe and reconfigure that furthers our ability to engage in the critical and visionary thinking needed to imagine the world differently (2001, p. 76).

So often we move through the world as passive observers having lost the ability or desire to be fully engaged with life. We judge but do not step inside the viewpoints of others. How can we move from judgment to action? From distanced spectatorship to connection and involvement? How can we gain the perspective and courage to see things from the inside out? Theater is a force that can take us there. There is a sense of double vision—on one hand, we are aware we are watching theater and are engaging in a safe exploration. On the other hand, we are fully engaged in the believable circumstances and characters we are presented with. It feels like life unfolding before us.

Boal's techniques of Forum Theater are not always easy and do not always succeed in the way one envisions. I have found that for the players who are willing to embark on the exploration, some growth and insights are assured. I recently asked my students in a Theater for Social Change class at Simon's Rock College to consider the sensitive topics we'd been exploring. I asked them "Do we have the right to do this work? It can be very difficult and often brings us into places and viewpoints that are uncomfortable." In response, one of my students looked at me squarely in the eye and asked? "If we don't do it, who will?"

> And that is the role of art—not only to show how the world is, but also why it is thus and how it can be transformed (Boal, 1993, p. 47).

References

Atlas, C. (2001). How do you make social change? *Theater,* 31(3), 62–93.

Boal, A. (1985). *Theater of the Oppressed.* New York: Theater Communications Group.

Boal, A. (1993). *Games for Actors and Non-Actors* (Jackson, A. Trans.). New York: Routledge.

Boal, A. (1996). Theater of the Oppressed Workshop. Paper presented at the Pedagogy of the Oppressed, Omaha, Nebraska.

Cohen-Cruz, J. (1994). Mainstream or margin?: US activist performance and theater of the oppressed. In Schutzman M. and Cohen-Cruz J. (Eds.), *Playing Boal: Theater, Therapy, Activism.* New York: Routledge.

Freire, P. (1993). *Pedagogy of the Oppressed.* (Ramos, M.B. Trans.). New York: Continuum.

Good, C. (2000). *Little Things.*

Green, S. (2001). Boal and beyond. *Theater,* 31(3), 47–54.

Kalb, J. (2001). Documentary solo performance. *Theater,* 31(3), 13–29.

Rohd, M. (1998). *Theater for Community, Conflict and Dialogue: The Hope is Vital Training Manual.* Portsmouth: Heinemann.

Schutzman, M., and Cohen-Cruz, J., Eds. (1994). *Playing Boal: Theater, Therapy, Activism.* New York: Routledge.

Schutzman, M. (1994). Canadian roundtable: An interview. In Schutzman, M. and Cohen-Cruz J. (Eds.), *Playing Boal: Theater, Therapy, Activism.* New York: Routledge.

Solomon, A. (2001). Irony and deeper significance. *Theater,* 31(3), 2–11.

Spry, L. (1994). Structures of power: Toward a theater of liberation. In Schutzman, M. and Cohen-Cruz J. (Eds.), *Playing Boal: Theater, Therapy, Activism.* New York: Routledge.

Torn to Pieces: Collage Art, Social Change, and Pre-Service Teacher Education

Morna McDermott

I am a person who has always imagined things three-dimensionally, adding depth of layers and shape to anything my mind can conjure. Two-dimensional images, while expressive and creative in their own right, seem only to give a "surface" representation. In contrast, collage offers a freedom to think in multiple dimensions. Collage art is liberally defined here as taking pieces of anything from the original sources and recombining them into a "new" composition on any object— from a table lamp to a round beach ball. For this reason, collage as a way of representing identity makes so much sense to me.

An arts-informed educator for the past 10 years, I wondered whether this process would make sense for pre-service teachers as well. This chapter reflects on an activity addressing images of pre-service teacher identity and collage that took place in a course I taught on integrating the arts into the elementary classroom. I suggest that collage can reveal the inner workings of how pre-service educators connect a system of thought that relates their own personal lives to their teacher identity. Creating collages allows emerging educators to discuss the shifting relationships between self, community, power, language, social equality, and educational practices, unhinging linear frames of thinking and dominant ideologies and practices that often go unchallenged in the classroom.

Collage, Representation, and Transformation

One of the goals of arts-based researchers (Block, 1992; Davis and Butler-Kisber, 1999; Denzin and Lincoln, 1994; Diamond and Mullen, 1999; Finley, 1998; Mullen, 1999; Paley, 1995) is to dislocate the center of ideological powers that reproduce exclusionary and oppressive forms of pedagogy and knowledge production. As these researchers suggest, perceptions of pedagogy are often revealed or reproduced (consciously and unconsciously) in our teacher education classes. By becoming inquirers as collage artists (literally and metaphorically) and encouraging similar reflective engagements with pre-service educators, we challenge a "curriculum [that] serves to reproduce the dominant culture, to exclude the cultures of subordinate groups, and to reproduce the power structure" (Block, 1992, p. 333).

The privileging of Eurocentric ideals and the silencing or displacing of minority cultures, languages, and races in K-12 education are frequently reinforced by scientific and objective modes of inquiry that encourage a "hands-off or disembodied approach to what we do" (Finley, 2001, p. 20). Using the scraps from our daily lives as the content of a more "collaged" pedagogy enables us to re-envision, re-center, or re-embody who we are. We re-present various layers of ourselves as "identity in relations," which leads to "strategies for change" (Block, 1992). Because of the style and techniques it embodies, collage becomes a location for collective socially-oriented action. These visual conversations suggest that, "what appears disorganized and chaotic might possibly reflect the healthy, constructive questioning of or experimentation with new ideas" (Jenoure, 2000, p. 202).

Collaging the Data

The four case-study participants—Jessica, Thor, Angela, and Jill*— were undergraduates at a Midwestern university who participated with 45 other pre-service teachers in a course on integrating the arts into the classroom. Using various combinations of visual and written materials and artistic techniques, these four participants made collages out of various two- and three-dimensional materials, including construction paper, styrofoam, paint, magazines, and photographs.

The study participants were selected by random sample. The names of 40 student volunteers were correlated with numbers 1–40. Four numbers were then randomly selected. This selection process emphasized the idea that the collage process could be meaningful to anyone, not just those students already more

"artistically inclined" or those who had already produced collages of higher "artistic quality." The notion of qualifying collages for this study by some "inherent" evaluation of quality reflects the colonizing of art, "forcing it to stand up to standards that are culturally alien to its creators" (Highwater, 1994, p. 258). Three of the four participants (Thor, Angela, and Jill) were Caucasian, and one was of Hispanic decent (Jessica).

I also considered how, in this study, I, as an arts-informed inquirer, might challenge traditional modes of data representation, including what and whom we represent in inquiry. Angela, one of the participants, says it best when she reflects, "By being 'forced' to represent my philosophies and influences through a collage, I have found new connections and questioned some of my pre-existing ideas."

The Four Collages

The titles and metaphors for each collage are drawn directly from transcriptions of the statements of the particular participant.

Angela: "A Quilt Made of Time"

Most important is the effect my future students will have in shaping my teaching practice. My past will affect my future, and that future will continually shape my teaching as I experience it. As I influence teaching and learning, so it influences me. Like a fine quilt, if one piece is left out, the entire product begins to unravel. Some of the threads that hold the quilt together are: wanting kids or helping kids want to learn, caring for people, and wanting to be a teacher.

Thor: "My Past Revolving Around My Future"

Making this collage made me remember and connect my background and past to the present. I cannot believe what a connection there is. I thought of a solar system type-thing, where you have your middle core and you have your outside. I feel that when I'm a teacher my whole life is going to be revolving around these kids and I accept that. I'm most happy when I'm with kids. You have your good and your bad days, but it's always something new and you're always learning something and it's something always different with young kids and that's what I love.

Jill: "A Driving Passion"

I have never had to answer the question before about why I wanted to become a teacher. I never really thought that I had a complete answer to the question—or if my answer was even correct. I thought that maybe I was making something up

Figure 1: Angela

Figure 2: Thor

Figure 3: Jill

Figure 4: Jessica

to just give people an answer. If I am ever asked this question again, I know that my answer will be that it is "a driving passion." I've been going at it for so long, and I think about getting in a car and just keeping going.

Jessica: "Something from Nothing"

I guess I chose to represent that because it's something so simple, and it's something that kids can look at and say, "I can do that." It's nothing like a painting or a portrait; it's something tangible that they could do. And it's something that's low cost and you don't need a whole lot of materials and you can just use scraps, and so I guess why I chose it is just because it was something that kids could relate to.

Style, Serendipity, and Collaboration

From the words and images of these four pre-service educators, three key words emerge that encourage us to rearrange our thinking about pedagogy: style, collaboration, and serendipity. Each study participant independently stated that these three aesthetic qualities in the making of their collages were the most significant factors in their rethinking as teachers.

Style

Collage is a poly-tropic, meaning "turning many ways" (Hyde, 1998, p. 52), form of representing language, transforming reflections built on linear or one-to-one correspondences into refractions of simultaneous correspondences. By plucking materials "from the obscurity of hardware stores or junk heaps and [declaring them] to be 'art'" (p. 123) 19th and 20th century European artists such as Miro, Picasso, Braque, and Duchamp aimed at creating a "new way of being in the world" (Block, 1992, p. 36) by giving up "the notion of path and home" (p. 36) in favor of being lost.

Remarking on her own process, Finley (2001) describes how her collage compositions consist of "the arrangements of shapes and spaces" that "integrate into an overall design, guided to their places by the intuitive and imaginative thinking of the collagist" (p. 19). One study participant, Thor, similarly remarked: "The placement was even something. I placed things in weird ways which I didn't notice before, but as I was putting pieces around, certain things couldn't be next to each other. And my collage just fell into place."

Gablik (1984) contends that art that emphasizes social and ecological imperatives is "much more eclectic, able to assimilate, and even plunder all forms of style and genre and circumstance, and is tolerant of multiplicity and conflicting

values" (p. 73). Art styles that provoke conflicting values and social imperatives when used within the classroom can, in essence, interrupt mainstream ideologies that stifle the imagination from becoming a source of empowerment and change. As "representations from both realms, the self...and society" (Finley, 2001, p.17), collage processes and products are not dichotomous but instead "composed in polyphony— characterized by many voices" (p. 17).

Serendipity

Serendipity implies that the process of collage making often emerges from unplanned origins when we find ourselves "lost," away from the carefully planned terrain of the familiar. It suggests that perhaps change comes not from our conscious "pre-set" mental framework but from "accidents." Accidents are valuable to change because "no self-contained world can induce its own fundamental change, because self-containment means it knows nothing beyond its own givens" (Hyde, 1998, p. 118). Because "control is maintained by the nature of the path and the impossibility—indeed unthinkability—of deviation from it" (Block, 1992, p. 326), the exploration of possibilities from unexpected sources is not only desirable but indeed necessary to break the controlling structures that suffocate change. During her collage process, Jill recalled:

> I was just flipping through magazines and finding words and I saw the word "passion" and it clicked that teaching is something I've always wanted to do...I wasn't looking for it (the metaphor) but when I came across it, I knew!

Collaboration

Collaboration might otherwise be understood as the democratic and relational process, also a by-product of collage style, of art making and meaning making. Collaboration represents art not from within the modernist ideal of the lone artist working far away from the din of social concerns but rather as a process situated within the community.

Study participants shared how they received "help" from others, making their work a collaborative representation of collective ideals. Looking over her collage, Jessica stated, "But this actually came from my roommate. She wanted me to do ballet slippers, so that came from her." This notion of community promotes student empowerment. When our classrooms are constructed as a "collage" of knowledges, we create a "dialogic rearrangement that is shared between the creator/designer of the artwork and its audiences as well" (Finley, 2001, p. 20).

Shifting Roles/Shifting Metaphors/ Shifting Identities in Pedagogy

The Pre-Service Teacher as Researcher

As Paulo Freire reminds us, schools might in fact be the most powerful (and last) site for social transformation because education, as he defines it, is "that specifically human act of intervening in the world" (1998, p. 99). I would add that it is through the language of creativity that possibilities for change can emerge. In other words, if "art has played a key role in forming our society's definition of reality," then it also "has the power to redefine that concept" (Gablik, 1991, p. 28).

In addition, Freire considers how a teacher also serves as researcher. The notion of "teachers as researchers" creates avenues for transformation to the extent that teachers are empowered as constructors as well as consumers of data. Autobiography and its multiple forms of representation (such as visual and collage media) draw from memory and contexts that situate individuals in the world. However, one of the challenges to the use of autobiography is the "the tendency for life history research to simply use memories of experience to explain classroom practice, without exploring the possibility of using memories as a springboard for change" (Norquay, 1990, p. 292).

Collage as autobiography does more than simply reorder or reflect our life experiences. Rather it "recast(s) [them] into a form that is analogous but does not replicate an actual experience" (Norquay, 1990, p. 138). Like a work of art, such narrative accounts become a "semblance, a composed apparition" (p. 138). This requires a willingness to "exclude no element of experience or activity as irrelevant to the search for understanding" (Buttignol et al., 2000, p. 81). As a means for engaging the self in the process of inquiry, collage art allows us to visualize things in shifting relationships to each other, perhaps as a cartographic experiment of the soul in dialogue with the life around it.

Shifting Metaphors

As a way of imaging our past, present, and future lives across multiple places and spaces, collage breaks free of linear constraints where items from the world might "mean differently" (Finley, 2001, p. 21). Each of the pre-service educator/participants considered how multiple and juxtaposed ideas within their collage might be identified with "shifting" metaphors. Their use of metaphor to describe the content, which included personal history, cultural beliefs, and ideas from their education courses, in a sense, stressed movement.

Although each participant started out with one metaphor reflected in the frame of their collage (i.e., Angela's pyramid) they found these metaphors changed or overlapped other metaphors (Angela's quilt). The idea for shifting metaphors emerged from interviews with the participants, each of whom referred back and forth between two or more related metaphors, woven together with visual imagery such as "revolving" and "threading" to connect various aesthetic and metaphoric properties of their thought process.

The chart on the following page illustrates the shift in metaphors that each participant created through the collage process. On the left side, I have identified the metaphorical "frame" for the construction of their collages. The metaphor category in the middle column reveals the secondary image that, in part, operated as a visual image for defining their teaching philosophies. The category in the right-hand column suggests that there is always movement implied in representation and subsequent meaning making about self and teaching.

Collage Frame	Metaphor	Action
Pyramid	quilt	threading
Apple	driving passion	moving forward
Box	solar system	revolving
Scrap paper	something from nothing	transforming

Connections between the formal properties of the collages (i.e., shapes, colors, and styles) and the content produce infinite possibilities for meaning in the space of the "in-between." Ultimately, I suggest that it is the last category of "action," that might offer ways to resist or transgress hegemonic practices and inspire shifting notions of identity.

Shifting Identities

Collage narratives and shifting metaphors reinforce a revolutionary change in what it means to re-present one's identity by aesthetic and, in its own way, fictitious means. The fictitious elements are those pieces of our being that emerge as our personal myths, stories, and mental images. The subjective issues that are the facts of our lives appear as burnt offerings and sparkling visions, elements that because of their ephemeral nature are often erased from the language of more traditional inquiry and linear narrative forms.

More than just reflecting on who we are, autobiography as collage leads to critical reflection, which "transforms the very social relations and cultural institutional practices out of which oppressive reading and writing practices (ideologies) develop" (McLaren, 1997, p. 99). Students' use of collage in constructing how they "see themselves" does not imply self as a "unitary" figure in the modernist sense.

Rather, these collages parallel a process of "aesthetic reflexivity" (McLaren, 1997), which uses allegory and metaphor to shift "away from transcendence and toward the immediacy of local contexts" in ways that "rupture the notion of expressive unity and views the subject as de-centered" (p. 86). Collaborative engagements and serendipitous ways of knowing open up a space for a more critical understanding of "self," which includes an analysis of how identity is rather "amoeba-like" in the struggle for space within "its local situation" (Grossberg, in McLaren, 1997, p. 87). The shifting collage metaphors invoke acts of "border crossing" (p. 87) between self and Other.

This practice enables white middle-class students to critically engage themselves in alternative world paradigms. Without the real-life exposure to first-hand experiences of oppression, the widening of understanding beyond a dominant worldview requires empathetic and imaginative engagement and a capacity to make risky ventures into self-critique and reflection. For example, Angela explains her collage process:

> This is where I notice the first major shift in my thinking. I always pictured my perfect little classroom as 25 little white kids sitting at their desk doing what they want to, and now that would be like a nightmare, to walk in and have that…everybody the same, everybody quietly seated! And like four or five years ago that would have been ideal for me to walk into.

Thor, too, considered how his identity as a white male relates to his approach to teaching:

> You have to know yourself and use prior knowledge to be able to relate to your students. Relationships between students and teachers are very important for growth, on both ends…I don't know what they (students) have to deal with at home, or why they act the way they do, but I want to understand. So I put myself in a situation where I could be taught from them. It's about bringing "me" into this classroom with these kids where I'm the minority and I don't know anything about that. I don't know what that feels like, you know?

In border crossing, one's identity does not "shift" from one image of the self to another in diachronic form. Rather, various elements of identity represent

themselves synchronistically, creating fragmented, kaleidoscopic formations of layers and ruptures, which emerge at any given moment within space and time. Rather than transcending context by an order of self-will, border crossing contends that who we are and who we can become depends on "situated knowledge" (McLaren, p. 89).

Collage style parallels the move away from the universal and "race-free" ahistrosocial idealization of the self and others and becomes a means for re-examining deeply entrenched meta-narratives that overlook the everyday experiences within classrooms. Jessica explained that the purpose of her collage was to represent both her identity within Hispanic culture and her personal teaching philosophy. She states:

> We need to talk about how diverse our culture is and the importance of cultures that aren't discussed as much as others in history books...making sure the students see themselves represented somehow, especially through the arts.

Conclusion

In the life world of the classroom, serendipity, collaboration and alterative styles of "becoming" produce sites where we might replace ideas of the "lone individual artist" (or student) with art (artists) and pedagogy (teachers) who possess an "astonishing potential to build community through empathetic social interaction" (Gablik, 1991, p. 17). Serendipity allows for syncretic forms of self to be articulated, while collaboration re-situates critical discourse in the form of relationships that take place within local time and place rather than existing as race- and history-free narratives. Discourse about self and the world of "things in themselves" becomes a discourse of movement, or "things" as they interact in relationship with each other.

I am reminded of the shifting metaphors such as "threading," and "revolving" inspired by the case-study participants. In this discursive space, metaphors begin to shape shift, and it is in this in-between space that things as they are become destabilized from their fixed positions of dominance, and possibilities for action become viable. Pre-service educators can dis-cover/re-cover/un-cover their own voices, change or re-embody their identities, and develop a greater sense of empathy for others through the language of serendipity, collaboration, and style.

Unitary images that represent meta-myths about teaching and learning are destabilized by tearing, re-arranging, and critically reconstructing pieces of self as they relate to culture, society, and schooling. I conclude by suggesting that artis-

tic practices such as the collage study are vital to empowering beginning educators to address social inequalities and power relationships as they emerge within their own classrooms. Having been given the opportunity to explore for themselves the power of art, they, in turn, may use collage and other art forms to empower their students as well.

Endnote

* For purposes of confidentiality, the names of the four study participants were replaced by pseudonyms they selected themselves.

References

Block, A. (1992). Curriculum as affichiste: Popular culture and identity. In Pinar, W. (Ed.), *Curriculum: Toward New Identities* . New York: Garland. 325–341.

Buttignol, M., Jongeward, C., Smith, D., and Thomas, S.(2000). "Researching the creative self through artistic expression," in *Researching Teaching: Exploring Teacher Development Through Reflexive Inquiry.* Cole, A.L. and Knowles, J.G. (Eds.).Needham Heights, MA: Allyn and Bacon. 61–86.

Davis, D. and Butler-Kisber, L. (1999). Arts-based representation in qualitative research: Collage as a contextualizing strategy. Paper presented at American Educational Research Association (AERA) annual meeting, Montreal, Quebec (session 17.12).

Denzin and Lincoln, Y. (1994). *Handbook of Qualitative Research.* Thousand Oaks, CA: Sage.

Diamond, C.T.P. and Mullen, C.A. (1999). *The Postmodern educator: Arts-Based Inquiries and Teacher Development.* New York: Peter Lang.

Finley, S. (1998). Teacher education faculty as researchers: Composing lives in context, a blend of form and content. Ph.D. dissertation, University of Michigan, 1998. *First Search:* 0127. Source: 59, no. 07A, 2439.

Finley, S. (2001). Painting life histories. *Journal of Curriculum Theorizing,* 17 (2), 3–25.

Freire, P. (1998). *Pedagogy of Freedom: Ethics, Democracy, and Civic Courage.* Oxford, England: Rowman & Littlefield.

Gablik, S. (1984). *Has Modernism Failed?* New York: Thames & Hudson.

Gablik, S. (1991). *The Re-Enchantment of Art.* New York: Thames & Hudson.

Highwater, J. (1994). *The Language of Vision: Meditations on Myth and Metaphor.* New York: Grove.

Hyde, L. (1998). *Trickster Makes this World: Mischief, Myth, and Art.* New York: Farrar, Straus and Giroux.

Jenoure, T. (2000). *Navigators: African American Musicians, Dancers, and Visual Artists in Academe.* New York: SUNY Press.

Jipson, J. and Paley, N. (1991). Daredevil research: Re-creating analytic practice: An Introduction. In Jipson, J. and Paley, N. (Eds.) *Daredevil Research: Re-Creating Analytic Practice.* New York: Peter Lang. 1–18.

McLaren, P. (1997). *Revolutionary Multiculturalism: Pedagogies of Dissent for the New Millennium.* Boulder, CO: Westview.

Mullen, C.A. (1999). Whiteness, cracks, and ink stains: Making cultural identity with Euroamerican pre-service teachers. In Diamond, C.T.P. and

Mullen, C.A. (Eds.) *The postmodern educator: Arts-based inquiries and teacher development.* New York: Peter Lang. 147–185.

Norquay, G. (1990). Life history research: Memory, schooling, and social difference. *Cambridge Journal of Education,* 20 (3), 291–300.

Paley, N. (1995). *Finding Art's Place.* New York: Routledge.

CHAPTER SIX

"To Smell the Wind": Using Drawing in the Training of Bedouin Early Childhood Professionals by a Jewish Teacher

Ephrat Huss

My aim in this chapter is to examine how the use of drawing can help bridge and equalize cultural differences between a Jewish teacher, an art therapist who is part of the dominant culture in Israel, and Bedouin students (part of a subculture in Israeli society) who are training for early childhood certification.

Art therapists are familiar with the use of the regressive, expressive, and reflective aspects of art to encourage a clarification of and transformation of values on a personal level within an art therapy setting as discussed by Allen (1995), Rubin (2001), Riley & Malichiodi (1994), Robbins (1994), Kramer (1971). I will examine the effect of a transposition of these qualities into a culturally charged teaching situation.

Due to the double disparity of power between Bedouin and Israeli cultures and between our positions as teacher and students in the early childhood education state certification program, it was difficult to conduct an in-depth clarification and expansion of culturally different beliefs and practices concerning early childhood. My assumption is that teaching and learning to implement early childhood skills demand a complex integration of intellectual and emotional skills. Thus, the use of teaching methods that can integrate the emotional aspect is important in all early childhood settings and especially in one that is culturally diverse.

I would like to illustrate the problem of disparate cultures with the following example: I opened the first lesson with a request for general questions and

concerns. The students' questions, aimed at understanding the rules of certified family day care, also included child-rearing questions that suggested they had no prior experience with small children. What to do with a crying child? What games to play? How to connect to the children? What to feed them? Considering that most of the students had raised from three to ten children and had been chosen for their child-care skills, I assumed that this helplessness was not a real "fear" of small children or a lack of experience with them but a reaction to something within our teaching situation.

Maybe facing certification within a different culture was part of what caused them to disengage from their own extensive child-rearing skills. This is discussed in the literature. Israeli certification is partially based upon American concepts of developmentally appropriate practice as accepted by academic institutions. Spindler (1997) claims that Western theories tend to be taught very rigidly to different cultures because the (culturally disconnected) content is nonrelated; it becomes formalized and taught in a rigid ritualistic manner. Dwivedi (1997) states that parent education programs often fail because the parents perceive the professional knowledge as critical of their own beliefs (p. 205). Debond (1993) states that caretakers use their internal theories on child rearing much more in their work regardless of how many new theories they have been taught. Parents sense that they must disconnect from the new theories taught or from the children themselves.

Leavitt (1994) claims that the danger of emotional disengagement from children is compounded by early childhood workers' low social and economical status. Olden (1953) describes the ability to empathize with children as a "back and forth" process of regressing to a childhood level and returning to the adult ego. Thus, disconnection from one's own cultural context of childhood and child rearing may mean disconnecting from the ability to empathize with children and feeling the helplessness expressed by the Bedouin women I taught.

The question that concerned me as a teacher from a different and dominant culture was how to find a didactic method and group process that would both connect the students to their own childhoods within their cultural context and integrate new practices and beliefs about child rearing. My training and work as an art therapist enabled me to draw upon the inherent reflective and transformative qualities of art as a possible way to deal with this issue. Gerity (2000) states that the language of art expands one's vision, stresses different angles, changing perspectives, and differing relationships of part to whole. Thus, art counteracts the impoverishment of experience that cultural disconnection creates.

Kramer (1971) stresses the integrating, expressive, and empowering aspects of art. She states that cultural issues are also expressed through art practices and in art education (2001). In the book, *Art Therapy, Race, and Culture* (Campbell, 1999), there are many examples of the use of art to bridge, express, and work with problems from a cultural standpoint. An additional reason for turning to drawing was that a nonverbal medium seems to connect inherently to the content world of preverbal early childhood. This affinity was illustrated in the subject of one lesson, the organization of time and space in the day-care center, a subject dealing with spatial concepts.

Maybe art can bridge the verbal and nonverbal "cultures" of grown-ups and children. Dwivedi (1997) states that creative experiences create a group where the adult equivalent of play takes place...to work together on serious issues. Art can also be a cultural bridge. Gardner (1993) states that drawing stresses spatial nonverbal intelligence, while verbal linear thinking is dominant in Western culture. Using art to move away from the dominant culture's verbal slant may help connect to people from a culture where other intelligences may be more valued. It may also help people who cannot express themselves in the dominant culture. Arnheim (1996) states that we have been burdened by the tradition that separates perceiving and thinking...one needs only to look at what happens in any act of productive learning to realize that it consists of an intimate interaction of observing and reasoning.

Workers in early childhood education are almost exclusively female, and thus, theories concerning the ways that women, especially those with little education, express themselves differently from men could also support the use of art. Beyond the emotive and cultural reasons for using art, Fyfe et al. (1993) claim that art is a didactic tool that encourages enthusiastic learning as it is not only theoretical but applied. Sergiovanni et al. (1988) stress the advantages of creativity in teaching adults, stating that description and interpretation from a subjective stand are more productive than the scientific model of comparing the material the teacher teaches to one objective norm. Fujita and Sano (in Spindler, 1997) use videos (a visual medium) of day-care work to mediate cultural discourse among professionals from different cultures.

> When working within a teaching situation, the aim is, beyond being sensitive to other cultures, to determine how to reach a working compromise or prioritize behaviors. Beyond general sensitivity and awareness, there is a need for "tools" to negotiate, transform, and work within different cultural frameworks. Art can be seen as a tool that integrates conflicting beliefs, that can then be observed and interpreted in many ways.

Savneet (2003) stresses that art with Third World women can serve as a de-colonizing tool by giving voice to women through holding a polytheistic view of the world, as long as the interpreters of the art are the women's and not an external structure. Wang and Burris (1994) describe how poor rural women in China photographed issues of concern in their lives to help policy makers understand their needs. Creativity is cited as an important technique to encourage critical consciousness in poor rural communities, through bringing personal interpretation and the engagement of the imagination to the contents being learnt, thus "learners are not passively 'educated' but must say their own words and risk expressing themselves…" (Ramirez and Gallardo, 2001, p. 68).

After building a theoretical case for using drawing within a culturally diverse teaching situation in early childhood, I would like to examine its implementation by reflecting on the use of drawing within one particular lesson. I trained the group of 20 Bedouin women described above to become certified family day-care professionals. My aim at this stage is not a formal evaluation of the outcome of using drawing but a reflection on the outcome of one instance of the use of art in a culturally diverse classroom, based on a video of the lesson and my own and the students' summaries. I take a subjective and reflective stance concerning the processes that I experienced within the lesson just as the students did, and so I will use the term "I, the teacher" when describing my interventions.

Sue (1996) stresses the importance of self-reflection when working with other cultures. As an art therapist, it is important for me to stay true to my subjective "way of knowing" just as it is important for me to let the Bedouin women describe their own experiences of the lesson in their own words. The following is a division of the lesson into two stages: the drawing stage and then the discussion of the drawings with a final summary of both stages.

Stage One: The Drawing Process

The directive was to "draw what children need in a day care." The students drew in pairs on half-meter pages using oil pastels. The pairings enabled a dialogue. The medium chosen was oil pastels, which are quick and neat and enable the creation of lines, areas, and textures. The video of the lesson shows the women involved in their drawing and holding lively discussions with each other in Arabic while drawing. Thus, their language was the dominant one in the classroom. As stated in the students' summary of this part of the lesson, three main themes emerge:

1. The pleasurable element: "It was fun," "I enjoyed it," "It was a good feeling."

2. The regressive-reflective element: "It made me feel my senses," "It reminded me of childhood," "I returned to old things that I'd forgotten", "I enjoyed drawing and returning to the past," "I remembered how many things I didn't have in the past."

3. The self-expressive and reflective element: "I had freedom to bring out what I have inside," "I felt free, I can draw what I want," "I expressed what is in my heart," "I felt the picture expressed both myself and others," "I felt independent and free," "I learned to draw better," "The drawing takes out what is in the heart," "The drawing helps reach the truth inside," "It takes out energy," "Art delves into the soul and helps if you have a problem."

Their summaries included many emotive words, and it seems clear that the drawing process helped them achieve a sense of connection to their childhoods and legitimized expression in a clear and "free" way. The pleasure, emotional connection, and reflectivity within the drawing process may serve as a buffer against the burnout that can result from the low pay and endless demands of working with young children.

It is interesting that their comments to me at the drawing stage expressed a lack of confidence similar to what they expressed in the preliminary conversation. The students constantly asked me if their drawings were "right" and were what I had intended. This lack of confidence was directed at me, the representative of the dominant culture, and stands in strong contrast to their comments in their anonymous reflections on the drawing stage, which stress the pleasurable, regressive, and expressive experience of drawing.

Maybe their transference expressed the distrust and powerlessness that the students felt toward my dominant Jewish culture, while the art enabled authentic expression that was not connected to me, the teacher. This differentiation between the interaction with the artwork and the interaction with the therapist is familiar in art therapy. It is my belief that art enabled a multifaceted connection to the content (distrust of the surroundings and pleasure in the activity).

Sue (1996) differentiates between cultures with an internal versus an external locus of control. The students may have been expressing their culture's external locus of control (e.g. "the teacher knows the answer"), while I was conveying my internal locus of control by claiming that the answers were "inside them." On this level, I am reinforcing my cultural stance through the process of drawing that I initiated and am creating an "experience" of an inner locus of control. This, paradoxically, could be seen as an imposition of my culture.

Stage Two: The Discussion of the Pictures

The pictures were then laid out in a circle in front of the artist's feet, creating a collective exhibition even as each picture was connected to its creator. The rules of the discussion were that anyone was allowed to approach anyone whose picture interested her with questions about the picture. This put the students in charge of initiating the discussion and its contents, while I included comments and questions as did everyone else. The students could answer in Arabic with someone translating for me. It was interesting that the language describing the pictures (as compared to the questions before drawing) was clear and strong as in the following example.

> Student: "This is a child and a doll."
> Teacher: "Tell us some more about that doll."
> Student: "The doll is very important for the child."
> Teacher: "Why is the doll important?"
> Student: "Because the child gives all his love to the doll and then the doll can calm him down."

The student may have been disconnected from the same information if she had been taught it theoretically without having been first allowed to connect to her own ideas about a doll. Thus, the pictures served as a trigger for verbalizing the student's understanding of early childhood within the context of her own pictures and culture.

The video of the lesson shows that the students were eager to talk about their own pictures but waited their turn in contrast to the first lesson, in which they all raised hands at once. I think this was due to feeling responsible for the content and also due to the concrete spatial organization that the pictures gave to the discussion. It was clear who had and had not spoken. The content of the lesson (organization of time and space within the day care) became the experience of the lesson, conveyed nonverbally in the here and now.

The students' summaries stressed the process of sharing and exchanging ideas as the most meaningful part of the activity for them: "I enjoyed that we listened to each other," "I preferred the discussion to the drawing," "There was a good feeling in the room," "Each has an opinion," "There were many types of expression," "It was nice to see others' pictures," "Each has his own feelings and thoughts, and we learn about others."

The possibility of learning new things from each other was stressed as meaningful beyond the new content. This exemplified the dominance of process over

product in early childhood. The drawings organized or prompted a division of space and type of discussion that were flowing and associative, connecting to how preschool children think. At this stage, a gradual inclusion of my priorities (those of the dominant culture) is accepted into the discussion. The following is an example:

> Student: "It is a puzzle on the table, so that the crawling child won't disturb the older child to play."
> Student: "This is the yard. The children are playing."
> Teacher: "Is there shade outside?"
> Student: "Yes, this tree."

Comments on the content level were as follows: "It helped to talk about different ideas," "I learned about children throughout the discussion," "I enjoyed all the different opinions," "I thought of other ideas from friends. I was interested in every drawing," "Everybody wanted to understand the meaning of the drawing," "There were many thoughts about all the pictures," "I saw new thoughts and this gave me new ideas."

Overall, we have followed a transition through regressive and expressive pleasure to group social skills and interaction and to the acquisition of new ideas. Again, this follows the way children develop.

The group effect of the 12 pictures spread out before us was that themes were revealed and then addressed verbally. For example, I noticed that many of the pictures stressed the outside of a house or tent rather than the inside area, even though the students were being certified to open day-care centers within their homes. The outside areas were drawn with more color, detail, and simultaneous action, such as children playing in different areas alone or together. The insides of the houses were drawn with thin angular lines and depicted empty spaces or rows of tables and beds. The inside and outside pictures are interesting in that they all have a skyline and sun. In other words the artist places himself or herself outside with an "x-ray vision" into the inside of the house. The following is part of the discussion around these obvious differences between inside and outside:

> Teacher: "I see that many of you have stressed the outside area in your pictures; Why?"
> Student: "Outside is important for children."
> Teacher: "Why? What does outside give to children?"
> Student: "A different world, freedom, movement, independence."
> Student: "Sand, the feeling of sand."
> Teacher: "We talked about the need to experience different senses at this age."
> Student: "The air, the wind, the smell of the wind."

The comments of the women about these outside pictures stress the importance of sensory experience, independence, and freedom of movement and the need of preschoolers to explore the world. In contrast, the conversation triggered by the inside pictures conceptualized "inside" as a physical care-taking and adult area.

> Student: "This is the play room, and this is our house. This is the sleeping room, and there's a yard."
> Teacher: "Uh-huh; it looks orderly."
> Student: "Here is food, a bed, and everything is clean."

This can be understood anthropologically as connected to the differentiation between formal male guest receiving areas and informal female household areas in Bedouin culture (Ledwando-Hundt, 1978). It can also be understood psychologically as an expression of the confinement and emptiness of the house for the women, who are not allowed to wander freely. I wish to stress that my aim is not to reach an anthropological or psychological conclusion concerning the Bedouin division of space but to understand these specific students' interpretations of their own pictures within their cultural context and to adjust my teaching to this. Mona Ehabaro (in Campbell, 1999) points out that both ignoring culture and assuming that everything one sees in a picture is culture can create misunderstandings of the pictures. The collective impact of the pictures created a collective statement or "map" of how these students conceptualized the space used in caring for children. I, the teacher, could then adjust my teaching to this, specifically, by making the outside areas safe and stimulating rather than spending time trying to enrich the inside areas.

Another interesting theme rendered by the group exhibition is the physical distance of the caretakers from the children. In three of the five inside/outside pictures, there is no caretaker inside or out, and in two there is a caretaker inside the house, with the children outside. In two of the five outside pictures there is a caretaker by the children. The two inside-only pictures also do not portray the caretaker by the children but in a separate room. The Israeli certification demands constant eye contact and physical proximity to the children both for safety and to encourage a strong attachment between children and their caretakers. This point was raised in the discussion around the pictures.

> Student: (about inside picture) "Here is everything that a child needs: food, a bed, toys, and everything is very clean."
> Teacher: "It looks nice, but where is the caretaker?"
> Student: "She's gone to heat some milk for the baby."

Teacher: "Yes, I understand. Is the baby crying because she's out of the room?"

Student: "Yes, but she can't be there all the time; she needs to leave the room sometimes."

Teacher: "Yes, but maybe we can plan the time and space so that she can be within the children's range of vision most of the time and do other things when the children are sleeping. Who were you with when you were outside as children?"

Student: "My older sister was in the yard with us."

The lack of proximity of the caretaker to the children can be understood in different ways. My instruction to "draw what a child needs in a day care," may have stressed the physical surroundings. Another possibility is a clash between a single-attachment culture and a multiple-attachment culture. In Bedouin society and many other collectivist societies, the older sisters and other relatives are often responsible for the small children. As the certifier from a different culture, one way of dealing with this difference would be to stress the need for the proximity of the caretaker to the children by changing beliefs or enforcing practices. Another possibility would be to try to adjust the certification model to suit the student's way of doing things.

Maybe the secular Jewish family day-care model, in which visitors aren't encouraged and the focus is on the exclusive relationship between the caretaker and the five children within her care, is not suited to the multiple-attachment model of an extended family culture (such as described by the student who remembers being with her older sister as a child). In other words, lack of caretakers in close proximity to the children within the drawings could be interpreted as a lack of attachment to the children, or it could be interpreted as a failure of the interpreter from another culture to get the "whole picture" (e.g., the inclusion of other figures, such as older siblings).

Brody (1987) describes group process in women's groups in which the therapist can define the problem either as an individual one or as the social system being unsuitable for women's needs. Jayanthi (2002) differentiates between cultures that segregate children's learning environments and cultures that let children learn by being near adults and observing adults' behavior. Thus, being around adults, interacting with them and with each other can be as informative as being with one adult interacting intensely with them. The students and I talked about this conflict of practices in a nonconfrontational way by discussing and observing a third element, a drawing.

Conclusion

My aim in this chapter was to observe and think about how the inclusion of drawing influences the balance of power and cultural conflicts within a teaching situation. I tried to use drawing in a way that integrates the emotional elements of art therapy with the content-oriented elements of teaching, because early childhood is such an emotionally and culturally influenced area of practice.

The multifaceted qualities of drawing seemed to clarify a culturally and emotionally complex teaching situation by helping to make personal and cultural beliefs overt, equalizing the teacher-student relationship and the relationship between cultures and enabling a nonthreatening discussion of differences. Drawing enabled a discussion that moved from the "concrete" space between the characters to a discussion of the metaphorical or emotional space between them. Art, like early childhood, is an integrative way of experiencing the world, combining thinking, feeling, doing, and reflecting simultaneously.

On the other hand, my efforts to include the student's understandings of early childhood within the lesson backfired on my wish to highlight them by creating a Western process stressing an internal locus of control (Sue, 1996). Highwater (1981) states that "Children of the dominant society are rarely given the opportunity to know the world as others know it. Therefore, they come to believe that there is only one world, one reality, one truth, the one they personally know" (p. 205).

I learned that even with the best intentions, I couldn't rub out my way of understanding the world, just as the students cannot, and my cultural norms are reflected in the way I teach just as much as in the content.

I think, looking back, that I also should have drawn my pictures to be questioned by the students. I identified with Abu-Lughod's (1993) description of her efforts to let women write their own stories in their own voices, while knowing that she was the organizer, editor, and "re-teller" of the stories, rewriting them according to her own concerns. In other words, it is not clear that the students conceive of this reflective process as gaining the information they need for being certified by a strange culture.

Maybe an intensive course in the history and philosophy of Israeli-secular childcare would have answered the pressing needs of someone trying to adjust quickly to a dominant culture in a more direct way. The process of using art and discussing pictures is time-consuming, hard to measure, and difficult to direct and, thus, may not be suitable for an intensive course toward certification.

Another conclusion could be that in order to truly understand and integrate the old and new ways of doing things, teachers of Bedouin students should be from the Bedouin sector, so that they can "translate" the demands of the Jewish certification to their own culture and negotiate certifications built around their cultural needs.

This is a preliminary exploration of this type of use of art, and because of its subjective nature, it would need to be properly evaluated to see if it is consistently effective and to see if the reactions were to the art, something within the teacher's personality, the group process, or to a combination of all these factors.

In support of the use of art in this way, this "free hand" exploration of one lesson enabled different aspects and connections to be explored. One of the central foci in early childhood education is the quality of interactions of childcare professionals with children. It would be interesting to examine further if the use of "nonacademic" teaching methods, more congruent with nonverbal, nonlinear "childhood" modes of thinking, may enhance this sensitivity to children's experience of the world. As stated, the pleasurable, and regressive elements of drawing, expressed in the students' summaries of the drawing part, may also help to counteract the burnout of working with small children under difficult conditions.

Another direction to examine further is the ability of drawing to navigate conflicts between different cultures by enabling both sides to see many simultaneous perspectives at a distance. In the political reality of Israel, both as a melting-pot society and a country in conflict, there is no option but to learn to work with and within other cultures, to equalize power and to negotiate (just as toddlers have to learn to listen to others and negotiate play). I will conclude by quoting Arnheim (1996), who states that "all problem solving has to cope with an overcoming of the fossilized shape…the discovery that squares are only one kind of shape among infinitely many."

References

Abu-Lughod, L. (1993). *Writing Women's Worlds: Bedouin Stories*. Berkeley: University of California Press.

Allen, P. (1995). *Art as a Way of Knowing*. Boston: Shambahala.

Arnheim, R. (1996). *The split and the structure: Twenty-eight essays*. Berkeley: University of California Press.

Bogdan, R.C. and Biklen, S.K. (1982). *Qualitative Research for Education: An Introduction to Theory and Methods*. Boston: Allyn & Bacon.

Brody, C.M. (Ed). (1987). *Woman's Therapy Groups: Paradigms of Feminist Treatment*. New York: Springer.

Campbell, J. (Ed). (1999). *Art Therapy, Race and Culture*. London; Philadelphia: Kingsley.

Cartledge, G. (1996). *Cultural diversity and social skills instruction*. Champaign, IL.

Debond, C. (1993). A little respect and eight more hours a day. *Young Children 1*. Vol. 4.

Dwivedi, K.N. (1997). *Enhancing Parental Skills: A Guidebook for Professionals Working with Parents*. New York: Wiley.

Fujita M. and Sano T. (1997). Day care teaching and children in the U.S. and in Japan. Ethnographic reflexive interviewing and cultural dialogue. In Spindler, G.D. (Ed.), *Education and Cultural Process: Anthropological Approaches*. Prospect Heights, IL: Waveland. 430 -454.

Fyfe A. and Figueroe P. (1993) *Education and Cultural Diversity*. London: Routledge.

Gardner, H. (1993). *Multiple Intelligences: The Theory in Practice*. New York: Basic.

Gerity, L. (2000). The subversive art therapist: Embracing cultural diversity in the art room. *Journal of the American Art Therapists Association*, 7, 200–205.

Highwater J. (1981) *The Intellectual Savage. The Primal Mind* (In *Culture and Psychology Reader* Veroff et al. 1995.

Jayanthi, M. (2002). Opening the black box, and interdisciplinary conversation on negotiating cultural realities with children, Paper given at Tufts University Center for Children, April 10, 2002.

Kramer, E. (1971). *Art as Therapy with Children*. New York: Schocken.

Kramer E. (2001). *Collected Papers*. London and Philadelphia: Kingsley.

Leavitt, R. L. (1994). *Power and Emotion in Infant-Toddler Daycare*. Albany: State University of New York Press.

Ledwando-Hundt, G. (1978). Women's power and settlement: The effect of settlement on the positions of Negev Bedouin women. Unpublished doctoral dissertation, University of Edinburgh.

Loony, S. and Kim, L. (1992). Beyond cultural sensitivity. *Journal of Counseling and Development*, 70, 112–118.

Olden, C. (1953). Adult empathy with children. *Psychoanalytic Study of the Child*, 8, 111–126.

Ramirez, L. and Gallardo, O.(Eds). (2001). *Portraits of Teachers in Multicultural Settings. A Critical Literacy Approach.* Needham Heights: Allyn and Bacon.

Riley, S. and Malichiodi, C. (1994). *Approaches to Integrative Family Art Therapy.* Chicago: Magnolia Street.

Robbins, A. (1994). *Multi-Model Approach to Creative Art Therapy.* London and Philadelphia: Kingsley.

Rubin, J.A. (2001). *Approaches to Art Therapy.* New York: Brunner and Mazel.

Savneet, T. (2003). Decolonization: Third world women and conflicts, in *Gender Issues in Art Therapy.* Hogan, S., Ed. 13, 185–193.

Sergiovanni, T. and Starratt, R. (1988). *Supervision: Human Perspectives.* New York: McGraw-Hill.

Spindler, G. (1997). Transmission of Culture, in *Education and Cultural: Anthropological Approaches.* Spindler G., Ed. New York. Rienhart and Winston.

Sue, D. (1996). *A Theory of Multicultural Counseling and Therapy.* New York. Brooks Cole.

Wang, C. and Burris, M (1994). Empowerment through photo-novella, *Health Education Quarterly.* Vol. 21, 172–185.

Winnicott, D.W. (1958). *Collected Papers, through Pediatrics to Psychoanalysis.* London: Tavistock.

CHAPTER SEVEN

Fighting for the Soul

Judith Black

The opposite of good is not evil. It is indifference.
 –Elie Wiesel

I received a call from the local police of my small New England town a couple of years ago. When they identified themselves and asked if this was the residence of Solomon Black, my blood ran cold. Why could the police be calling about my 13-year-old son? I began bargaining immediately with The Almighty. The petition was two-fold. "Please let my child be safe." "On the other hand, if he has caused misery to someone, let your wrath spew down upon him!" It's an odd coupling. The truth was quickly forthcoming. My son was being brought up for a civil rights violation! It was reported that he and two friends called a girl from their class "spick" and told her to "go back where she came from." I was dumbfounded. If this was someone else's child I'd have chalked this up to no moral education, neglectful parenting, or a child with no ability to think independently. Alas, none of these are the case. This child, my child, is the great grandson of Jewish immigrants, named after my father's adopted son (an African American), who has been raised in a multiethnic community. He knows better.

I was anxious to hear his version of the "incident." In the tradition of 13-year-olds, when first asked if there had been trouble that day at the beach, he quickly stripped his face of response and shrugged his shoulders.

Kid: "Huh?"

Mom: "Was there some name calling?"

Kid: (continuing to feign innocence) "I don't know what you're talking about."

Mom: "Come clean. I got a call from the police."

Kid: "Mom, (he is exasperated and oh so innocent) this girl has been teasing us (him and his buddies) all year. She's a pain in the behind."

Mom: "So, you call her a pain in the behind. What makes it OK to toss out invectives about her racial or ethnic heritage? Those things have nothing to do with her being a 'pain in the behind'."

Kid: "Cool off mom! I didn't say anything."

Mom: "What happened?"

Kid: "One of the other kids said that stuff to her. He called her a spick. I was just there. I didn't say a thing."

Mom: "So being 'just there' doesn't make you guilty?"

Kid: "Mom, you need to relax. I didn't do anything. Besides, this is just the way kids talk."

Mom: "Sweetheart, indifference is what makes for genocides."

Kid: "Mom, you're a little off the deep end on this."

This incident and conversation were the beginning of a new battle. Obviously, the way we lived was not enough to combat contemporary culture. Peer pressure fueled by our cultural standards and norms is a more powerful force than I was prepared for. Confronted with television shows based on brutal irony as establishers of the norm, a society permeated by and accepting of violence, racism, material gluttony, and economic exploitation, we are faced with the option of dragging our children into wooded isolation for the years of adolescence or competing with a culture whose most overt values will result in hollow-eyed creatures staring yearningly at the eerie blue light emanating from an electronically motivated box in the living room. We are fighting for our children's souls.

What could I do to help my own child and others set a course through these treacherous years? How can this course accept all that is their commission to live and sort through and still offer guideposts and safety islands for them? How can I use the arts with this age group to help them determine the more humane, kinder, path to take in any situation and find the strength to steer for it? How to help them know that every action or inaction has resonance in this world?

Obviously no one thing can provide all this, but as a storyteller I am left to look to my trade and ask, "Can it be a force for promoting moral introspection, thinking, and action?" First, let us attempt a definition. What is moral thinking and action? Many stories offer "morals." Aesop's Fables, Hans Christian Andersen, and The Berenstain Bears all offer little wisdoms for moral living. I believe that these stories offer specific lessons rather than challenge individuals to question their own actions and thinking. If following a list of rules or living by specific predesigned behaviors is a sufficient guidepost for moral living, then Jews could have retired after Sinai, Christians with the Golden Rule, and Moslems would have shaped a perfect world from their Seven Pillars of Faith. Fortunately or not, most of life is lived in a gray area where rules can guide you, but absolute laws of behavior bear no resemblance to the moment-to-moment choices and actions we are constantly faced with. Hans Christian Andersen's steadfast tin soldier braved all forms of humiliation, pain, and, finally, death as he stood steadfastly "holding his bayonet firmly and looking straight ahead." Aesop's ant worked diligently, never allowing himself rest or comfort. His reward was to survive the winter. That slothful old grasshopper just sang and danced, and I don't have to tell you where his passion for the living arts led him. Stories with such absolute moral messages teach their lessons with a rigidity that requires full compliance or breakage and, to boot, are about as attractive as a bare raw radish for dinner. That dingbat, macho piece of tin might well have saved his life, sensitized others to his situation, and found his lady love if he'd ever allowed himself to ask for help. That little compulsive ant might just enjoy his life if he allowed a little of the cricket's music and the grasshopper's passionate step to infuse his world. Also, by sharing rather than scorning the grasshopper's passion, he might have inspired him to work a tad harder, which could have resulted in his salvation! I want young people to learn how to feel and think and search, in every situation, for the most humane resolution possible to any situation.

As a storyteller I am in a prime position for presenting stories that will challenge people's thinking and feelings about their behaviors. The beauty of a well-conceived and well-told story is that the listener identifies with the characters of the tale, enters their world, and emerges with their experiences and understandings. If our goal is to promote moral thinking and development, then what better tool to create a cognitive and moral dissonance then seeing and feeling a situation from a new vantage point? As educators, we can then draw young people into experiences that will help them evaluate what they have learned and felt in the story and apply it to their own lives. I propose that we take this opportunity

in educational settings and utilize an often-dormant avenue for growth and learning. More fully aware of the challenge than ever, I wanted to implement this goal with a middle-school population.

I am often called upon to share stories out of history. In Duxbury, one courageous teacher has had me come a number of times and tell tales from the Shoah. If the Holocaust had been a quirk in time and not an echo of Bosnia, Armenia, Rwanda, etc., etc., etc. it would have little relevance for us. But even if the heinous behavior exhibited in these nations was not a rule rather than an exception, these events are also echoes of situations that surface daily in the lives of adolescents like my son. Not that adolescents are asked to kill their Jewish, Hutu, or Croatian neighbors, but they are asked daily to stand by and be partner to acts that immediately degrade a human being, and could, by the examples we see in our world, lead to genocide. My son stood by at the beginning of one of these acts.

One can tell the sad and horrible tales of exploitation and murder, and everyone lends an ear. Such stories are filled with tabloid drama, passion, and the stuff of human interest. Simply by telling a personal tale from the Holocaust, a new and thus equivalent vantage point on that event is shared. We can, however, do much more. We can use the terrifying extreme of these tales to encourage adolescents to reflect upon their lives and the long-term ramifications of their decisions and actions. Telling the story is not enough. If you have an agenda, in this case to stretch the moral thinking of adolescents, then the story must be used as a springboard, and your role as an artist-educator is to bring this goal to fruition. I have been developing workshops that would relate the themes of the Holocaust to peer pressure and scapegoating within the school environment. The participatory workshops, which include improvisational drama and critical-thinking skills, have been designed to meet some of these goals.

The Story

I begin with a story. This is a tale told in first person from the vantage point of a young woman whose family lives in a small Hungarian town. You experience, through her eyes, the sequence of events so common to those persecutions. People, one by one, are stripped of their privileges, isolated by physical identification and curfews, forced from their homes to local and then regional holding areas, and are ultimately incarcerated in one of the many concentration camps that Hitler established for the annihilation of the Jews, gypsies, intellectuals, homosexuals, and others deemed not Aryan enough in the Europe of the 1940s.

I choose this type of story because, far from sensationalizing the issues and events of the Holocaust or even moralizing about anyone's actions, it simply relates one young woman's experience. You are drawn into her world with the same innocence and trust that she lived in it. I want my young audience to identify with a like-aged person and come to understand how, indeed, this could happen to a bright, strong, vibrant, person like any of them. It is very simply her story.

Questions

After the story I take questions. These often indicate the depth to which the audience understood or were innocent of this piece of history, and it also allows time for the story and its implications to sink into their imaginations.

Workshop Follow-Up

The objective here is to help students come to understand that there are no neutral roles in this life and explore possibilities for empowerment.

I Have Seen the Enemy

Drawing from the characters in the story and the students' knowledge of history, I ask students to create three lists.

Victims

The most obvious is the Jewish population, but students will usually generate a more complete list, including gypsies, intellectuals, homosexuals, the physically handicapped, Jehovah's Witnesses, and others.

The question often arises: "What is a victim?" It is a difficult question, as most of us are victims as the result of internal fears or external circumstances at some point in our lives. In this case, the definition can be clearly stated as "individuals or groups isolated, persecuted, and exterminated by the Nazi regime." It is, however, a good idea to maintain that the definition changes depending upon the circumstances.

Students will almost always be aware of Jews as the objects of Nazi persecution but less aware of the other minorities that suffered at their hands. By introducing these other communities, the Nazi persecutions begin to come much closer to home. In our generation, homosexuals in this country continue to be persecuted and, in some cases, exterminated. Simply saying the word "homosexual" in a middle school evokes nervous, self-conscious, giggles. At this early point in the synthesis, simply have students note their response and possibly

share with them some of the events involving the persecution and murder of gays within the last decade.

Historically, Native Americans and their way of life were systematically destroyed by the European settlers who named this land. If you are not familiar with this history, *Bury My Heart at Wounded Knee* by Dee Brown is a good starting place. By exploring victims, past and present, it becomes increasingly more difficult to create an "us" and "them" mentality. Once you realize that your forbearers perpetrated very similar crimes, you cannot deny that the possibility of this behavior also lies in you.

Perpetrators

I define them as those who sought actively to isolate, persecute, and exterminate the aforementioned groups. We love "bad guys." If people can find evil outside themselves, then they, by conclusion, must be good. We yearn for bad guys. Facing History and Ourselves[1] reminds us that there were very few committed Nazi Party members (200 to 400), and yet they were able to draw an entire continent into a genocidal journey. The student's task here is to understand who actually stated and engineered "The Final Solution."

What's the difference between a German and a Nazi? Students will often offer that the Germans are perpetrators, when in fact it was the committed core of the Nazi party that initiated the acts we know as the Holocaust. This is a wonderful opportunity to discuss democracy. Germany was a democracy during the rise of the Nazi party. We live in a democracy. You might want to discuss the various popular political parties. What are some political parties that are active but do not hold a large percentage of public support? How can a voracious right-wing minority gain control of a government in a democracy? How can they influence a major party? How can a majority who disagree with them be heard? Help students reflect on their role and potential as citizens of a representative democracy.

Often the role of collaborators will emerge here. What is an active collaborator? The story depicts a number of them. The head of the Town Council, who lied about the use of family lists for ration stamp books (These were used to round up the Jews of the town for "deportation."), is a good example of a willing collaborator. Do these persons belong on the "perpetrator" list? Let the students decide.

Bystanders

Who watched? Who stood by as Jews, gypsies, intellectuals, homosexuals, the physically handicapped, Jehovah's Witnesses, and others were isolated, persecuted, and exterminated by the Nazi regime? This last list usually results in some

cognitive dissonance. We are not used to examining this role. Often I will have to walk students back through the story by asking, "Who instigated the first isolation and defrauding (being set apart with the Star of David on their coats, limited in movement, denied business ownership, given restricted rations, etc.) of the Jewish population?"

The conversation moves to specific perpetrators. The Nazi invaders, supported by the Town Council and offered enforcement by local soldiers, allowed these policies to be set into place. Once we establish this I ask again: "Who watched?" They offer ideas. Our list begins. "When the town crier first told all 600 Jews of this small town to come for a week's stay in the synagogue, who did not instigate, suffer from, or protest this decree? Who watched this happen?" Our list lengthens. "When the family was resettled in a Jewish ghetto in the nearest large city, who was responsible for the 'relocation?' Who just watched?" Our list grows longer still. We continue in this pattern of discovery through the end of the story. Students often come up with ideas and groups that I had never even considered.

This list gets Talmud scholars going because there are many hairs that could be split. Students raise questions about people who benefited from the persecutions, but did nothing to instigate or enforce them—young men drafted reluctantly but serving in the German army, those who joined the Nazi party under duress in order to keep a job or position.

Whenever possible, throw the questions back to the class. Using a consistent definition for a perpetrator as those who actively sought to isolate, persecute, and exterminate the aforementioned populations, have them determine the status of these groups.

Bringing It Home

Drawing from their lives at the school, I ask students to create three vertical lists.

Victims

"In your school and community what kind of kids get singled out and picked on?" Victims have included those considered "geeky," having a mild physical deformity, a strong intellectual disparity on either side of the norm, representatives of minority racial or ethnic groups.

Students will not feel free to share this knowledge. It is taboo to talk about in large groups and especially around adults. As the leader it is best to begin by sharing your own experiences. Were you picked on as a kid? Why? Who was the object of derision in your school or community at the age of these students? Why

do you think they fulfilled that role? (It is important to have previously cleared this discussion with administrators and teachers prior to this session and let students know that they will not be chastised or disciplined for honest participation.) I don't edit but simply record their observations.

Perpetrators

No one thinks of himself or herself in this role. Instead of asking for characteristics of perpetrators, ask for descriptions of their behavior. How does someone point out another's weakness or difference and act on it? At first they are shy to share the real and nasty antics that are pulled, but with a little cajoling and promises that there will be no personal repercussions for their honesty, another list is created. Perpetuators' behaviors tended to range from name-calling and rumor-spreading to hat-throwing and locker-banging. Once on a roll, these list are easily developed.

If students cannot or will not suggest behaviors, remind them that these lists are not censored, and go again to your own childhood. I have used such examples as:

"The other girls in the cabin used to call me Judy Doddy, and throw socks at me."

"Whenever Tim would walk within a block of us we all hold our noses and pretend to cough and gag from the stench."

"Ed used to elbow kids into their lockers so hard that their books would fly all over the floor during period changes."

A few of these usually loosen them up.

Living the Issue

Now we start cooking. I separate the class into groups of approximately 12 students each and ask each group to assign one person to the role of victim and one to the role of perpetrator and to make a circle with the victim and perpetrator opposite each other. When I give him or her the go signal, the perpetrator is to use as many behaviors as he or she needs to in order to establish dominance over the victim. Perpetrators can draw from their own arsenal or from the list of perpetrator behaviors that we just developed. This is a short period (60 to 120 seconds) and must have a clear beginning and ending. During this short period, all attending aids and adults are asked to coach the perpetrator with vim and vigor to fulfill their role. All the energy and focus goes into yelling encouragements, ideas, and praises at the aggressing perpetrator. At the end of the allotted time, I

blow a whistle and ask everyone to freeze exactly where they are.

Middle-school students are often self-conscious at the beginning of this exercise. It is important to choose, as the perpetrator, a student who is willing to act out the role. Occasionally there is a sadist in the crowd. Keep an eye out for someone who might fly into full-blown physical violence. Remind them ahead of time that no physical pain can be administered, and remove them if necessary. The freeze at exercise end is very important. Students need to note their physical stance and feelings.

Evaluation and Action

Have all students observe where they are standing and their body shape and position at the exercise's conclusion. It is not until this moment that students grow aware that this exercise was not about victim or perpetrator. It was about them, the 10. Students are asked first to evaluate their body language from the position they froze in. Ask such questions as:

> "Are you in the same location as you were two minutes ago? If not, where did you travel to?"

> "How do you feel, physically? Is your body tense or relaxed? Are you feeling anything specific in your neck, chest, stomach...?"

> "What was your verbal response? Did you laugh at name-calling and sometimes even join in? Were you appalled by the name-calling? What did you do in response to it?"

> "Would anyone like to share other responses they had?"

(Note all responses before considering them.)

More often then not, the group has gravitated away from the victim and toward the perpetrator. If this was the case, ask them why they think that happened. If they gravitated toward the victim, ask them why they think that happened.

Often our bodies tell us what our intellects won't admit. Once they discuss their physical state, ask them what it represents in terms of their unconscious response to the activity.

Laughter can be used to many ends. It is both a way to discharge nervousness or discomfort as well as a way to greet authentic joy and humor. If they did laugh, ask them which of these sources their laughter was born in. Students usually will share a high level of discomfort around this exercise. I encourage and reinforce all their responses.

There's always one youth who just loves this exercise and would have wished only that it could have been more physical and longer. Instead of chastising this youth for a sadistic streak, ask why there is one. Continue to follow his or her reasoning and its logic to its source. "Why is it fun to watch someone be humiliated?" "Why does that give you pleasure?" Eventually you will come to ground zero. The student will often discover that if someone else is the focus of derision that he or she is, for this time, safe from it. This is exactly where you want to be. If, however, they take you in another direction, go. It might be a place that we can all learn from.

The Big Question

"Why didn't anyone stop the perpetrator?" It is in the answer to this question that we begin to see and understand how oppression is allowed to live and thrive among any population of good souls. Students will have good reasons for not standing between the perpetrator and victim. From fear for their own physical or social standing to the belief that I, as the authority figure, had sanctioned the exercise, their reticence to intervene is logical. I welcome all their reasons, and they often come up with rationales for inaction that I could never have generated. They all have a place because they represent legitimate fears and necessary self-preservation.

It is at this juncture that I refer to our story and thinking about the Holocaust. We look at the three lists. "Which is longest? Why didn't these people, the obvious majority, do anything to stop the isolation, persecution, and extermination of Jews, Gypsies, intellectuals, homosexuals, the physically handicapped, Jehovah's Witnesses, and others?"

In truth, the reasons given for nonintervention, are usually darn good ones. No one wants to be the next victim or risk the safety of their family to speak out for a cause that is not theirs. Were their reasons for nonintervention the same as yours? Were the bystanders in either situation innocent? If people were not willing to stand by and watch others be abused at any level, could a Holocaust happen?

That fact is that bullying in the school and community is similar to those acts practiced against the Jews of Europe that were actually close precursors of the Holocaust. If large numbers of bystanders had taken a position, could Hitler and a few hundred dedicated Nazis have perpetrated the Holocaust? If you and your friends don't like behaviors that isolate and bully others, do you have the power to stop it?

Our final work is for students to generate ideas and actions that make them successful activists in stopping bullying behavior. In smaller break-out groups, often the original 12-person exercise group, I ask them how, without putting themselves at undue risk, they might stop bullying behavior. Developing these strategies helps to build a sense of community that is absolutely necessary if students are to feel the level of empowerment necessary for taking strong moral actions in their world.

There is not a finite list to be created, but students should be encouraged to look at levels of functioning.

First they must have a system of communication that will enable them to diagnose a common issue or problem. They must then develop a plan of action that does not recreate the very problem they are trying to solve. They must have a system of evaluation and ongoing communication to monitor their results. It is best for them to create a theatrical scenario demonstrating their technique rather than simply reporting on it.

Their thinking about solutions can be as one-dimensional as the cartoon shows they have been raised on. As they plot and discuss, continue to throw in questions that will expand their thinking, such as:

"Will going to a teacher or the principal solve the problem for all time?"

"Will hitting someone enable them to behave in a kinder way?"

"Have you asked yourself why the perpetrator behaves in the way he or she does?"

"Can you deal with the source of their rudeness, anger, or cruelty rather than its manifestation?"

Conclusion

I finish this storytelling workshop by returning to my son. If Elie Wiesel is correct and "The opposite of good is not evil. It is indifference," what was my son's obligation?

Kid: "One of the other kids said that stuff to her. He called her a spick. I was just there. I didn't say a thing."

If my son is willing to put himself between the crassness of his peers and the object of their derision, could he not also stop the next Holocaust?

References

Facing History and Ourselves: A Holocaust Curriculum. (1982). International Educations 51 Spring St. Watertown, MA 02172.

While you're cruising, why not visit my web site at www.storiesalive.com?

"If I Really See You...": Experiences of Identity and Difference in a Higher Education Setting

Karen E. Bond and Indira Etwaroo

> Beyond the ideas of right doing and wrongdoing, there is a field. I'll meet you there. When the soul lies down in that grass, the world is too full to talk about.
> —Jalal al-Din Rumi, 13 c. Persia

The wooden floor is bare, the space overwhelmingly large. Students enter one or two at a time and stare out at the vast emptiness. The few who know each other speak in whispers as new arrivals continue to enter the space. On this typical first day of an undergraduate course entitled "Dance, Movement, and Pluralism," the majority of students do not consider themselves dancers. This is where one of the most remarkable discoveries resides. For many, Dance, Movement, and Pluralism becomes a place of surprise, freedom, and self-transformation according to students who have experienced the course:

> I don't know if you noticed, but this dance class has brought out things about me that I never even knew existed. I never knew that I could feel so much freedom ... that I could get in front of people and actually dance. That even surprised me after I did it. I also have to mention that before this class, I never danced. I mean never! I really believe in myself now. (freshman, Vietnamese woman)

> I like that I am able to express myself through movement without having to be an expert or professional dancer. (sophomore, Jamaican woman)

> I used to identify myself as a dancer until I lost faith in myself after I got rejected from an elite university dance training program. Now I want to be a special education teacher and own a dance studio. (junior, female)

Indira

I am a writer of dance, creator of dances, and teacher who instructs through and with dance. I am housed in a black female body of African/Caucasian American and Guyanese American ancestry. I am heterosexual and have always belonged to the working class. I own and acknowledge all these social constructions of gender, race, ethnicity, sexual orientation, and class because I believe that to omit them is to reify the idea of a norm. I realize that I am not the typical instructor in higher education that most of my students have grown accustomed to. Many have told me that I am the first black woman instructor they have taken a class with in this university setting. The complexity of this position is another discussion altogether, situating my students and me in a space that is not aligned with hierarchies of race and gender that are prevalent and perpetuated in higher education (Higginbotham, 1995; Mabokela and Green, 2001).

My emergence in higher education as a graduate student dance instructor has been through the course Dance, Movement, and Pluralism, which I taught five times between 1999 and 2002. To say that one will always be in love with their first love is true in this case. This course will remain the standard for all future courses that I might teach.

I am committed to dance as a tool for social ex/change. I invite students into the "field" that Rumi invokes to shed inhibitions, to "move" beyond social conventions and boundaries, to challenge pluralistic facades, to question and remain comfortable with that which is uncomfortable, and, most of all, to dance what cannot be spoken.

Karen

I was born into a middle-class suburban American family of Anglo-European descent (English, German, and Norwegian), and have many memories of a dancing childhood. My mother, an only child, like me, had done "aesthetic dance" as a young girl. She encouraged my early living room twirlings and enrolled me at the local dance studio. My best recital role was a pumpkin fairy, and orange remains a favorite color. I taught my first dance class at age 10 in the leafy backyard of a neighbor, for which I charged five cents per student. Many years and dance experiences later, I migrated to Australia, where I realized a full-time vocation teaching dance in higher education (1976 to 2000).

In September 2000, I returned to the United States to join Temple University's Dance Department. Interested in working with a diverse undergraduate population, I requested assignment to Dance, Movement, and Pluralism.

Teaching the course for the first time in the fall of 2001, I was fortunate to share a parallel journey with Indira. Within the first week, we made a delightful discovery that we both highlight existential insights from Persian poet Rumi in course materials and lectures.

I see myself as a learning and teaching specialist with a phenomenological orientation that highlights students' and teachers' experience as the basis of educational process. I embody a progressive pedagogical paradigm inspired by John Dewey, Rudolf Laban, Johanna Exiner, Anna Halprin, Max van Manen, bell hooks...and many others! I maintain an ethical and scholarly commitment to illuminating young people's perceptions of dance as a source of theory and social and educational advocacy (Bond, 2000; Bond and Stinson, 2001). This fueled my interest in contributing to the current text.

Background and Overview of Dance, Movement, and Pluralism (Course #R280)

Since 1986, the undergraduate core curriculum has been the heart of Temple University's version of the general education that many American universities include in degree programs. The core offers broad exposure to areas of knowledge that are thought to enhance intellectual potential, imagination, and judgment—preparing students for a rapidly changing world with an emphasis on lifelong learning (Temple University, 2000).

R280 is a one-semester, three-credit elective within the race studies core. Up to three sections of 25 to 30 students are offered each semester. Classes meet twice weekly for 80 minutes. The course attracts aspiring opera singers, lawyers, cheerleaders, fund managers, doctors, teachers, psychologists, and many others. Class lists read like United Nations subcommittees. Through the lens of dance, students address vital questions of race, ethnicity, gender, class, age, religion, ability, and sexual orientation as intersecting elements of personal and cultural identity that make up the tapestry of American society.

R280 integrates theory and practice through a multimodal, layered curriculum. Students move and dance; create and perform movement studies; view videotapes; read articles; conduct studio and field observations; attend concerts; write a reflective journal, a concert review, and an academic synthesis paper; and participate in class discussions. Content is enriched through visits from guest artists. By the end of the course, all students have performed in solo and group studies that highlight the potential for personal and social change. Student assess-

ment is not focused on a final product. Rather, the educational journey that students experience and document is pivotal. In this process, the ways in which students know themselves and the world are questioned many times over.

One particular educational journey in R280 is highlighted in the following personal teaching narratives. These emanate from a time when pedagogical agendas all over the United States merged with an event that changed the way many Americans contemplate the world—September 11, 2001.

Fall 2001

Karen

Like countless others, on the morning of September 11, 2001, I watched a passenger jet strike a World Trade Center tower on live television. At first I thought I was seeing a movie preview, and I remember the agitation of disbelief that took over my body when I grasped that this was not a feat of computer animation. I didn't sleep that night, wondering how many R280 students would appear for class the next morning (the third session of the course). I hoped that my long engagement in dance as a mode of learning, personal healing, and social integration would be adequate preparation for this occasion.

When I walked into the studio, many students were waiting in silence. I took a deep breath. We formed small sitting circles so that those who chose to could voice their feelings and be heard in a contained space. Forty-five minutes of intense conversation passed before I felt the group's energy shift and called for a large circle. One by one, students spoke—every single one, across the range of opinions and responses, from grief to anger (both pro- and anti-United States), to fear, to hope. One angry Latina student challenged, "I'll probably get beaten up for saying this, but...." A young man disclosed, "I used to feel black first, now I just feel American." When we finally stood up, I initiated a familiar dance class ritual. Once again each student spoke in turn, this time nonverbally, with a "breathed gesture" that the entire group then embodied. This silent pulsing manifestation of our collective energy sustained me through the day.

At the next class, students reflected on 9/11 and the course in their journals. A pre-law female student of Italian origin wrote: "This is the only class that I look forward to going to...people are respectful here." A Korean male participant revealed: "This is the first course where I don't feel any racism." Several students affirmed the metaphor of the gesture circle, for example: "We should be aware of how we're moving all together as human beings." I had a sense that students were

finding solace in the heartful and artful context of R280. A second-generation American of Eastern European lineage wrote in her class journal,

> My mind is not totally here because of my friend not being found yet...this has been the longest week since my dad died. ...Working on our presentation, I found three people today who are fun and creative.

Something that stands out from the day-after session is how course values, as symbolized by Rumi's transcendent field, provided my anchor to facilitate open disclosure. I am now able to envision more concretely Norman Denzin's (1992) notion of "a radical, nonviolent pluralism that represses no one and liberates all" (p. 23).

Indira

It was a morning like any other—awakening to a long, delicious stretch. I walked into the living room where my husband stood strangely still, staring at the television. Beside him I witnessed the collapse of a World Trade Center tower. My stomach and knees felt weak as I began to ask out loud, "What's going on? Is this for real?" We rushed outdoors to catch a glimpse of New York City's downtown skyline across the Hudson River. Billows of smoke rose from where the World Trade Center towers had previously stood. We walked home in our makeshift assortment of clothes that we had hastily thrown on. I was dazed, confused, and ashamedly grateful that my husband who works in the World Financial Center adjacent to the towers had an audition that morning and planned to report to work at noon. That evening, after hours of a zombie-like existence in front of the television, my mind went to my students in R280, who I would meet with the next day. What would they desire and need to say?

In watching my students' expressions of 9/11, my body remembered the kinesthetic sensations that I experienced while watching the towers' collapse. Five students sliced, punched, and swirled through a circular, counter-clockwise pathway, seemingly striking out at an invisible target. They inhaled deeply, as all faced out and fell forward (like trees that had been chopped), their hands catching the weight of outstretched bodies with a thud. Silence. "Two airplanes have crashed into the World Trade Center towers in an apparent terrorist attack" was spoken. They dragged themselves to the center of the circle—lifeless—and searched for one another's hands.

Another student stood in stillness as newspaper captions were read: "Fire fighters are searching the rubble...people are afraid...rescue volunteers from all over the world have come...candlelight vigils throughout the city...." One

minute passed, then two, then three, and she continued to stand in stillness. She wiped a tear from her eye and sat down.

Students spoke through movement, and 9/11 became a call to arms—arms that embraced one another and self. Several months later, a student reflected on the importance of dance in his healing process:

> September 11th touched so many people. It is about life, death, struggle, leadership, survival, and so much more. I feel that expressing my feelings through dance may give me a new understanding of how I have changed as well as how the world has changed. (East Indian male, theater major)

What follows draws on teacher and student journals, syllabus materials, student papers, video recordings of class performances, and course evaluations to illuminate R280 as a microcosm of social integration. Most examples come from our Fall 2001 classes, but photographs from Indira's Spring 2002 course, and several anecdotes from colleagues who have taught R280 are also included. Two key projects are described: the "Who am I?" solo and the final group performance. The chapter concludes with interpretive commentary, in which we address the layers of meaning in Dance, Movement, and Pluralism.

Who Am I?

> Madonna, Bill T. Jones, and I have something in common. We wish to be heard…to express ourselves freely. Art is not about imitating other artists who fit into the societal mold. People live on through their art. It is the driving force that makes us invincible. (final paper: white female, communications major)
>
> I am ready to learn outside of books. It's all about feeling and experiencing you. (journal)
>
> I did not like the solo performance. It made me uncomfortable. (journal)

The assignment Who Am I? challenges students to look inside themselves and re/discover all that is best and wisest, funniest and most authentic and to express these qualities in a three-to-five-minute solo. As students venture into the study, some compare themselves to an "ideal dancer." They begin to feel too fat or too

male or too Latino. One student wrote in a journal entry, "I am afraid that I will reveal who I am and no one will like it." Others celebrate their complex identities through dance, like a young woman in Karen's class, who spoke this text during her solo: "Who am I? I have many attributes: I am black, I am woman, I am smart, I am graceful, I am lyrical, I am in love, and I am loved…I am blessed." Another danced fluently with limbs painted green, titling the solo "Green, Gay, and Glad."

In preparation for the Who Am I? solos, Indira asks students to bring in a favorite picture of themselves. She recalls:

> One student held up her picture, and, after moments of silence, she began to cry. Some students in the circle became teary-eyed; others seemed to be holding their breath; others looked down at the floor; we all waited. She continued by saying, "This is my high school graduation picture. It was the first time that I looked at myself and thought I looked pretty."

> Several days later, she stood in the center of the performance space, erect, with her back to us and her smile reflected in a mirror held in her right hand. She watched us watch her. In this simple gesture, this young African American woman found a way to impart her lived narrative. Even if only for a few moments, she claimed the space as her own and accepted us as witnesses.

A number of participants approach the solo with the hope or intention of such transcendent experience. From a pre-performance journal entry in Karen's class:

> I am of no special national origin, no solid social class; I do not practice my parents' religion. I identify with other victims of sexual abuse. I have no idea how to dance that, but since it comes from inside me, I feel that it will just come out.…I hope to become someone who can help other victims or even save a potential victim. (freshman, white female)

From the same group, a 32–year-old recent immigrant drew on previously unexplored cultural roots (traditional Korean dance) to express feelings about his new country, writing after his solo: "Coming to the U.S. I believe that I was born again, and I want to express this resurrection with my pain and agony in my dance." Another student placed a Chinese vase with an American flag in her performing space, dancing the tension between her desires for cultural assimilation and retention of ethnic identity.

Who Am I? solos mediate the unique and the collective as students exchange roles from performer to audience, gaining appreciation for the stamina required to be a supportive observer. A pedagogical theme related to witnessing will be

revisited later in the chapter. The solo sharing establishes a context for R280's broader inquiry into questions like What is America? and What is an American? One student inquires about American identity through a text that accompanies her creative process:

> Every day I walk past people; I don't see color, gender, or preferences. Why is it that when you see difference, you judge?...Isn't this the country of freedom and diversity where we are all supposed to come together and walk hand in hand? Then what is this country we call America really about? (black female)

In small groups, students draw models of "America." These efforts show a range of perceptions from metaphoric (e.g., a patchwork quilt) to idealistic (the Liberty Bell) to cynical (a blind-folded figure of Diversity). In identifying a place in the tapestry of pluralism, each student comes face to face with his or her own socially constructed identity of race, class, ethnicity, gender, sexual orientation, religion, age, and ability.

Final Performance Project

Along with a final paper, small group performances held on the last day of class provide an opportunity for students to synthesize experiences and knowledge gained in R280. While sourced primarily from dance and movement, students may also incorporate text, music, costumes, and props. Participants discover quickly that this collaborative project is pluralistic in nature. Each individual brings something unique to the study, yet themes and content have to be negotiated and refined in the group, foregrounding once again the challenges and potentials of human diversity.

Students report that the final group project is both rewarding and difficult, as it becomes a site for expression of shared social agendas. From journal reflections:

> My group decided that violence is a controversial but enriching subject. We all relate to this in our personal ways. I think that will make our dance even more diverse and meaningful. Just because I have never been exposed to immediate violence does not mean I cannot relate or comprehend. (Korean/Philippine American woman, undeclared major)

> Some people in our world think it is okay to belittle the genocide that occurred during slavery. Slavery becomes downplayed, as if our heritage wasn't stripped from us. These false ideas are being taught in the education system and projected to the world through media. We are still suffering from the effects of slavery. We are still oppressed and looked at as inferior. Change begins with starting to love ourselves as black women and sharing this with other races. (African American, communications major)

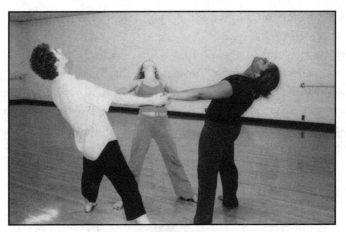

Figure 1

Many students cite the final group study as the hardest assignment in the course:

> The group dance was difficult! I did not have the energy to get upset with people who didn't get here on time to practice.

> The more I think about rehearsal today, the more concerned I become because six people couldn't agree on one single idea. What does that say about society as a whole?

> I'd rather do a solo instead of working with others because I want to express my own individual emotion.

> I now have much greater understanding of how my actions affect others.

> Dancing with other people means learning to trust.

> The group projects brought us closer together—literally.

> I learned that you won't always work well with some people.

In spite of the social challenges, the final performance event is for many the high point of the course. A student concludes, "By dancing with each other, with people of races and ethnicities different from our own, we have learned so much from each other." Another speaks more specifically, "I loved working on the group dance...to combine a little bit of each of us and create a whole new and unique dance." One participant declared, "This class has inspired me to dance again." A young female cantor from a synagogue that frowns on performance offers a critical perspective: "Fundamental believers of any faith should never try

to sap the enjoyment out of performing. This forces us to move backwards in our quest for a pluralistic society. "

Energy is high and contagious in this final sharing. One student described a "heightened collection of energy" in which qualities of kindness and generosity were present. In Karen's class, one group brought food representing the diverse ethnic backgrounds of its dancers. A male communications major summed up, "The interaction and unity of this class was like one I've never experienced in such a big, diverse group of people."

Figure 2

Layers of Meaning in Dance, Movement, and Pluralism

If I really see you, I will laugh out loud, or fall silent, or explode into a thousand pieces.
And if I don't, I will be caught in the cement and stone of my own prison.
 –Jalal al-Din Rumi. 13 c. Persia

It would be easy to suggest that R280 meets criteria for effective curriculum as suggested by contemporary learning theories and leave it at that. We know that today's university students are concerned about issues of diversity (Temple University, 2002) and that R280 allows cumulative, embodied, and interactive engagement with this topic in many dimensions. A theater major notes, "I wish more classes focused on social interaction between students so that a comfort level is reached for a good learning atmosphere." A male Caucasian biology major shares, "I think it is a shame that we have to take a class to learn about appreciating people's differences. It should be something we already know, but it isn't."

In every session, students are invited to revisit their sense of personal and social ethics. Canadian philosopher John Ralston Saul (2001, p. 93) suggests, "If not central to our daily lives, ethics is nothing." Further, "ethics has to wake up every morning…there is an element of drudgery to it" (p. 66). In R280, the ever-present possibility of drudgery in ethical self-confrontation is balanced by the regular opportunity to exercise what Ellen Dissanayake (2001) describes as the human predilection for "making special," creating aesthetic and artistic representations that illuminate individual and communal identity, mutuality, and difference.

To conclude the chapter, we will foreground an aspect of pedagogy that we believe is central to the effectiveness of R280 as a realm of learning and social change. From the earliest moments, students have opportunities to perform and observe each other in performance, to "really see" each other and to be seen. Witnessing occurs through more than the eyes (Figure 2: Witnessing). From the first circle introductions to the final group project, students practice kinesthetic empathy and intersubjective awareness as in this Anglo-Indian woman's description of a guest artist's solo:

> A figure slowly walks in, bundled up with layers of clothes. In my head I'm thinking, "Hmm, what can she do with all these clothes on?" There's no way she can move… However, as I watched, I began to be engrossed in her movements. I felt as if I should be bundled up also. She looked at the audience and shivered…. The way she shivered, I felt that I, too, was getting cold chills.

Through observation exercises outside of class, students extend their inquiry into a broader area of social possibility. A young Irish Catholic woman recalls:

> When I was given the experiment to notice my eye contact to others while walking in public, I realized that I hardly ever make eye contact. During most of the day, I am walking with my head down and avoiding people's eyes. But because of having to notice this trait, I have tried to improve on this and have walked with my head held high and making short glances at people. I owe myself this respect and also the other people around me.

The energy and commitment required to witness peers in an open, supportive manner is emphasized throughout the course. Regular opportunities to share class explorations establish an ethos of performance as a generous space for both performers and observers. An African American female student wrote, "I have a story to tell and I'm going to allow everybody to enter my world…even if it is only for one minute."

The metaphor of witnessing applies also to empathic listening in class discussions, as in this reflection from a female Sri Lankan student:

One of the most inspiring discussions we had was about racism, prejudice, and accept-
ance.... I felt like embracing and comforting—when she told us how she discriminated
against herself because of her color and appearance. I have also seen myself as inferior
because of my skin color. As I heard each story, I saw a part of myself. I also had a
moment of awakening when I realized that I, too, need to change in order for the world
to change.

Coda

This chapter has highlighted participant perceptions of experience and learning
in Dance, Movement, and Pluralism, an undergraduate university core course at
Temple University, Philadelphia. In closing, we wish to acknowledge our own
roles as interpreters. This narrative was constructed from two pairs of eyes, ears,
and hands, and two hearts taking in the individual and collective expressions of
many students. Our individual pedagogical and human sensibilities have influ-
enced what we have contributed here, but what surprises us as we conclude this
project is the quality of congruence in our valuing of R280. In spite of genera-
tional, racial, cultural, and occupational historical differences, R280 brought us
together and enabled our discovery of shared knowledge and vision. Indira has
moved on to do Ph.D. fieldwork in Ethiopia, accompanied by her infant daugh-
ter born during this writing project. Karen is currently enjoying her second
teaching experience in Dance, Movement, and Pluralism.

We embrace together as one with love from the heart.

There is love as we embrace as one.

In sad times, at happy times, at the uplands, at the sea...

On the earth, at the heavens...

We embrace as one.*

Endnotes

Where provided in student self-descriptions, we include racial, ethnic, and other
characteristics of those whose anecdotes illustrate the chapter. However, to
preserve confidentiality and anonymity, we cite no names.

On September 11, 2001 the United States sustained an unprecedented terrorist
attack when two hijacked passenger airplanes crashed into the World Trade
Center (New York) and a third into the Pentagon (Washington D.C.). A

fourth plane did not reach its intended target, crashing over open land in western Pennsylvania.

Thank you to Luke Kahlich and Leslie Elkins.

*Traditional Hawaiin melody cited in final student paper, Fall 2001.

References

Bond, K.E. (2000). Revisioning purpose: Children, dance and the culture of caring. Keynote address. In *Proceedings—Extensions & Extremities: Points of Departure*. LeDrew, J.E. & Rittenberg, H. (Eds.). Regina, Saskatchewan, Canada: University of Regina. 3–14.

Bond, K.E., and Stinson, S.W. (2001). I feel like I'm going to take off! Young people's experiences of the superordinary in dance. *Dance Research Journal*, 32, 2, 52–87.

Denzin, N. (1992). *Symbolic Interactionism and Cultural Studies: The Politics of Interpretation*. Oxford: Blackwell.

Dissanayake, E. (2001). *Art and Intimacy*. Seattle: University of Washington Press.

Gloria, J. (1995). Black feminist pedagogy and schooling in white capitalist america. In *Words of Fire: An Anthology of African American Feminist Thought*. Guy-Sheftall, B., Ed. New York: The New Press.

Green, A.L. and Mabokela, O. (Eds). (2001). *Sisters in the Academy*. Sterling, VA: Stylus.

Higginbotham, E. (1995). Designing an inclusive curriculum: Bringing all women into the core. In *Words of Fire: An Anthology of African American Feminist Thought*. Guy-Sheftall, B., Ed. New York: The New Press.

Mabokela and Green. (2001). *Voices of Conflict: Desegregating South African Universities*. New York: Garland Publications.

Saul, J.R. (2001). *On Equilibrium*. New York: Penguin.

Temple University (2000). *Learning for the New Century. Freshman Seminar Reader*. Philadelphia: Temple University Press.

Temple University (2002). Core task force report. *Faculty Herald*, 31, 3, 4.

A Theoretical Approach to Working with Conflict through the Arts

Vivien Marcow Speiser and Phillip Speiser

The authors' work with conflict through the use of the arts has been honed by people, conflict, and change for close to 30 years. The authors have worked with culturally diverse groups in the United States, the Middle East, Europe, and Africa, and their approach is predicated upon the belief that the arts are cultural equalizers and can enhance communication and expression and become vehicles for increasing self- and group awareness.

The combined use of the arts allows for group enactments, in which experiences can safely be shared and expressed. This type of sharing often facilitates transformation so that individuals can understand those who are different, problem solve together, and eventually create images and strategies that express their wishes and dreams for more peaceful solutions to difficult situations.

Whether one is dealing with tensions and complexities in Israel, the AIDS epidemic and rampant violence in South Africa, political refugees living in Sweden, the fast pace of change in Russia, or the emotional aftermath of September 11, the arts help to express feelings, explore differences, and open avenues for communication for people in need.

Philosophical Foundation

Arts-based activities, which explore cultural differences and similarities, promote social relatedness among individuals of different backgrounds. This approach is a cornerstone for developing conflict-resolution and violence-prevention strategies.

Violence erupts when conflicts cannot be resolved by nonviolent strategies, and successful alternatives to violence depend upon understanding the self and others, eschewing stereotypes, recognizing and accepting emotions, and summoning maximum creative energy in the service of peace. This process can begin when people from divergent paths share the painful determinants of the present conflict.

The arts in educational, mental health, and community settings are ideal vehicles for creative conflict resolution. First, images, movement, music, dramatic enactments, and stories have commonalities that are easily acknowledged across cultures and which help us recognize our common humanity and permit us to communicate heart to heart.

Second, the arts serve as a means of individual expression, helping people to experience their uniqueness, their history, their problems and desires, and to acknowledge these same elements in other people. Perhaps most importantly, the arts mobilize passions and will power for our common survival. Even when a group is as deeply divided as white and black participants in South Africa in the apartheid era, divisions can be put aside in simple circle games in which non-controversial issues, such as birth order in families, can be safely explored.

Conflict often has a devastating effect on individuals, groups, organizations, communities, and nations, but we all know that one can never be in a relationship or a society without conflict arising sooner or later. The greatest survival task for individuals in a society is to learn how to deal with conflict so that it is not devastating, destructive, and growth-inhibiting. Conflict, when dealt with in a positive manner, can actually be healthy for individuals and groups. Conflict can produce change. It is often the first step toward recognizing differences and identifying values or areas that are perhaps outdated or unusual.

In working with groups, simple ice-breaking exercises such as asking the group to divide into pairs in which one member embodies and speaks "yes" and the other says "no" gets people to playfully embody the conflictual situation. Group members can then work on the level of what feelings are brought up by saying "yes" and "no." Conflict can lead to unity. Addressing issues in a straightforward manner rather than keeping things under a lid opens the door for communication. It gets people talking to each other instead of about each other. This is the beginning of a solution. Also, conflict promotes compromise. When one engages in a process geared toward change, people learn to work and live more harmoniously within themselves and with one another.

Creativity, the ability to find new solutions to old problems or adequate

solutions to new problems, is used to attain outcomes that benefit everyone involved. The authors have consistently found that when the work is completed, groups are able to build images of hope for the future. A most striking example of this is the images of hope that participants drew in the shape of leaves of a tree, expressing their hopes for a better future after September 11, 2001.

Stages of Group Development

We have identified five overlapping and recurrent stages of group development. Arts-based interventions and structures will be explored within our discussions of these stages.

Stage 1. Building Trust and Empathy through Intrapersonal Sharing

When working toward conflict resolution, we have found that the initial stages of group development focus on building trust and empathy among group members. This applies to all groups, whether the group is ongoing or newly forming and however the group is constituted. As group leaders or facilitators, we have found it critical to articulate clear boundaries in the evolution of group norms and mores.

The function, purpose, and goals of the group must be clear and agreed upon by all group members. Time and participation obligations and constraints must be clarified as well as members' willingness to engage in the work. As participants begin to work and to share, group norms of behavior will emerge that must be elucidated so that there is clarity of understanding and general agreement among participants.

Leading or facilitating conflict resolution groups poses particular issues because how group leaders respond to conflicts that emerge in the group sets the tone for what can be accomplished in the group. Group leaders working for conflict resolution must themselves be comfortable in dealing with conflict, and this single most important factor will determine that levels of trust and safety will develop within the group.

An example of how facilitators deal with conflict is the challenge we faced when leading a group of Israeli and Palestinian participants in which one member became extremely agitated. She began to scream that she personally blamed all Israeli Arabs for the losses of Jewish lives in the Intifadah and ended up sobbing, "I hate you, I hate you, I hate you!" As facilitators we took a moment to reflect on our own feelings and acknowledged the "difficulty of emotions" that

had surfaced for everyone. This moment of reflection led one Palestinian to say to this person, "I can see that you are very upset and even though you say that you hate me, I can see that you are a human being in pain, and I love you." In the ensuing discussion the group began to make inroads in the development of trust, and both the leaders and group members were able to move forward.

Other challenges we have faced as group leaders have taught us that our cultural notions about time, for example, are open to interpretation. We have learned to negotiate with group members in Israel, for example, about not scheduling the group to meet around the times when road traffic is at its heaviest or when holiday travel is at its peak. Even though we do not allow smoking in sessions, when we worked in Russia, we found that Russian participants often needed to take a smoke break at the moment when things began to "heat up" in the group.

In the beginning stages of group development, our model relies upon arts-based approaches to help participants identify developmental influences that have created internalized values and attitudes as well as understand the ways in which they have internalized oppression. In order to develop trust and empathy toward others, individuals need to accept the continuity of their own experience, whatever that experience has been. A technique for grounding participants in the ongoing flow of their lives is to use "lifelines." Participants are asked to visualize, from adulthood through early childhood, the times that they remember understanding that they or others in their environment were different. Then they draw or write about these developmental moments. As participants recapitulate their experiences, they often find moments in their childhood when they understood that they or others were discriminated against. They realize that these critical incidents were formative in the development of their own values and attitudes.

As participants begin to share their stories and experiences with others, they begin to find moments of compassionate resonance with their own experiences, as well as those of others. Through the sharing of personal stories, trust and empathy begin to develop in the group. We have found that the more people share, the more they are willing to take risks and invest themselves in the group. Group trust begins by connecting with the self through intrapersonal sharing. For example, a Palestinian woman stated that she never felt safe as a child in her school because the Israeli army had once fired upon suspected terrorists in the school. Now she has become a schoolteacher in order to help protect young children who might find themselves in similar circumstances. Jewish educators in the group were able to identify and empathize with this experience.

Stage 2. Definitions of Self and Other through Interpersonal Sharing

As a group progresses in building trust and empathy, individuals begin to assert themselves and to differentiate themselves from others by finding their areas of commonality and difference. We can assist this process by providing structures that help participants to notice how they react as they pay attention to themselves and to others.

It is also important to develop listening skills as participants move into this interpersonal realm. One useful exercise asks participants to sit in pairs in which one person tells the other about himself or herself. Empathic listening requires attending to what is being said by simply listening and not responding. The listener does not amplify, contradict, or otherwise interact with the material being presented. Participants repeat what they heard to their partners, sentence by sentence, until there is agreement between the partners that what is being said is what is being heard. Back in the large group, each member of the dyad presents the other to the group in such a way that the other feels free to correct the introduction where such correction is warranted.

Then participants are asked to create "self" collages by clipping pictures and words from magazines and newspapers, which they will then share with other group members. Participants are also encouraged to present self-definitions through music, movement, enactment, and performance. Some participants create dramatic self-presentations; another might sing or dance or use art materials to create a self-portrait.

The progression from intrapersonal to interpersonal sharing is an overlapping process and helps to solidify the group as long as all members participate and receive response and feedback from others. Once the group members have listened to themselves and have shared some aspect of their personal experience with the group, they are better equipped to begin to build empathic bridges and resonance to others. Building such listening and expressive skills lays the groundwork for further group participation and recognition of others.

Once this groundwork has been laid, we begin moving toward the working stages, which involves enlarging the frame to look at the larger socio-cultural picture. This can emerge as members interview each other in pairs and then introduce their partners to the group. For example, a black South African participant introduced his white partner as someone he would once have been automatically suspicious of, but whose story had touched him when he learned that both of them had grown up with single mothers and absent fathers.

In another exercise, participants are asked to break up into subgroups of six to eight people. Each member is asked to break into or out of the circle of the subgroup. This exercise generally evokes an exploration of the dynamics of power and gives participants an awareness of their characteristic styles in handling and dealing with conflict. Participants are given an opportunity to examine their styles of managing conflict and are encouraged to "try on" new ways and strategies for dealing with conflict within the group.

Stage 3. Mapping the Socio-cultural Context

As the group moves from initial stages of building trust and empathy through the sharing of personal stories and listening to the stories of others, intrapersonal and interpersonal themes will begin to become located in the socio-cultural domain.

One's foundation for dealing with conflicts throughout life is developed intrapersonally and is brought into play whenever conflict is encountered among people. As the social sphere expands from the family outward to other groups, the potential for conflict expands as subgroup encounters subgroup, and as groups from different religious, ethnic, social, and cultural backgrounds come into contact. The potential for harmony and conflict is implicit in every encounter because issues of power, wants, different needs, and access to resources come into play. In addition, the potential for conflict exists in the idiosyncratic judgments that come into play in almost every encounter.

As conflicts begin to emerge between individuals and between groups, one realizes that there are different styles for handling conflict, and these styles are determined by one's intrapersonal development as well as by the socio-cultural context in which one has grown and developed. Some cultures deal with conflict openly and with confrontation, and disputants in an encounter deal directly with one another. In other cultures, interpersonal and intergroup conflicts are handled through the interventions of third parties, and the disputants themselves never come into direct engagement.

In working with building conflict resolution skills in the socio-cultural context, it is critical for group members to locate themselves both as individuals and as members of groups. As with understanding personal issues in terms of internalized oppression, it is also important for participants to see how culturally and socially determined prejudices impact upon their behavior, attitudes, and preferences.

In working with situations where there is a majority/minority issue operating, in particular, when the numbers of participants on opposing sides are

uneven, it is crucial that members of the minority group are given opportunities to express their feelings and issues about oppression and that the majority-group members listen to these points of view.

The use of the arts allows for access to and representation of intense and painful feelings, and members of groups who feel dominated by other groups must give expression to their feelings and thoughts so that the dominant-group members can connect with the issues that surface.

An example of this can be found in the enactment by a group of Palestinian participants who role-played a situation in which one of the members had been unable to rent an apartment in Tel Aviv because he was an Arab. The Jewish group members related empathically to the situation and began to talk about how even though they were members of the dominant culture, they felt a certain kind of "shame" in this situation.

In working toward the resolution of conflict and in building skills in conflict resolution work, we have found that oftentimes the very notion of resolving conflict is itself conflictual because long-standing conflicts between groups that are deeply rooted are not easily resolved. What is significant in such circumstances is to bring individuals and groups from diverse and potentially conflicting backgrounds into dialogues in which they can begin to listen, hear, understand, and build bridges toward each other.

In effect, we ask them to work toward coexistence, which is about learning to live with conflict. The structures we have used to get at the socio-cultural issues consist of individuals mapping themselves in relationship to others. This mapping can be physically represented on paper or can be expressed spatially in action games.

An example of "mapping" is asking participants to take a sheet of paper and to draw circles to represent all of the groups of which they see themselves as members. People are asked to decide for themselves what these groups should consist of.

In the ensuing discussion, the range of groups in a particular society is exposed, and the dynamics of inclusion and exclusion can be explored. Participants taking opposing sides in any position will find that even though there are areas of difference that divide them, there are also areas of similarity that they share, such as order of birth within their families of origin or being parents.

Even in groups that are quite formal, with little contact between men and women, or between ethnic and cultural groups, we have found that when we engage in sociometric activities, we can eventually progress to more loaded top-

ics such as religion and other differences. Sociometry is the study of group rela-
tions through the exploration of the roles and the place one occupies in a group.
Using sociometry, participants can be asked to arrange themselves in a line rep-
resenting a continuum, such as youngest to oldest group members, or by geo-
graphical locations, north to south, or by height.

Another use of sociometry is asking the group to sit in a circle and stand up
according to various categories, such as men/women, married/partnered, or sin-
gle/divorced, or whatever other variations group members would like to ask
about. The more intimately a group is working, the more politicized these enti-
ties will become and the more serious the issues to be explored.

As participants begin to identify themselves as a group and as subgroup
members, by affiliation, by birth, by history, by culture, and by social issues, they
deepen their understanding of the larger forces outside of individual and per-
sonal history. They can identify their prejudices and the ways in which these have
become attached to particular groups. It is relatively easy to look past prejudices
when dealing with individuals on an individual basis.

This allows the group to operate so that the individual can accept the other
as he or she accepts himself or herself. What is inordinately more difficult is for
the individual to see and accept himself or herself as a member of a group, car-
rying with it as it does certain rights, privileges, and obligations. What is even
more difficult is to begin to see and accept oneself as a member of a group that
might be oppressing another group.

The dynamics of inclusion and exclusion operate almost universally, and
chances are that every participant will fall into a group that has more or less
power in relationship to other groups. Groups will often compete in an effort to
determine which group has been historically the most oppressed rather than face
up to the injustices they have perpetrated against others.

We have found that a critical moment in group development comes when
group members who perceive themselves as coming from oppressed groups are
able to share their feelings about this oppression with members from what they
consider to be the oppressive group. An example of this dynamic is when an
Asian American woman shares with the group that following September 11, she
began to be very afraid that she, too, would be persecuted for her difference,
which allowed other group members to share their own fears about alienation
and difference, even though they all looked like white Americans.

Until group members are able to face their own history on a personal, inter-
personal, social, and cultural level, they will not be ready to accept responsibili-

ty for their own position and attitudes, values and prejudices. They will not be able to see others as they really are. Until all group members are able to freely express how they see themselves, they will not be free to examine these attitudes, values, and prejudices and make the moves that are necessary in the dismantling of such. It has been our experience that when sufficient trust and empathy has developed in a group, group members will be able to share their own images of internalized oppression, and most importantly, be listened to and heard.

Stage 4. Imaging the Political-Institutional Context

As the work progresses, one stumbling block that always emerges is the enormity and seeming impossibility of working through prejudice, discrimination, and oppression. Due to the breakdown of the peace process and other issues, there is much discouragement across the political spectrum in the Middle East right now. In such moments of political stalemate, there is a tendency toward hopelessness that can mire participants in anger, frustration, and despair. These feelings can become an inhibition and defense against making any inroads toward a peaceful solution.

The microcosm of the group becomes the macrocosm of what is happening politically in a society and will reflect the changing political currents. Particularly, as the work begins to draw to a close, participants will begin to withdraw toward entrenched positions that often focus on feelings of helplessness and hopelessness.

In such moments, there is a need to focus on the work itself. One method that has proved valuable in our work is the introduction of games that focus on the dynamics of power and the reversal of these power dynamics. One such game involves the assignment of numbers to group members. Each member is given a number from 1 to 10, and the assigned number is placed on the forehead of each participant, so that the person cannot actually see the number. The participants are asked to mill around the room and relate to one another on the basis of the number assigned. On a continuum, 1 equals lowest power and status, and 10 equals highest power and status. After the group has done this, participants are asked to line up according to what they thought their number was.

After participants know what their numbers are, there is some discussion about the exercise and about the arbitrariness of power, and then the roles are briefly reversed as 1 becomes high power and status and 10 becomes low power and low status. It is important that the numbers, and consequently the roles, be reversed so that all participants can experience the range of behaviors that accompany the role.

Another structure that demonstrates the capacity for changing or transforming the political-institutional picture involves creating body sculptures. Group members create subgroups that represent the political positions that members hold in common. This involves much discussion between group members as the criteria for subgroups are defined and as each subgroup begins to form.

Each group is then asked to create a movement image that symbolizes the political opinion of the group. Once the image has been formed, the group is asked to freeze the image and then to relate to another group and to verbalize their political position. As a cacophony of sounds begins to fill the room, participants are asked once again to freeze the image.

The groups are asked to move further away from and closer toward one another, once again the images are frozen. Participants are then asked to sit together in their subgroups and to work out a political manifesto of what it is that they want individually and collectively. Then they create a dramatic scene that demonstrates what they want from each other.

During the presentation of these dramatic scenes, it becomes evident that most groups across the political spectrum tend to want the same sort of things. These include freedom from persecution, religious tolerance, and personal and collective security. The very real divisions between groups are articulated clearly, but a basis for common goals is also established.

After each group has presented their improvisation to the larger group, groups are asked to reverse roles and to reverse positions. For example, a Jewish group that was advocating for settlement of the West Bank is now asked to advocate against settlement of the West Bank. This role reversal is a powerful tool for allowing some measure of understanding of opposite points of view and usually generates productive discussion that is more inclusive of the positions of others.

As a final task, groups are asked to create a final image of their group and are asked if there is any piece of the image that they would like to transform. For example, one group had polarized itself into an entrenched position of Jews against Palestinian Arabs. In the final image, the groups moved from fists raised against each other to reaching out toward one another.

Stage 5. Visioning and Revisioning the Spiritual Context

In order to create a working environment that honors the difficulty of bridging the chasms between people of different beliefs, religions, and social and cultural backgrounds, we have created rituals for beginning and ending groups. The group begins with an opening ritual such as the lighting of a candle, reading a poem, or pronouncing a nondenominational blessing and invocation. The group

ends with a closing ritual, such as one in which each participant creates images and words on paper to leave in the center of the circle, and each participant takes an image out of the circle as he or she leaves. A similar closing ritual involves each participant placing a stone in the center of the circle and taking a stone out of the center as he or she leaves.

A mechanism for creating continuity throughout the life of the group is asking participants to decorate envelopes with words that express characteristics of their personalities. Each envelope is hung on the wall throughout the working life of the group. Each participant is expected to give feedback and response to every other group member by placing words and images into the envelope during the course of the work together. At the closing session, each member retrieves their envelope and reads through the responses.

Each member is then asked to prepare a final statement for the group that expresses what they have learned and the hopes and visions that they have for taking what they have learned back into their personal and professional world. These closing statements can be presented in artistic form. What generally emerges in the closing sessions is that participants are able to find moments of resonance and connection with each member of the group. In the closing presentations, individual differences and similarities, emerge and are held and honored within the group.

As each member shares personal hopes and visions, in that moment the collective hopes, aspirations, and visions emerge into the collective consciousness of the group. In these brief moments, the individual and the collective meet in commonly held understandings, in similarities and in differences. It is in this honoring of the views of all its members that the spiritual power of the group resides.

As authors and as group leaders, we realize that the issues we are working with through the arts are often intractable and not amenable to easy "fixes" or fast solutions. For us it is often enough to offer the possibility for communication and expression to participants whose lives have been touched by pain and conflict and to help in the emergence of divergent points of view.

We have been touched by all those individuals we have worked with and believe that they too have been touched by the power of the arts and the healing potential of telling their own stories to others. We encourage our readers to think about ways in which they could incorporate some of the structures and sessions we have described here.

CHAPTER TEN

Little Signs of Hope: Art Therapy Groups with South African Children

Angela Rackstraw

The "Art Therapy program" takes place in groups at various schools in extremely poor and marginalized informal settlements and townships just outside Cape Town. These townships are direct reminders of the apartheid regime. The groups have been set up and are sustained with difficulty. There is no state funding for something as "alien" as art therapy. There are eight art therapists in a country with a population of about 42 million. Art therapy is, therefore, an unknown and regarded with some suspicion. None of the children with whom I work has had access to mental health services, nor have their parents.

Working with the community to gain trust and support is of paramount importance. The groups need to be set up slowly, giving everyone with concerns or suspicions the chance to raise them. The community members, teachers, and clinicians have needed to be informed about the efficacy and necessity of such groups. It is necessary to continue this dialogue so that the apathy most seem to feel, possibly as a result of feeling overwhelmed by insatiable need, does not affect the group or the therapist. It is important to realize that many of the teachers, parents, and guardians, who have also lived in painful circumstances, have had no emotional support themselves. These members often attempt, at an unconscious level, to sabotage the groups as envy arises.

Many of the children live in iron shacks in informal settlements, where there is no concept of personal space, due to overcrowding and inadequate physical space. Families often share one room and sometimes one bed, if there is one. Few

households have electricity or running water—and certainly no toilet facilities. To have a tap attached to the outside of one's home is considered a privilege.

The schools in the area are ill equipped; often there is neither electricity nor proper toilet facilities. At one school, the only running water was from a urinal, where we had to wash paintbrushes, palettes, and our hands.

Until recently, little has been known about the effects of widespread and chronic violence on the children of South Africa. Generations of children have grown up in a society ravaged by apartheid, a society now trying to rebuild itself following a change in government. The legacy of apartheid, however, continues to affect the lives of all who live here. Indeed, in some areas, violence is escalating, and problems of poverty, unemployment, poor or no housing, and completely inadequate education and health systems continue to wreak havoc in so many lives.

It has been found that a high proportion of children have emotional problems as a result, and many are considered to be suffering from post-traumatic stress disorder (PTSD). As children fall through the cracks of a health system that is far from ideal, in which mental health issues barely make the agenda, the psychological impact of ongoing violence and deprivation has, to a large degree, been neglected.

While a number of studies have focused on the effects of political violence, very little has been written about the effects of ongoing community violence. Westaway (1993) attributes this failure to ignorance, overloaded and inadequate services, and the reluctance of professionals to confront traumatic events. Caregivers are so overloaded with their own difficulties that they are not able to acknowledge the effects of this violence on their children, creating a "silent conspiracy of coping."

The emotional response of these children to situations of ongoing violence and "diffuse forms of traumatic living" (Gibson, 2000) could be likened to those of children living in war situations. The likelihood of developing personality problems and adult psychiatric disorders is high for children in both types of situations.

The following are some examples of direct violence that children in the art therapy groups and their family members have experienced:

- One boy's home was petrol-bombed.
- Two of the children have been shot, needing surgery. Two have been stabbed.
- Five have recently lost older brothers in shootings.

- Another witnessed his cousin being shot while watching television at home.
- One boy witnessed his father killing a man.
- A girl was raped by her father for several months and witnessed him killing a neighbor.
- A girl found the body of her four-year-old cousin, who had been raped and strangled.
- Many have been raped, two requiring extensive surgery such as colostomies.
- Many of the children are beaten severely with pieces of hose pipe (the most popular weapon, often found in school staff rooms), sticks, etc. These beatings still occur. Two have had boiling water thrown at them.
- One girl came to school with the imprint of an electric iron burned into her cheek. Social Services would not follow up on the case, due to "lack of evidence."
- All the children are familiar with the sounds of shooting. At least 90 percent have seen the body of someone who was shot or stabbed.

Apart from the above horrific situations, the vast majority of children come from homes where there is often no food in the house. Also, more and more children are being orphaned as a result of the AIDS pandemic in South Africa, and this has had an impact on the group.

The children in the group have gradually and spontaneously shared these situations with the therapist, and now more recently, with other group members. They have mostly emerged during sessions that have been nondirective in nature. The children have never been asked to think about or draw "something horrible or violent."

The groups meet weekly during the school term. Although we sometimes find ourselves wandering around with art materials looking for a suitable space to work, these are "working groups" with the group dynamics usually found in a therapy group. We need to adapt the group to specific needs, however.

We begin with refreshments, as often children will not have had a meal since at least the previous day. Sometimes teachers from other schools forget to bring the children, so members will often come into sessions late or not at all, in spite of reminders. If we are in a "borrowed" room, teachers often wander in and out, which we try to deter.

As mentioned, the groups are mostly nondirective in nature, except for the first session or when it feels appropriate to introduce a specific theme because a child might benefit from this. The first session is a "getting to know each other" session in which children are encouraged to tell each other and the therapist anything about themselves in a drawing. We start with basic art materials such as koki pens and pastels, as some have never encountered paint or brushes before. These are also materials that could be considered as more "containing" in nature. It is often shocking to see what children communicate in the first session, although many produce "idealized worlds" for a while.

It is explained that the group is a space where members can talk about anything they choose, even issues that are difficult and sad. I allude to the fact that someone felt they might benefit from a space where they can talk about these issues, get some extra support, and make art.

Sometimes I have no idea why a teacher, social worker, school nurse, or neighbor has referred a child to the group until several weeks later. Sometimes a teacher will refer children because "they are naughty, and sleep in class"; "they ignore us"; "they've changed, something is wrong;" or "this child can't sit properly, someone has done something to her." Sometimes other community members will express concern about a child being abused or beaten.

For the sake of this chapter, I have selected three vignettes in which children have spontaneously shared something when they have felt ready or needed to do so. All names have been changed.

Bongani, 10 Years Old

Reason for referral unknown at this stage. A timid looking boy with a squint, wearing glasses. Little eye contact, appears shy.

During the first "getting to know each other" session, Bongani made an image on an A2-size paper (Figure 1). In it are three figures, although it was not clear that the figure on the extreme right actually was a figure. Although he started tentatively, Bongani soon became completely absorbed in the drawing he was doing in oil pastel. He later used diluted inks; his face lit up with obvious pleasure. When the children were invited to tell us about their images, he chose to speak with me on his own.

Bongani was visibly anxious as we spoke. I gently asked nonintrusive questions, reminding him that he could tell us anything he chose to and that he could even make up stories about his image. He chose to identify the three figures.

Figure 1

The figure on the left with outstretched arms is his father, and the central one is his older brother. He is the one on the right, wearing glasses. He identified the trees, the family home, his father's car, a sun, and some clouds. I asked if anyone was in the house. He replied that his mother was at home cooking. He pointed out that his father was shouting. He told me that his father and brother often shouted and hit him but he didn't know why. I said that couldn't be nice at all and wondered aloud whether anyone tried to stop the shouting and hitting. He looked down, shaking his head with sadness and resignation, and said his mother was too busy or tired. He then got up to leave, saying he had to get home.

I was left wondering how he felt, having just exposed himself as he had, leaving him feeling extremely vulnerable. I wondered what he was going home to and was struck by just how much his image communicated.

The difference in the three figures is remarkable. Both the father and brother have facial features and look slightly menacing with wide, grimacing mouths with teeth showing. Both have differentiated legs and arms, although the brother has only one precariously attached armlike appendage. Bongani has none of these. He looks more like one of the trees in his image; his body, drawn without legs, looks almost trunklike. His arm looks more like a branch, and apart from his glasses, he does not seem to have any facial features. He looks literally powerless and rooted to the spot. Underneath his body where his feet should be, there are what appear to be roots, albeit not very strong or deep ones. I did not feel it appropriate to share my observations with him.

Bongani was a quiet and withdrawn child, showing little enthusiasm or energy. Lethargic, and even dull, would be an apt description of his presentation. He seemed depressed. The lonely, disempowered figure of himself in his drawing seemed to confirm this.

The following week's session was nondirective. Bongani chose to make another image of himself, this time with his mother. What is particularly striking is the size of his mother who fills the A3 page and the fact that he is right at the edge of the page, only about 2 cm tall. His towering mother is scolding him because he had forgotten to watch the food on the fire, and his home had almost caught fire while he played outside with friends. Bongani pointed out his father in a hospital bed. He then said that his father has "the AIDS" and "is often sick." When his father is sick, his mother has to "look for money on the streets," begging at traffic lights in the city so that she can buy food. He said I could tell no one this.

Figure 2

Some months later Bongani made an image that he held back for several weeks until he felt able to share it with me. The image (Figure 2) is of himself talking to God and his father. His father is in a coffin at his feet, and he is surrounded by other coffins. He said with great difficulty that his father had died of "the AIDS" and that "no one must know, not even teacher." Nobody at the school knew that his father, the breadwinner, had died. We were able to explore how very alone he felt, how much pain and loss he had experienced, and the fact

that he was unable to share this with anyone at home. One reason for this was that there is a hierarchy of mourning and he was lowest on the list, besides which nobody had time to concern themselves with his pain. He felt he should now be the breadwinner as his elder brother lived elsewhere. Tragically, his brother was shot and killed in an incident over a cell phone some months later.

Bongani gradually found it easier to speak, going from "the timid member" in the group to speaking openly in it. Indeed, he presented a mischievous side of himself and made it his responsibility to ensure that everyone adhered to the group rules that members had agreed to.

He found it possible to work through the loss of his father through his images and objects. For example, one week he made a clay model of a car, and he spoke of his father having been a taxi driver. He expressed sadness that he was too young to have inherited his father's car, which was being used by a neighbor.

Figure 3

Another week, he spontaneously shared a dream in which he was out fishing. A large shark was swimming in the water (Figure 3), but after a struggle, he was able to kill it and take it home for supper. Note how very different this drawing is from the first drawing of himself made many months previously. He is no longer the disempowered boy but is able to overpower a dangerous shark and make use of it, too. He is able to think about and acknowledge his fears and is able to verbalize this appropriately. About a year after he left the group, I received a message from him to say that his mother had recently died of AIDS, but that he was "okay," and "just wanted to tell" someone.

Xolani, 10 Years Old

The reason for Xolani's referral was initially unknown. His teacher later report-ed that his schoolwork was poor, his concentration almost nonexistent, and that he slept during class, never completing a task. He vacillated between being dis-ruptive and completely withdrawn.

In the "getting to know you" session, Xolani quietly began drawing on an A3-size paper with oil pastels. He chose to share his image only with me instead of with the group. He had labeled most of his images in English (Figure 4), even though he was Xhosa speaking—this was no doubt for my benefit.

Figure 4

Even though he had labeled the separate images on his page, he still took time to identify these. I had immediately seen the "boomb" and was probably as anxious as he was as we came closer to talking about that part of his image. Everything he had drawn was obviously important to him. For example, he was very proud of the fact that not only did his house have a clock, he was learning to tell the time. Not only did he have a dog, he fed it.

He went to great lengths in describing his family members, including a mother and father, and many siblings. He told me that his family had a televi-sion set and that they often watched it together in the evenings. So far, "an ideal world" had been presented. He paused here—underneath the image of the tele-vision set was the "boomb." I waited. Xolani then shared that while his family was watching television one night, a petrol bomb had been thrown at their house. His sister and father had been taken to the hospital, both severely burnt.

His house had burned down, and he now lived with his grandfather. He said that his father now lived "somewhere else"; he didn't know where. He thought his sister was still in hospital (this had happened about six months previously) but also thought she might have died.

I wondered about the immediacy of him telling me about the "boomb," which had torn his family apart. Did he want to shock me, or was his need to let someone know what was happening in his world—an overwhelming one? The effects of the "boomb" had been overwhelming; his life would never be the same. Not even his teacher knew about this. Xolani seemed to have nowhere to take the pain and horror of this experience.

I later found out that only Xolani and his brother lived in his grandfather's home. He knew the whereabouts of no other family member except his mother who was "in Johannesburg somewhere," more than 1000 km away. It was later in the sessions that he wrote a letter to himself from his mother, telling him that she loved and missed him. When sharing this, he spoke of the huge sadness and aloneness he felt at not knowing where she was or when he would see her again. Sadly, this is the case for most of the children in the group; most do not live with their mothers.

Emarentia, 10 Years Old

Emarentia was referred to the group because she had been raped by her uncle, and her behavior at school had become disruptive. A social worker had arranged a new placement for her, but unknown to anyone, this had broken down, and Emarentia had returned to her grandmother's house where the rape and abuse had occurred. She was forbidden to tell anyone this. She had received no counselling or follow-up visits. Her grandmother denied that her son had raped Emarentia, in spite of medical evidence to the contrary.

For several weeks, Emarentia drew flowers and repetitive patterns. She seemed withdrawn, although she fully engaged with the art materials. Initially, I let her be. Then one day I noticed her crying as she wrote and attempted to cover up her page. When her tears were acknowledged, she spoke easily.

She had written about how much she hated her mother, who had abandoned her as an infant but now lived only two streets from her. She showed the writing to me, and we explored her angry and hurt feelings of betrayal and loss. She spoke of how she hated her life and how she wished she had not been born. One week she made an image of coffins in a church that seemed to surround a central coffin, which was painted red. All the others were in muted shades. I imme-

diately thought of Bongani's image made two years previously in a different group. She spoke of how the man she thought was her father had shot and killed someone the previous week and was now in jail. She said there was death all around her (there were daily shootings in the area, and even while we were in the group we heard the shooting outside), and she wished she were dead.

I was concerned about her level of depression, and explored this with her, asking if it might be her in the coffin. She started crying and said she had tried to walk in front of some cars, but they had all swerved to avoid her. It then emerged that she was again living with her grandmother and uncle and unable to sleep at night for fear that he would come into her room and rape her again. She often spent the night out on the street, refusing to go home.

Apparently the uncle was threatening and taunting her in public, saying she was "a slut and a liar." We agreed she needed to move and contacted her social worker. Emarentia asked to go to a children's home, which took five months to arrange. All this time, Emarentia lived in fear. She is doing very well in her new surroundings (at least at the moment) and has the support of the grandmother who appeared not to believe her initially.

None of these children's situations changed drastically, nor were they likely to. All were still alone, and none had a primary caregiver that was loving and nurturing; however, what was important in the groups was that their loneliness and pain were thought about, acknowledged, and shared. In their different ways, the children were able to find voices through the use of the art materials at a pace that was comfortable for them, in a space that was containing and supportive. Bongani went from being a powerless figure who was "rooted to the spot" to a boy who was able to look at, verbalize, face, and conquer his fears in a dream. He became the spokesperson for the group and for the members who were yet to find their voice.

Xolani seemed to have been waiting for a space that could contain his horrific secret, his "explosion" of the truth. He was finally able to share this through a simple image. He later shared the other losses in his life.

Emarentia took time to "own" her awful situation, first presenting an ideal world. Eventually, she found that there was sufficient space in the group for her to think, work through her situation, and find the words to communicate.

I believe that this group provided a space that gave all members sufficient room to begin thinking and that the use of the art materials added to this feeling of space as the pressure of the spoken word was taken away. They were all able to share the "unspeakable," and the acknowledgment of this helped them find the words and, therefore, their own voices.

Debra Kalmanowitz and Bobby Lloyd (1999), following their work in the former Yugoslavia, wrote about the pervading sense of emptiness they were often left with, feeling that what they had to offer was not "good enough." They stressed that the art sessions could not and should not attempt to fill this gap. They realized that they had a responsibility to bear witness to the individuals they met and worked alongside. The art sessions needed to serve as a container strong enough to hold whatever arose. In this way, the act of witnessing became an active intervention.

Winnicott (1971) wrote about the need for the doctor to be "a sympathetic witness to the child's distress," saying that the "unanxious recognition" of a child's situation or pain, is in itself an intervention. He speaks about an "appreciative understanding" of the child's situation. He looked for what was in a child, waiting for acknowledgment.

Malcolm Learmonth (1994) speaks about "active inactivity" as being a vital part of the therapy process, whereby what is required is the total presence of the therapist so that he or she might see and hear all that is being shown and verbalized. He goes on to say that, for many, the experience of being witnessed and believed when telling one's story is therapy in itself. The client needs to know that he or she is being seen and heard.

Like Winnicott, he says that recognition and understanding of the situation by another is an intervention. Learmonth stresses that a "pre-condition of witness is presence." The therapist needs to be acutely alert in order to be truly present and engaged in listening.

Additionally, the therapist needs to avoid filling the space that is being offered to the client. The client needs this space to truly "be." A client who has been traumatized often feels flooded by the trauma and, in this way, becomes the trauma. Intrapsychic space that has not been flooded by the trauma must be accessed (Harper, 2001).

In art therapy, there is the image or object to be focused on by both client and therapist. This is often less threatening for the client in that the focus is taken off him or her personally, and they are able to externalize manageable bits of the trauma. In this sense, they become witnesses together of both the finished art image or object, and the actual process of art making.

It is incredibly hard to bear witness. Therapists, in order to feel better and possibly to screen out the horror of feeling helpless and "not knowing," will often become "overly helpful, clever and/or pathologizing" (Harper, 1999). In this way, the therapist "reconfirms his/her role" (Harper, 1999). This is particularly evident with clients whose situations do not seem to change or, indeed, get worse.

Blakeway (1995), stresses this by saying that we are not here to "help" our clients, but rather to "bear witness." He goes on to say that it is much harder to bear witness than it is to be helpful. Being helpful makes both the client and ourselves feel better for a while. Conversely, bearing witness could very well make both the client and the therapist feel worse in the short term. Most often, the client feels a sense of helplessness. Providing help to the client is a way of perpetuating this sense of helplessness.

Winnicott stressed the importance of having no easy answers, of "not knowing," and being able to tolerate that. In the art therapy groups, there are certainly no easy answers for either the children or me. With difficulty, I have come to accept that I cannot change situations or make it "all better." What I can offer is a relationship and a space that is both therapeutic and co-constructed. In this space, I can accompany the children on their journey as they begin the process of rediscovering themselves.

When working with art materials or playing, a transitional space is created, which will, one hopes, enable the client to rediscover the self. As Winnicott (1971) says, "It is in playing and only in playing that the individual child or adult is able to be creative and to use the whole personality, and it is only in being creative that the individual discovers the self."

In doing so, the children should begin to feel more alive as they get in touch with their creative selves and those parts of themselves that have not been impinged upon by trauma. It is hoped that the wide array of art materials, as well as the "permissive environment," will go a long way in helping them do this.

It is vital for therapists to work through their own processes as well. Understanding one's own needs and responses to the work is imperative in preventing conditions such as vicarious traumatization or burnout. Vicarious traumatization refers to the "cumulative effect of doing trauma work across clients" (Pearlman and Saakvitne, 1995), and to its "pervasive" impact on the therapist.

Shirley Hoxter (1983) asks how therapists can "bear to be aware of such pain" and questions whether we can maintain our sensitivity without being completely overwhelmed. When I read or hear of a pervading sense of helplessness or

emptiness felt by therapists working with traumatized children, I feel enormous relief. I often feel not only emptiness but often a sense of hopelessness.

It is easy to feel hopeless, disappointed, and even cynical when the vast majority of people living in South Africa still live in abject poverty. One needs to remember that real change takes decades to occur, and alleviation of poverty is on the agenda of many leaders.

It is, therefore, important for me to remember what the groups can offer the children. It is here that many of them seem to find it permissible to think about and attempt to make sense of their awful circumstances. It is here that they learn to listen to and support one another, and to begin to respect both each other and themselves. Most importantly, this is their group—and they do the "work". All we do is provide a framework and bear witness to their journeys, journeys they must begin in order to move away from their painful past and present into a future that offers more possibility.

References

Blakeway, A. (1995). *Holding, Containing and Bearing Witness: The Problem of Helpfulness in Encounters with Torture Survivors.* London: The Medical Foundation.

Gibson, K. (2000). *Addressing Childhood Adversity.* Donald, D., Dawes, A. and Louw, J., Eds. Capetown: David Philip.

Gibson, K. and Swartz, L. (2000). Politics and emotion. *Psychodynamic Counselling,* 6, 2, 13–153.

Harper, E. (1999). The gift of empty space. Paper presented at the Eighth International Symposium on Torture, New Delhi, India, September 1999.

Harper, E. (2001). Personal communication.

Hoxter, S. (1983). *Psychotherapy with Severely Deprived Children.* Boston, M. and Szur, R., Eds. London: Routledge.

Kalmanowitz, D. and Lloyd, B. (1995). Personal communication.

Kalmanowitz D. and Lloyd, B. (1999). Fragments of art at work: Art therapy in the former Yugoslavia. *The Arts in Psychotherapy,* 26, 1, 15–25.

Learmonth, M. (1994). Witness and witnessing in art therapy. *Inscape,* 1, 19–22.

Pearlman, L.A. and Saakvitne, K.W. (1995). *Trauma and the Therapist.* London and New York: Norton.

Phillips, A. (1988). *Winnicott.* Cambridge: Harvard University Press.

Westaway, J. (1993). Post-traumatic stress disorder in a group of sexually abused children. Unpublished M. Phil. thesis. University of Cape Town.

Winnicott, D.W. (1971). *Playing and Reality.* London: Routledge.

From a Different Place: Confronting Our Assumptions about the Arts and Social Change

Judith Beth Cohen and Frank Trocco

> We yearn for freedom… freedom to think, freedom to move, to express ourselves and to be understood. We can find this freedom through the creative arts. (Ibdad, undergraduate student from Saudi Arabia)

As contributors to this volume, we share the assumption that art can create social and cultural change. We all see students whose artistic efforts are flashes of innovation, and we read stories in the national press about artistic production healing social ills. These connections become strained, however, when Western ideas about art are confronted by students from non-Western cultures. Often, we see art's apparent power to transform and transcend carefully retailored, with the results defying straightforward assessment.

Women in the Islamic kingdom of Saudi Arabia live as second-class citizens; they cannot participate in public life, and when outside the home, they must be veiled and cannot drive automobiles. Though education became available to girls in 1956 and women were admitted to universities in 1964, colleges are strictly segregated. Until very recently, the government defined women's educational needs as preparation for the roles of wife and mother or for activities "that suit her nature," such as teaching, nursing, and medicine (Brooks, 1995, p. 149).

Transcending these limits, a number of women from Saudi Arabia have been completing degrees at Lesley University in Cambridge, Massachusetts. Though Saudi men can study abroad at government expense, such scholarships are not available to women. Not only are government scholarships unavailable to women, according to our students, the publicly available instruction that exists

is centered on rote learning and memorization. Because some Lesley programs do not require full-time residency in the United States, students like these are able to maintain their domestic responsibilities at home while working toward an American degree.

Lesley's adult pedagogy is based on a close educational collaboration among teachers, students, and peers and owes much to Dewey's conception of education as a continual process of reorganization, reconstruction, and transformation. Central to this approach is hands-on experience and the development of critical and reflective thinking skills (Dewey, 1916).

Building upon the democratic principles that Dewey stressed, we also subscribe to Mezirow's (1991) theory of transformative adult learning, which posits that a disorienting dilemma leads to self-examination, a critical recognition of one's assumptions, and, ultimately, to changes in both perspective and behavior. We align ourselves with educators who favor educational practices that promote the participant's liberation from oppressive power relationships and the creation of social justice (Freire, 1970; Giroux, 1992; hooks, 1994). We view adult growth and development as a continuous spiral throughout the life span with individuals moving toward more complex ways of knowing and meaning-making (Belenky, et al., 1986; Daloz, 1999; Kegan, 1982; Perry, 1968).

Finally, we offer an interdisciplinary curriculum in which the arts are an essential component of an undergraduate degree. Like Maxine Greene (1995) and others (Perkins, 1994; Gablik, 1991), we regard the arts as a vehicle for accomplishing personal and, ultimately, social transformation.

Our work with Saudi Moslem women has challenged some of these theories as well as the teaching methodologies derived from them. Can our student-centered, "emancipatory" pedagogical approach be applied to women from a closed Islamic society? For more than a decade, we have watched these women find culturally discrete ways to apply the arts toward social change in their own country. In the following case studies, we examine the projects of two of these adult women. Through their examples, we hope to expand our understanding of how art and social change interact in one particular non-Western culture.

From the very beginning, we found ourselves questioning our own assumptions about freedom, oppression, and pedagogy when working with women from an Islamic state in which women lack legal status. One Saudi student, asked by her faculty advisor to put more of her own "voice" into her writing, challenged us by asking, "Don't you think that your demand is extrapolated from a Western model of culture?" She pushed us to wonder if our very vision of art as a vehicle for expanding consciousness and minimizing oppression is a Western construct.

Given the so-called clash of civilizations symbolized by the events of September 11, 2001, our need to understand the Arab world is urgent. As we embarked on this project, we wondered if we, as white Westerners, could render these women's experiences accurately, and avoid the Orientalist tendency to make them into the exotic "other" (Said, 1978). We came to regard ourselves as collaborators in a mutual exploration. In the process, we questioned and revised our own premises about adult pedagogy and about Islam.

Just as our students cannot be reduced to the oppressed, veiled stereotypes represented by our media, we are not merely a Jewish-American female and a Catholic-American male. By the same token, we cannot be pigeonholed with the shibboleths of, "materialism, liberalism, capitalism, individualism, humanism, rationalism, socialism, decadence, and moral laxity" (Buruma and Margalit, 2002, p. 4) associated with Westerners. Our multiple identities are contingent upon our contexts. Thus, we approach this project not as scholars of Islam or the Middle East but as adult educators, self-defined as learners along with our students.

We hope that the traditional power differential between researcher and object of research or professor and student is mediated by our own ignorance and curiosity. We neither expect our Saudi students to create a social revolution in their home country, nor would we necessarily want them to. They can and do challenge the repressive social situations they experience in their communities in ways that effect subtle but potentially long-term change. They begin to challenge societal norms through their participation in an interdisciplinary adult educational model in which the arts are integrated into their academic programs.

Our Saudi students have shown us that art, as Australian critic Robert Hughes (1986) suggests, "works like a mole below the surface of social structures" (p. 226). In cultures like Saudi Arabia's, its effects may emerge long after the art itself has been made. In a University of Iowa speech, Hughes argued that Americans share the belief that art must be morally therapeutic, inherently spiritual, and above politics; however, he sees such moralizing as a product of American provincialism. "That people are morally ennobled by works of art is a pious fiction" (p. 220), he asserts. "No painting ever saved the life of a single Jew or a single Cambodian; but in a more circuitous way, art can still be said to create models of dissent, not collectively but individually" (p. 226). The very concept of the avant-garde began as a military metaphor coined by Saint-Simon in 1825; it was from this notion that the idea of art leading the masses to new ideas developed (Hughes). It may be a myth that art can implant radical ideas in the social consciousness, but our Saudi students demonstrate that the creative vision can work quietly and cleverly to advance social change.

I believe that the arts serve as a methodology or strategy for learning. They help to expand traditional teaching methods into a fascinating and imaginative forum for exploration of subject matter. (Ibdad, personal communication, September 25, 1999)

During her studies at Lesley, Ibdad, a primary school teacher, experienced a deep socio-cultural conflict when she was exposed to feminist pedagogy. Reading *Women's Ways of Knowing* (Belenky, et al., 1986) moved her to gasps of recognition as she identified herself as a member of the group that the authors call "the 'silenced' women." While this book helped Ibdad view her own development from a different perspective, her personal discoveries led us to question the wisdom of pushing all students to apply this developmental model to themselves. We may believe that such critical reflection inevitably leads to change in the status of women, yet Ibdad warned her impatient teachers that change would take time, perhaps measured in generations, to come about, saying, "I am a woman from a different place, where we have been subjected to centuries of suppression that has left its distortions and scars on our psyches."

We might be tempted to view her situation as parallel to that of blacks living in the segregated South, but there is a critical difference. Growing up in that repressive time, musicologist Bernice Reagan Johnson, founder of the African American a capella group, Sweet Honey and the Rock, was always aware that breaking the culturally imposed silence surrounding the oppression of blacks was so dangerous it could lead to her death (O'Brien and Little, 1989). Yet, our disfranchised, veiled students, albeit from a privileged Saudi social class, seem confident and fearless, embracing their ability to circulate in multiple communities, unlike historically oppressed black women in America.

For her bachelor's thesis, Ibdad designed an integrated creative arts curriculum that included visual art, drama, music, storytelling, and movement for the elementary school where she taught. In a country where mathematics and humanities are the dominant school subjects and the visual arts are marginalized, this was a courageous project. As Ibdad makes clear, "Classroom teachers, pressured to teach traditional basics and to make certain that their students excel on standardized tests, sometimes view the arts as frivolous, distracting students from the real and important learning that is the main and required business of education."

Art forms in Saudi Arabia have been limited by the principle of aniconism, a religious prohibition against representing any living creature by painting, sculpture, or other means. This stems from the Islamic belief that only God can create life. Like the Jews, Moslems are concerned that people will worship images

rather than God, so such restrictions also serve to prevent idolatry. When Mohammed conquered Mecca, his armies destroyed both pagan statues and representations of God (Janin, 1994). Given this prohibition, the spoken and written word, the art of calligraphy, and beautifully designed functional objects have predominated in Saudi art.

Art education has also been limited in Saudi Arabia. As Ibdad affirms, "For years, few qualified art teachers have taught in our public schools. Anyone in the school could be assigned to teach arts, regardless of their qualifications." Regardless of this, she has been determined to "move the arts from the peripheral to the central place in the classroom." With this resolve as a guide, Ibdad used movement and dance to bring life to classroom storytelling and to instruct the children about the body and its parts. She employed music to help her students think about mathematical relationships, and the visual arts to "captivate the children's attention" when teaching about the subjects of architecture and religion.

Ibdad realized that educational reform was necessary to cope with the modern world. She knew that a more creative approach would engage her students and that "integrating the creative arts throughout the school curriculum can create magic in the classroom." She fought for overarching, substantive revisions and succeeded in implementing the arts curriculum developed in her thesis project into her school. The Saudi Ministry of Education is in the process of reviewing the national curriculum for the long-term purpose of reform, and Ibdad's institution is being used as a pilot school by the government. Perhaps this could lead to a commitment to the arts as strong as Ibdad's. "When I taught these subjects I noticed how the children's eyes lit up," she says. "I felt that now they had something with essential substance."

Sulim, another Saudi student, demonstrates that working with one's own story can lead to deep self-reflection, the construction of new knowledge, and, ultimately, social activism. Writing a memoir, along with the subsequent research she undertook, gave her the tools for becoming an activist on behalf of deaf children and their families. As the mother of three hearing-impaired children, living in a country that has few services for individuals with disabilities, Sulim was hungry to learn. Urged by her faculty advisor to begin with her own life, she wrote a narrative about her experience as the mother of deaf children. In a hierarchical, family-oriented society like Saudi Arabia, mothers turn to older relatives for advice, and questioning their authority is considered improper. Literature that focuses on mothers has been rare, even in the West, until very recently. In feminist narratives, the daughter's story is often told while the mother is silent.

Giving voice to maternal experience can make an important contribution to the dominant discourse (Hirsch, 1989).

Sulim's work in personal narrative writing led her from self-expression to becoming an agent of change. In her process, she moved from a personal question, "What does this mean for me?" to a question with more universal ramifications, "What does this mean for other parents and children?" Such questions are often a first step toward activism (Cohen, 1991). Sulim's memoir became a "narrative of resistance" (hooks, 1994), as she put her experiences into words, then researched the information she needed and reached out to others beyond her own community. Since the act of writing disrupts the calculations of power and knowledge, Sulim, with her language skills and her membership in overlapping communities, was practicing what Middle Eastern scholar, Miriam Cooke (2001) calls "multiple critique" (p. 107).

A self-identified religious Moslem woman, Sulim was educated in France and is fluent in English. Her language skills gave her access to multiple discourses and communities. Through reading Western books by parents of handicapped children, she saw that she was not alone. Though she had the financial means to find resources for her own children in Europe and the States, her convictions as a Muslim gave her the moral vision to help those at the bottom of society. In 1997, when she undertook her project, she described her culture as a "closed society where appearances are important..." where many "conceal children's handicaps," and "the deaf are not accepted at universities" (Sulim, personal communication, September 29, 1999). When she sought speech therapy for her deaf child, she found that rehabilitation services "were in their infancy," and the only deaf educators available were Lebanese or Egyptian. She also found that no official sign language existed, and though deaf children naturally develop and teach each other a creolized sign language, they encounter prejudice when they use their hands to communicate.

Despite the presence of many deaf relatives in their family and the fact that she married her mother's cousin, neither Sulim nor her husband had attributed their first-born son's hearing loss to genetics. Such a topic was never mentioned in the family. When she finally consulted a geneticist and learned that the condition was caused by an autosomal recessive gene, it was a revelation to her. Further research revealed that 66 percent of hearing loss in her country was hereditary due to consanguineal marriage. Though neither she nor her husband had hearing problems, they were carriers of the gene and thus had a 25 percent chance of having a deaf child. Her research also revealed that otitis media,

inflammation of the middle ear, is common in Saudi Arabia because sand in babies' ears can lead to inflammation. The misuse of antibiotics in a weak health-care system also contributes to childhood hearing loss.

Though Sulim understood that her next child might also be deaf, she and her husband went ahead with another pregnancy. In her narrative, she relates this decision with humor, a literary device that gives her ironic distance on her own situation and allows her readers the aesthetic pleasure of comic relief. She describes asking her deaf son, "How would you feel if the baby had your hearing problem?" He replied, "We would have to buy so many batteries we might run out of space in the refrigerator," he replied. In a further example of her ability to note the humor in a painful situation, she movingly describes her older son's joy when he got his first hearing aid, and assumed it helped her as well. Over and over again, he asked her, "Can you hear me? Mama, can you hear me?"

With the birth of her second son, Sulim lived in suspense, waiting to see if he, too, would be deaf. She shares her anxiety with readers, viewing her own behavior with wry humor. For example, in one passage she writes, "The next couple of months were pure torture, not knowing if he were deaf or not. It is a wonder the child did not lose his mind. I crept up behind him, banged pots and pans, yelled his name and startled him in his sleep."

After researching the causes of deafness and learning about the powerful, self-assured deaf community in America, Sulim decided to seek out the mothers of deaf children in her country, including desert-dwelling Bedouins. Although her affluence and social class had formerly given her little opportunity to mix with tribal people, her experience of raising deaf children provided a connection that cut across rigid class barriers. Narrative writing served as the vehicle through which she documented her encounters with these women, telling their stories in their own words. Carrying out this project allowed her to transgress the gender norms of her culture, but she accomplished this while maintaining her role as a good wife and mother.

Sulim then set herself the goal of empowering parents of deaf children by writing a book that would share her personal experience and knowledge and help them to become advocates for their children. In referring to the book, Sulim said, "Parents will identify with the anxiety I experienced. I describe my pain and the grief process I went through as I slowly began to accept my child's deafness" (Sulim, personal communication, September 29, 1999). She suggests methods parents can use to overcome both their fear and their fatalism. For example, she explains that she communicated with her son in the darkness by placing his hand

on her throat so he could understand her through tactile vibrations.

Though Sulim's project conflicts with neither her religious beliefs nor her gender role, her work helps to redistribute power away from the theocratic state into the hands of individuals. Her work challenges the notions that deafness is God's will and that we must accept a given destiny. From her research, Sulim compiled a needs assessment report that urged her government to improve services for the deaf. Ultimately, she was determined to create a quality service commensurate with American Speech and Hearing Association Standards. Today she helps run the Institute that she initiated, the only one of its kind for educating hearing-impaired children in Jeddah. Like the other women in this study, Sulim works toward reform from within her culture. Almost invisibly, she rejects the dominant discourse on deaf children and advocates for the inclusion of mothers in their education, while remaining within the sanctioned role of nurturing mother and observant Muslim. By telling her own story and reaching out to others, she slowly transforms her society without being openly oppositional.

What do we learn from Sulim's story that can inform our own thinking about education, the arts, and social change? First, we can recognize and honor the powerful tradition of women as storytellers in Arabian culture. We remember that it was through her narrative gifts that the Princess Sheherezade kept herself alive (Wiebke, 1993). If writing and other forms of storytelling can be a source of power for women, then certainly the narrative arts can be encouraged in education for social change even when our students are orthodox believers. The existence of outspoken women within traditional religious practices may seem oxymoronic, but Cooke (2001) argues that the act of writing creates a transnational identity even for traditionalists.

Cooke (2001) also rejects the idea that an organic link between our birthplace and our language creates our identity. She argues that no one has a fixed, essential center or single, foundational identity. Even fundamentalists like the Saudi preacher Fatima Naseef claim that the primary role of wife and mother can give way in a state of emergency and that all Muslim women have the right of jihad or struggle. This notion itself implies some identity fluidity (Cooke, 2001). Cooke further argues that the role of wife and mother in Islam entails a religious and political activism that cannot be confined to the home, contrary to the practices of the Taliban regime. Finally, she points out that such a "linking of apparently mutually exclusive identities can become a radical act of subversion" (p. 60).

Despite Islam's well-known proscriptions on women's freedom, Muslim lit-

erature contains other contesting images of women. There are references to islands inhabited and ruled exclusively by women (Cooke, 2001) as well as to the fact that at the time of the Prophet Mohammed (seventh century), women played important roles even in battle. Despite the limits on women mentioned in the Qu'ran, the text also stipulates many rights unavailable to European women at the time of its writing, such as the right to own and inherit property, pursue knowledge, and express opinions (Ati, 1998). Husbands were urged to give their wives sexual pleasure, surely not a concept present in Medieval Europe when these tenets were instated. Subsequent doctrinal divisions and debates led to the erosion of these rights, and more restrictions were encoded in later writings. Most scholars agree that the veiling and sequestering of women originates in pre-Islamic tribal practices that were simply continued. Thus, the story of women in Muslim societies is far more layered than the sad fate of women under the Taliban in Afghanistan would indicate and suggests that it is possible to maintain traditional female roles while being revolutionary. If educators oversimplify the lives of women in Islamic countries without contradicting media stereotypes, which are fueled by biased political agencies, their students will simply adhere to a shallow official view.

In our eagerness to honor and celebrate multiethnic art and culture in our teaching, it is necessary to avoid seeing our students as interesting cultural artifacts, a trap we might have easily fallen into when we first encountered our Saudi students. When we view students primarily as types of an ethnic group, race, sexual preference, or social class, we are in danger of reducing them to an essential identity and, thus, silencing them. As they begin to write, study, and reflect, even students from extreme right-wing or fundamentalist groups will inevitably take on a plural identity, which can lead to what Cooke (2001) calls "multiple consciousness," similar to what Belenky et al. (1986), refer to as "constructed knowing" and what Mezirow (1991) labels "critical reflection." Sulim and the other women we have interviewed exemplify those who "remain in the community. . . even when (they) criticize its problems" (Cooke, 2001, p. 113). Studying in a Western setting, they are able to form alliances and network outside their home base. Their actions may lack the drama and visibility of campaigns promoting Saudi women's right to drive or vote, but they are nevertheless helping to reshape the image and status of Muslim women and, ultimately, their societies (Cooke).

In our most recent communication, Sulim writes that she has been "appointed to the first ever committee in Saudi Arabia for the training and employment of women," created by royal decree to speed up the process of women entering

the work force. She has also helped found a nonprofit society dedicated to preserving Arabia's textile heritage. In addition to collecting the traditional dresses worn by the Bedouin tribes, this group has hired a dozen deaf girls to reproduce traditional embroidery and create items that can be sold. She ends her message this way: "So many changes need to happen down here.... Let us hope that the world will move toward building bridges between cultures and civilizations rather than talk of wars between them. If you and I can care for and respect each other, then so can all the others" (Sulim, personal communication, January 5, 2002).

Conclusion

Our American fascination with the exotic and our concern about social issues within Islam reveal much about our own collective worldview. A Lesley student from Somalia who grew up in the United States but decided to adopt traditional dress as an adult explained her decision this way, "I used to see the hijab as a sign of women's oppression before I researched the reason why Muslim women wear it. My decision six years ago has not hindered me from holding a professional job or being taken seriously as a student. By wearing it, a woman sends out a message that she has no need or desire to be physically attractive" (Kamsa, personal communication, September 26, 1999).

For this American Muslim woman, the veil, rather than limiting her, gives her greater freedom. In a similar paradoxical example, two American professors teaching at universities in Singapore and Malaysia found that educational practices we might regard as colonialist had been claimed as their own by the indigenous cultures. When these instructors introduced the more "progressive" method of refusing to evaluate students on their final exam performance alone, their students complained that they were imposing the "American style" on them. Based on their experience, these colleagues caution against repeating imperial scripts of domination or paternalism in the name of changing selected power relationships (Robertson and Martin, 2000).

Many of us passionately believe that art can transform and transcend social inequities, initiate educational reform, and improve historically unjust conditions. Although art may hold some revolutionary edge in non-Western cultures, our case studies demonstrate that we cannot rush the rate of change, rely on Western models, nor consistently expect to see what we recognize and value. Though it may be difficult to set aside our epistemic privilege, we must accept social adaptations on their own local terms. As educators of a multicultural,

international population, we can listen to our students and try to view the world through their eyes, so that our attachment to emancipatory artistic pedagogies does not become more oppressive than liberating.

References

Ali, W. (1997). *Modern Islamic Art: Development and Continuity.* Gainesville, FL: University Press of Florida.

Ati, H.A. (1998). *Islam in Focus.* Beltsville, MD: Amana.

Belenky, M.F., Clinchy, B.M., Goldberger, N.R., and Tarule, J.M. (1986). *Women's Ways of Knowing: The Development of Self, Voice and Mind.* New York: Basic.

Brooks, G. (1995). *Nine Parts of Desire: The Hidden World of Islamic Women.* New York: Doubleday, Anchor.

Buruma, I. and Margalit, A. (2002, January 17). Occidentalism. *The New York Review of Books,* 49(1), 4–7.

Cohen, J. (1991). Confronting ethical issues. In *How Writers Teach Writing.* Kline N., Ed. New York: Prentice-Hall.

Cooke, M. (2001). *Women Claim Islam: Creating Islamic Feminism Through Literature.* New York: Routledge.

Daloz, L. (1999). *Mentor: Guiding the Journey of Adult Learners.* San Francisco: Jossey-Bass.

Dewey, J. (1916). *Democracy and Education.* New York: Macmillan.

Freire, P. (1970). *Pedagogy of the Oppressed.* M.B. Ramos, Trans. New York: Herder and Herder.

Gablik, S. (1991). *The Reenchantment of Art.* New York: Thames & Hudson.

Giroux, H. (1992). *Border Crossings.* New York: Routledge.

Greene, M. (1995). *Releasing the Imagination: Essays on Education, the Arts and Social Change.* San Francisco: Jossey-Bass.

Hirsch, M. (1989). *The Mother Daughter Plot: Narrative, Psychoanalysis and Feminism.* Bloomington, IN: Indiana University Press.

hooks, b. (1994). *Teaching to Transgress: Education as the Practice of Freedom.* New York: Routledge.

Hughes, R. (1986). Art and politics. In *Human Rights/Human Wrongs: Art and Social Change.* Hobbs, R. and Woodward, F., Eds. Des Moines: University of Iowa Museum of Art Press.

Janin, H. (1994). *Cultures of the World: Saudi Arabia.* North Belmore, NY: Marshall Cavenish.

Kegan, R. (1982). *The Evolving Self: Problem and Process in Human Development.* Cambridge, MA: Harvard University Press.

Mezirow, J. (1991). *Transformative Dimensions of Adult Learning.* San Francisco: Jossey-Bass.

O'Brien, M. and Little, C. (Eds.). (1989). *Reimaging America: The Arts of Social Change.* Philadelphia: New Society.

Perkins, D. (1994). *The Intelligent Eye: Learning to Think by Looking at Art.* New York: Getty Trust.

Perry, W.G. (1968). *Forms of Ethical and Intellectual Development in the College Years: A scheme.* Austin, TX: Holt, Rinehart & Winston.

Pope, H. (2002, January 2) For Saudi women, running a business is a veiled initiative. *Wall Street Journal.*

Robertson, E. and Martin.B.K. (2000, March). Culture as catalyst and constraint: Toward a new perspective on difference. *College English,* 62, 4, 492–509.

Said, E. (1978). *Orientalism.* New York: Random House.

Sheets, H.M. (2001, November 25). Stitch by stitch, a daughter of Islam takes on taboos. *New York Times,* 33.

Wiebke, W. (1993). *Women in Islam from Medieval to Modern Times.* New York: Marcus Weiner.

CHAPTER TWELVE

Women's Craft Cooperative: Crafting Lives

Barbara Summers and Alev Danis

This chapter demonstrates the success of the Women's Craft Cooperative (WCC) in providing its members with a supportive program and the necessary tools to move toward economic independence. The WCC is not based on a formula; rather, it is tailored to each woman's individual needs and builds on talents and creativity. The chapter will describe how creativity can radically change people's self-perception, increase their self-confidence, and provide them with a firm basis from which to explore avenues of development that previously seemed unattainable. Many women in the program have received negative messages throughout their lives, which have diminished their feelings of self-worth. As each woman progresses through the WCC, she learns she has a unique vision and is a creative and productive individual.

> Being part of the WCC is great and has made me feel more worthwhile than I have felt in a long time. The sharing and inspiration and laughter as we create beautiful objects and watch other people buy and enjoy is wonderful. —Elizabeth

The origin of a vision is often a very simple idea. This vision was no different. There were many programs available to provide job training to disadvantaged women, but there was no program in the Boston area where women could learn and implement the skills needed to develop a positive self-image using the arts and creativity. If such a program could be structured, combining these aims with concrete achievements and skills, it would provide the tools women would need to begin the journey to positive self-identities. Thus, the Women's Craft

Cooperative (WCC) was born. We have always tried to listen to and respond to the women's voices. It is with this conviction that we have turned to the women for their reflections and insights. Their direct quotes are woven throughout this chapter.

The WCC, a program of Rosie's Place, provides poor and homeless women training to design and craft jewelry, and at the same time provides basic job-readiness skills. By designing and creating the brooches and other products, each woman very quickly witnesses her artistic achievements. The most important aspect of the training is that the women begin to see themselves as creative individuals and not simply as poor and homeless. For many of these women, their identities have been linked to less than positive personal and social identities. To be able to see oneself as a craftsperson, in a positive light, rather than poor, homeless, mentally or physically challenged, unemployed, or HIV positive, is a huge leap in their self-perception.

> This is the first time I have had a job where I could relax, and still do my job and give my best...this is the first time in my life I feel free. —Laura

A shared commitment to disadvantaged women as well as strong interests in the creative arts led the authors to form a partnership and develop the WCC at Rosie's Place. After meeting with a number of Boston shelters and care providers, it soon became clear that the following basic elements were necessary to incorporate into the program: (1) a steady, safe and supportive environment, (2) an avenue for creative self-expression, and (3) a means to provide income to the participants. It was essential that the product and any future products would be marketable with competitive prices, well designed, and of good quality.

After putting together a business plan that incorporated all these aspects, we approached Rosie's Place (the oldest women's shelter in the country). We had a number of meetings with the executive director to clarify our goals and to look at additional sources of funding. One of the results of these meetings was a $15,000 grant from Conrail. To make sure we were on the right track with the merchandise, we provided prototyped samples of the button products to potential retailers in order to get their feedback. This proved invaluable when we began marketing the WCC products.

Looking over the original business plan today, it is gratifying to see how close we have come to our goals and aims: to teach each woman how to design and create a good quality pin, to teach all aspects of merchandising, to create the opportunity to earn a weekly paycheck, to increase each woman's sense of self through positive achievement, to provide additional job skills as needed or

requested by the women, and to generate profits to benefit the WCC members and offset a portion of the program costs.

Once we had a viable business plan, Rosie's Place took the leap of faith with us, and the WCC was in action. Our beginnings were very humble. In September 1996, we launched the WCC with an immediate target of designing 200 brooches to sell in six weeks for the annual Rosie's Place major fund-raising event.

The first group started with 12 participants who designed and produced brooches after a brief but intensive training period. Our first and most critical event was a great success, both financially and psychologically for the women. Coupled with this was the astonishment and pride that the women expressed at seeing their creations admired and bought. Subsequently, the women began to take their work more seriously and understood that when we referred to them as craftswomen, this was not empty praise but was based on actual achievements. Added to this was the financial success of selling $4,000 worth of brooches.

> I did not think that the jewelry would be on display at such special places. That makes me feel good because I know I'm a part of it whether it's my bracelet or someone else's bracelet, I just know I'm a part of it. It's like all of us did the bracelet together, even though the individual did it. —Evelyn

Collaboration is a very important aspect of the training within the WCC and one of the fundamental reasons for the success we have achieved. As a result of group discussions with the women, we developed many training courses, including sales, team building, communication skills, design workshops, financial planning, and tax workshops. Classes still play a very important part in each woman's development, and through a scholarship fund at Rosie's Place, we are able to provide payment for a range of classes at adult education programs and art schools. These are of great benefit to the women, 90 percent of whom have utilized the scholarship funds for classes in which they have learned to incorporate new skills and inspirations into their work and personal lives. To provide ongoing feedback, each woman's products are inspected for quality of design and production at least twice a week, and techniques are critiqued, always in a positive and supportive way. In addition, there is a yearly comprehensive performance evaluation based on the successful Rosie's Place employee model, along with a personal development plan for each member.

> Oh, I think I have become a lot more confident, a lot more assertive, more of a risk taker, in every way. And that's because Barbara and the people have encouraged me and also sent me to classes. Another thing they do is send you to all kinds of classes. That has

broadened my horizons too. In those classes, I have learned to be assertive, how to read people, how to get things done in a nice manner. And I have met a lot of people here that speak up, so I have taken a page from their book. They let me know it's okay to speak up, not to let people step on me. —Elizabeth

Many of the women had not worked for a number of years and had had psychological and physical problems that prevented them from obtaining or maintaining a more traditional job. One of the first challenges we faced was to provide an agreed-upon method of conflict resolution. Since the women's personal issues can spill over into the workshop, one solution that evolved over the years was to implement a formal interview and screening process as a way to minimize foreseeable conflicts when selecting new trainees.

I enjoy working with the others and showing them what I am working on…love the job, the people, the bosses, the atmosphere…before WCC I hadn't been working, and it feels good to be going to work; everyone is very nice. —Mary

Another source of assistance to the program and a positive influence on the women are the many interns who have been involved. Through their fresh ideas, dedication, and enthusiasm, the program has been able to achieve a higher level of success. Our most recent intern, Mandy Clark, has assisted in the interviewing and the transcribing of the women's quotes in this chapter.

Program Influences and Personal Impact: Developing a Positive Self-Identity as a Craftsperson

As part of the process of designing and executing a piece of work, each woman initials the back of the product. This is something we implemented in the very beginning of the program to help each woman identify with what she was creating. Some women were better designers, and a number of women proved to be more proficient in technique and implementation of a design. Everyone, however, reached a point of being able to create a finished work. Over time, the women began to see themselves as craftspeople, which was significant for them in cultivating a more positive sense of self.

I really believe in our work, so I guess it comes across. I do love all the products that I make. It gives me a lot of pleasure to find someone who is going to like them as much as I do….It has opened a lot of windows. I think my family is pretty proud of me now. —Elizabeth

Presentation and marketing of their work in a professional manner were critical to making the whole concept real to the women. We took great care in devel-

oping a tag to attach to the items that identified both the program and artist. One of the main struggles of being homeless is the loss of identity and purpose. At the heart of our philosophy was the concept of using the creative process as a vehicle to create identity and pride.

The marketing and selling of the products created by the Women's Craft Cooperative provided a platform where the women could see how much their work was appreciated and valued by the public. From the beginning, the women have had the opportunity to be involved in the selling, as well as development, of new products, such as barrettes and bookmarks. By receiving customers' positive feedback on their work firsthand, identifying themselves as crafters and productive individuals resonated with each woman.

> When you get a letter from somebody that says that they really enjoyed your work and they thought it was wonderful, it just gives you a nice feeling to know that you really did something good....It's a good feeling to know that you have accomplished something and somebody else likes it. And I think all the other women like it too. It's a good self-esteem job.—Laura

Learning through Mentoring

When we started the practice of peer mentoring, we observed that women transitioned more easily into the program than when the staff trained several women at a time. Early on, we found that having a long-term, seasoned member of the craft cooperative act as a mentor created a greater comfort level for a new woman just coming into the program. Within this one-on-one relationship, the mentee would seek out suggestions and feedback and would accept criticism more readily.

In addition, the opportunity to serve as a mentor provided a positive opportunity for a seasoned member to exhibit leadership skills, boosting their self-esteem.

> I think Elizabeth [Leslee's mentor] affects my creative process on so many levels. You know she brings a lot of variety in her design perspective. She has been very entertaining; I really enjoy her. The vibe she's into has really affected me. —Leslee

Creativity

Most of the women in the program had never been in a work situation that allowed them to think of themselves as creative. Our approach was built on the premise that creativity was not only something you did but a way of thinking and putting something together that "worked." Whether it was a design or an

idea, it was a form of problem solving. Everything the women made was from buttons, but each design and product involved choices and critical thinking. As each woman became comfortable with the fundamental elements of product construction, she would gain confidence to develop her own style of design.

Some women have found it stressful to develop their own designs and preferred to work on standardized designs that we created for them. We feel that it is important to meet a woman at her individual ability level and try to draw on her strengths. In order to have a product that would be easy for those women who lacked the dexterity or attention to do the more complicated design work, we developed a product (a bookmark) that they could easily make. This approach has proved to be successful at all levels, allowing all the women to feel they are important and creative as contributors to the success of the Women's Craft Cooperative.

To further support creativity, we offer workshops in design, color, elements of product design, and marketing. We present these classes in an open format that encourages the women to develop their own instincts and to become more aware of design in everyday life. The women's contribution of ideas has been significant in the development of many of our products.

> ...Once I got involved, I saw the beauty coming out of these buttons. I never thought buttons could be so beautiful, I just looked at a button as a button; I never thought it could be made into something so creative and so beautiful. Lots of buttons are so beautiful....I love it here, because I love the artwork, being able to create. —Evelyn

What is almost magical at times is to see the impact all this has on some of the women when they see that they are creative and start to see themselves as craftspeople. The Cooperative's theme of "turning buttons into business" is a metaphor for our approach to economic development; while each woman has the essential elements to succeed, she may need help in putting and keeping all the pieces together.

> ...I never knew I could make those bracelets. I never knew how to do the bookmarks— none of that stuff. Now I like it. I like doing that kind of stuff now, really. I never thought I would be doing it, you know? It looks like, "I can't do that," and now I can. It's great. —Ruby

Teamwork and Structure

Essential to maintaining a positive, productive, and safe work environment has been our focus on creating a group that has good team players. As we interview

applicants for the WCC, we ask about their experience working in groups and how they cope with conflict. Even though a woman may lack expertise with crafting or creativity, she may still be able to develop those skills. It is much more difficult for a woman who has problems working within a group to develop "group" skills. Generally, a woman who cannot develop those team-building skills will choose to leave the WCC within a short period of time.

The women of the WCC come from diverse social, economic, educational, and racial backgrounds. There are also women who may have physical or mental challenges. Their strengths, abilities, and motivation have increased when they have a common purpose, as well as a sense of partnership within the team. The idea of creating products that are sold and bring revenue to offset the cost of running the Women's Craft Cooperative allows them to feel part of the process. By engaging the women and encouraging them to share and support the ideas of problem solving, resolving conflict, asking advice, and giving feedback, their participation and contributions in creating a working team is meaningful to the entire group.

> ...I like the setup down there. Everyone is required to do a certain thing and it's expected of us. But it works around to where we are actually doing the same thing; it's a circle. One day you might be doing bracelets, but tomorrow you might be doing barrettes. It evens out so not the same person is doing the same thing all the time. —Laura

In situations where the women are sitting around working, they will share ideas, technique, and inspirations with each other. If one woman is struggling with a design or needs to complete a task, another woman will go over and assist without being asked. This sense of respect, caring, and commitment to their work and each other transcends the work situation. In the positive times in the women's lives, such as when one woman may be about to take big steps such as going back to school, finding permanent housing, going in for medical treatment, or looking for a full-time job, the women will encourage each other. In difficult situations that the women face, such as homelessness, abuse, deaths, and other traumatic experiences, the women are also very supportive. If a woman has setbacks, there is no expression of judgment toward her from the other women. The remarkable thing is that many of the women will continue to work during these difficult times, partly for financial reasons but also for the camaraderie with the other women. As Elizabeth reflected, "There's a good sharing, helpfulness, and working together...it has increased my horizons, my world...you feel safe, you feel valued."

Transition

In July 2002, we transitioned from a job-training program into permanent part-time employment for the women. We are very excited by this change, which will provide the women with greater security, both financially and psychologically.

For most of the women, options for employment after they leave have, for the most part, been limited to entry-level or low-paying jobs. Additionally, many of these jobs require a degree of physical strength that few of the WCC members have, and some jobs are difficult for the women to commute to. Furthermore, these jobs do not necessarily provide a supportive work environment, which is greatly needed by these women. Whether it be physical or mental challenges or family commitments that prevent full-time work, it is clear that for many women, the WCC is more than just a stepping stone to another job. It is a place where they wish to stay. The women have expressed to us that they do not feel stigmatized, ignored, or isolated at WCC. When women are struggling with housing issues or ill health, we have the flexibility to provide time off so they can sort out these problems, and this minimizes their job security stress.

To further guarantee the stability and longevity of the program, we wished to build on the market recognition that the WCC products have achieved. While we currently have two major clients (and are in 25 regional stores), we will be targeting national catalogues and additional stores to increase revenue from sales. When we started, revenue covered 35 percent of the cost of the program, and revenue now covers 68 percent. Increasing the revenue even more will cover more of the cost, thus allowing the potential for increased work hours for the existing women or possibly the employment of additional women. Another benefit of permanent part-time employment is an experienced group of craftspeople that can continue to maintain the quality and consistency of our product. This is particularly important during our busy months (October through December), when it is critical to fulfill our large order commitments. A dedicated and well-trained staff is required.

The decision to transition the program into a permanent place of employment was made in collaboration with the women. Each made it very clear that a permanent job in the WCC had always been her dream. The women requested more training in design and sales, which will be provided for them in the coming months. Given the choice of staying in the program or transitioning out with a job placement plan, each woman decided to stay and was exhilarated by the security this would provide.

> The ripple effect has been through everything in my life because of this. This has given
> me the schedule and the flexibility at the same time. I couldn't have handled a 40-hour
> job somewhere. I really hate to think what would have happened to me if I hadn't been
> here and I felt like I was safe; I felt like I was respected; I felt like I was part of an impor-
> tant group, that we were doing something worthwhile as a unit and as an individ-
> ual...the stability and the structure saved my life I imagine. —Leslee

Such a transition is the start of many changes for the women, who will con-
tinue to develop skills enabling them to more effectively participate in society as
they strive toward economic independence. There will be a greater emphasis on
personal responsibility for design creation and production goals, as well as an
increased emphasis on job standards, such as punctuality and attendance. Much
of the success of the WCC must be credited to the women's dedication to their
goals and loyalty to the program.

> There's good sharing, helpfulness, working together...I look forward to coming to
> work...WCC has brought a lot into my life...it has increased my horizons, my world.
> —Elizabeth

Another source of the WCC's success is our partnership with other institu-
tions, businesses, and many volunteers. For example, Harvard Business School
students have helped us develop a strong marketing plan that incorporates tar-
geting new business (locally and nationally) such as women's organizations and
businesses that connect with the mission element of our program.

As we enter our seventh year in the WCC, we have evolved from a job-train-
ing program to a micro-business, employing participants on a permanent part-
time basis. Over the years, each woman has had her struggles, challenges, and
successes. Some women have chosen to stay; many women have successfully
moved on to employment, additional job training programs, and pursuing edu-
cation; yet there are others who continue to struggle. It is our hope that the
WCC has provided them with the tools to approach their challenges with a more
positive self-image and continue to value creativity in their lives.

References

Bard, M. (1994). *Organizational and Community Responses to Domestic Abuse
and Homelessness.* New York: Garland.

Belenky, M.F., Goldberger, N.R, and Tarule, J.M. (1986). *Women's Ways of
Knowing.* New York: Basic Books -HarperCollins.

Herman, J.L. (1992). *Trauma and Recovery.* New York: Basic Books-
HarperCollins.

Liebow, E. (1993). *Them Them, Who I Am: The Lives of Homeless Women.* New York: Penguin.

Loth, R. (June 2, 1996). Women's work—The Women's Education and Industrial Union , a venerable Boston institution, reconnects to its roots as a place that helps give women control over their lives. *The Boston Globe Magazine,* 16, 25–30.

Prochaska, J.O.D., Carlo C., and Norcross, J.C. (1992, September). In search of how people change—applications to addictive behaviors. *American Psychologist,* 1102–1114.

Serge, I. (October 3, 1996). Boston's queenmaker—the spark plug of the bold girl's network, Sheryl Marshall helps power women to the top. *The Boston Globe,* E1 and E6.

Warsh, D. (December 22, 1996). Making room for the homeless. *The Boston Sunday Globe,* F1.

Wilson, W. J. (1996). *When Work Disappears—The World of the New Urban Poor.* New York: Knopf.

CHAPTER THIRTEEN

Transformative Connections: Linking Service-Learning and Pre-Service Art Education

Carol S. Jeffers

For many years, pre-service teachers and I have been coming together in elementary art methods courses not as students and professor but as co-learners seeking to explore the possibility of a "connective aesthetics," which, for Suzi Gablik (1995), is based in vigorously active and impassioned engagement that would restore art's connectedness with the world after a century of vision-oriented, purist ideals (p. 17). For us, art could no longer remain cloistered, lifeless and objectified as it is inside museum walls.

Actively engaging in both critical and empathic dialogue, our learning community has become energetic and process oriented and has established vital connections to, through, and with the visual arts. Through dialogical connections, then, we have constructed knowledge, not only in process but also "as a process of human relationship" (Gilligan, 1992, p. 173). Moreover, this knowledge is understood to be the product of a functional relationship between discourse and community, such that knowing and learning are not possible without discourse and discourse is not possible without community (Liu, 1995, p. 14).

Recently, I added a service-learning component to my art methods course, which has become a powerful tool in the hands of these prospective teachers, enabling them to expand our learning circle and include young people from local and distant communities in dialogical explorations of a connective aesthetics. Service-learning, which integrates academic content and community service, is a form of experiential education that is highly contextual, purposeful, and trans-

formative. According to noted authority, Andrew Furco (1996), service-learning, which is based on a Deweyan philosophy, occurs, "when there is a balance between learning goals and service outcomes" (p. 12). A balanced approach ensures that "service, when combined with learning, adds values to each and transforms both" (Honnet and Poulsen, 1989).[1]

Cross-Country, Cross-Cultural, Cross-Curricular Connections

This chapter focuses on the elementary art methods course mentioned above and the long-distance model of service-learning utilized in several sections of the course.[2] In this model, a hybrid of community service and learning, pre-service teachers on the West Coast and third, fourth, and eighth graders on the East Coast, were able to build meaningful cross-country, cross-cultural, and cross-curricular connections through the visual and language arts. Becoming pen pals with students in Baltimore and Virginia Beach, the pre-service teachers in Los Angeles facilitated dialogical explorations of a connective aesthetics through which personal, visual, and cultural narratives were constructed around shared experiences of place, symbol, language, and culture.

Embedded in this model is a communications imperative that requires participants separated by distance to work at clearly articulating and elaborating on their ideas, insights, and feelings in order to build connections through which learning occurs.

Baltimore and Virginia Beach were chosen as sites for the cross-country project because of personal connections to some teachers in these communities. In addition, these teachers were supportive of the project philosophy, willing to gather their students' letters, drawings, and other materials and send them to the Los Angeles pen pals in a timely manner.

With respect to goals and outcomes, the teachers structured the project to facilitate third graders' understanding of symbols used by indigenous cultures, increase fourth graders' writing achievement, and improve eighth graders' communication and presentation skills. The project was also intended to promote pre-service teachers' professional development. It proposed that these adult participants be facilitators who would work with the students to address authentic intellectual, aesthetic, and social problems; actively negotiate and construct new identities; share multiple perspectives on the meaning of art; and learn to think critically and creatively about complex issues of teaching and learning, particu-

larly in distant communities. The hope was that "participation in service-learning experiences that are focused on the needs of children/young people may prepare prospective teachers to participate in a learner-centered holistic educational system and in ways that reflect an ethic of caring" (Root, 1994, p. 96).

The cross-country project, which comprised a period of 10 weeks, proceeded through a series of structured activities and planned exchanges (about every two weeks) of letters, art postcards, and individually or jointly created drawings and poems. Designed and directed by the children's teachers and me, these activities were seen as the means by which goals and desired outcomes would be achieved by the project's end.

In addition, some wonderfully spontaneous and student-initiated activities shaped the project and its course. Though unplanned, these activities proved to be integral to the project, adding to its zest and addressing the question of how learning occurred. Taken together, the planned and impromptu activities illustrate quite vividly that the content of learning cannot be separated from its form, and the "what" of learning cannot be disconnected from the "how." In this spirit, the following paragraphs weave together descriptions of the planned and spontaneously occurring activities that gave the project its form and content.

As planned, all participants began by reflecting on their respective communities and how they wanted to represent the place they called home to their randomly assigned pen pals on the opposite coast. While the children sent drawings, some illustrating sharks swimming among the waves at Virginia Beach and others depicting Baltimore's Superbowl champion Ravens, the pre-service teachers shipped boxes filled with souvenirs, cultural objects, mementos, and other materials they had collected. These included maps of the infamous Los Angeles freeways, tourist attractions, and celebrities' homes, newspapers printed in Spanish, Mandarin, Korean, and Armenian, souvenirs from Disneyland, Universal Studios, and Warner Brothers, movie footage, Mexican candy, a sample of sand from the beach at Malibu, sets of postcards featuring the Hollywood sign, Chinatown, and downtown Los Angeles, Lakers and Dodgers memorabilia, and pennants, mascots, and bumper stickers featuring our university insignia (Cal State L.A.).

Upon receiving the boxes full of novelties, the children and their teachers spontaneously decided to set up displays, creating a "California Corner" in their respective classrooms. Meanwhile, the children's drawings revealed just how little the pre-service teachers actually knew about Baltimore and Virginia Beach. Within nanoseconds, the adults searched for more information about these

Eastern seaboard cities via the Internet. They were surprised to learn, for example, that Virginia Beach is near Norfolk, which is home to a large naval base, similar to the one familiar to them in San Diego. They were also surprised to discover that Baltimore is a working port, like the ports of Los Angeles and Long Beach, and that the historic ship, S.S. Constellation, is docked in Baltimore's Inner Harbor, which flows into the Chesapeake Bay, home of the famous blue crabs. As much as they had hoped to broaden their pen pals' horizons, the pre-service teachers suddenly realized the children were expanding theirs as well.

Curious about one another and with many questions, the bi-coastal pen pals began to engage and build connections. In the first round of letters, they introduced themselves, describing their interests, families, and communities. These letters, as with all other items intended for the pen pals, were gathered in the respective classrooms and sent collectively as class packages to the appropriate school addresses.

In preparation for these class mailings, participants were provided with plain envelopes and asked to label them with their pen pals' names. Quite unexpectedly, however, adults and children alike went well beyond the mere act of labeling. Their creative and connective juices flowing, they chose to make these institutional envelopes special, decorating them with unique and expressive marker drawings, brightly colored designs, stickers, and glitter, effectively creating a form of folk art that became increasingly more elaborate with each round of exchanges. It was as if these participants were actively exploring a connective aesthetics through a new genre of envelope art, even as they merely sought to personalize their correspondence inside and out.

To facilitate the third graders' studies of symbols used by Native Americans and other indigenous cultures, the pre-service teachers gathered resources and information on the tribes of California and the Southwest. They traced symbols of the Chumash, Hopi, Pueblo, and Navajo, using them to begin a process of creating drawings or designs with their pen pals in Virginia Beach. Beginning with a single symbol (identified on the back of the 8 1/2 x 11" sheets), these "starter" drawings were sent to the children, who were encouraged to respond by adding color, symbols and other elements, perhaps of the Eastern Woodlands tribes studied by the third grade class.

These developing drawings and designs were then sent back to Los Angeles, where the adults responded in turn. Crossing the country several times, these co-created drawings continually surprised and delighted the recipient artists. The children also originated "starter" drawings for their adult pen pals to work on.

Upon receiving them, however, the adults generally were reluctant to alter what they considered to be cherished gifts from the children.

In an effort to further extend the children's studies of cultural symbols, the pre-service teachers also gathered information, lesson plans, and other materials pertaining to the November 2nd observance of Dia de los Muertos (Day of the Dead), a cultural and religious celebration well known and loved in Los Angeles but apparently unfamiliar in Virginia Beach. An abundance of candles, paper marigolds, and celebratory calaveros (skulls), skeletons, and other festive decorations was sent to Virginia Beach in time for the third grade class to plan their own Day of the Dead celebration. As suggested by the lesson plans, the teacher built a simple structure for a class altar and decorated it with the candles and symbolic marigolds sent by the pen pals.

With the video camera rolling, the children stepped up, one by one, to place the brightly painted clay calaveros they had made on the altar. Addressing their pen pals, they each explained the significance of their skulls and of the color choices they had made. They also held up the African masks they each had completed for another assignment, describing them in terms of the materials and symbols used and in terms of the mask's powers to ward off evil spirits, bring rain, or enhance fertility.

The videotape arrived in Los Angeles toward the end of the project after several exchanges of letters, art postcards, and drawings had already occurred. Completely captivated by the tape, the pre-service teachers played it again and again, each time watching closely for their pen pals and beaming with joy upon seeing the children they had come to know through the pen pal exchanges.

Also in Virginia Beach, eighth grade students participated with another group of pre-service teachers in similar planned exchanges of letters, art postcards, and co-created drawings. Although unplanned and according to their teacher, uncharacteristic, the eighth graders voluntarily decided to videotape one another while presenting their end-of-the-year portfolios to their Los Angeles pen pals.

On "The Tricky Lake Show," a clever parody of *The Ricky Lake Show,* they conducted humorous interviews with classmates, each of whom was given an opportunity to share the contents of their portfolios and discuss conceptual and technical aspects of their artwork. Delightful and informative, the tape impressed their teacher as well as their pen pals.

As the incredulous teacher exclaimed, these were the very same students who had historically hated presenting their portfolios in class and had to be forced

into doing so several times during the school year. For the more authentic purpose of communicating with their pen pals, however, the eighth graders were eager to apply their presentation skills, willingly describing the media, processes, and techniques used to produce their artwork. While the pre-service teachers were both humbled and inspired, the eighth grade teacher was gratified by the taped evidence of her students' well-developed communication skills and purposeful learning.

In the cross-country project involving fourth graders in Baltimore, the emphasis was on writing about art. Each student in the class was given a place-mat-sized laminated copy of Chagall's *1915 Birthday* and, without introduction or explanation, asked to write a response to this rather ambiguous painting on the first day of the project (pre-project writing).

Meanwhile, in Los Angeles, the pre-service teachers worked with their students in groups, engaging in dialogue about the same painting. They also researched the life and times of Marc and Bella Chagall, developing higher-order questions they would use to engage their new pen pals in dialogue about the symbolic meaning of the painting's bright colors and strangely floating figure. Through several exchanges of letters and art postcards, the bi-coastal pen pals shared insights and ideas about *Birthday* and other works of art, even writing five-line poems, or cinquaines, about the project's iconic painting.

Toward the end of the project, the children were asked to write about *Birthday* a second time (post-project writing). The pre-service teachers then learned to score the pre- and post-project writings using rubrics that the Baltimore teacher and I had designed. In doing so, they effectively served as raters for the fourth grade teacher's ongoing research on children's writing. By comparing the two sets of scores, the pre-service teachers and the fourth grade teacher could determine what, if any, changes in writing had occurred during or as a result of the project. For the pre-service teachers, the task of scoring proved to be as challenging as it was gratifying. Ultimately, they discovered that the children had made statistically significant gains by going into detail about the meaning of the painting's mood, story, and symbols.

Transformative Connections

While quantifiable results such as these are extremely important and indicate that the fourth grade project goal was achieved, equally compelling were the observable changes in children's attitudes toward writing. Many of the fourth graders, particularly those who were reading and writing below grade level and

labeled as "learning disabled," were unmotivated and began the project with neg-
ative attitudes in general. These were the students whose teachers had found
them to be openly resistant, balking at written assignments in the past. Once
they began receiving letters and cards from Los Angeles, these students became
interested and focused and had a purpose for writing. Indeed, they insisted on
responding immediately to their pen pals' engaging questions about the mean-
ing of *Birthday* and other shared artworks.

Most remarkable was the child who was drawn into the Chagall painting,
which he had dismissed, at first describing it only as "weird" in his pre-project
writing. Through his pen pal connection, he willingly revisited this painting with
an awakened sense of curiosity. His pre-project writing, a one-word response,
developed into several thoughtful paragraphs of post-project writing and a poem
for his pen pal. Filled with purpose and insight, this child wrote eloquently and
philosophically about Chagall's birthday gift of abiding love for his wife, Bella.

Additional results were discovered in the pre-service teachers' journals. They
were asked to keep journals throughout the course and to consider their journals
quiet places for regularly reflecting on and analyzing their experiences of the serv-
ice-learning project. Consisting of six semi-structured entries and a comparative
analysis of pre- and post-project reflections, the journals were learning tools that
enabled pre-service teachers to systematically document change and growth in
their own professional development across the 10 weeks of the art methods
course.

By comparing their own reflections on having been a fourth grader with
their pen pals' current experiences, for example, pre-service teachers found they
gained deep insights into the construction of identity, their own as well as their
pen pals, in the context of shifting temporal and cultural realities. Moreover, pre-
service teachers found they developed a much fuller appreciation of young peo-
ple's creative and cognitive abilities, realizing that they had greatly underestimat-
ed today's youth. In the process, they learned to set higher, more realistic expec-
tations for their future students and question their own sometimes stereotypical
views of teaching. In doing so, they grew to appreciate what it takes to become
a constructivist teacher, the kind of teacher who learns from and with his or her
students.

These recurrent themes, revealed through a content analysis of the journals,
suggest that the cross-country project had promoted the pre-service teachers'
professional development. As hoped, their "ethic of caring" also had developed,
as suggested by a poignant note sent by the fourth grade teacher from Baltimore
at the end of the project:

December 5, 2001

Dear Class,

Thank you so much for making our students feel so special and cared for. I know that this pen-pal thing started as a class project, but our students were very touched by your caring. Many of the students purchased special folders to keep all of your letters and even the envelopes. They talk about you like they know you personally, and in some cases, they do. You have shared parts of your lives with them and somehow connected. After the tragedy of Sept. 11th, many of our boys and girls were scared and confused. I think that may have come out in some of their drawings. Many of them had visited the Pentagon last year in third grade and one of my students lost family at the World Trade Center. Your letters and gifts inspired our children, showing that there is still good in people from all over the world. Thank you once again.

There is an often overused saying, "To teach is to touch a life forever." You have touched many.

Sincerely,

Mary

Final Thoughts

Throughout the project, the various teachers on the East Coast were amazed by the remarkably high levels of excitement and engagement in their classes. They observed glowing faces, unusually exuberant and motivated behavior, and found their students to be eager, even impatient, awaiting packages from the West Coast. Upon receiving a box, they witnessed the children's sheer delight in discovering the surprises contained within.

This bubbling energy mirrored what I observed in my own classes. The preservice teachers were just as excited as the students to participate in the pen pal project, rushing into class to see if any packages had arrived and when one had, gleefully grabbing their pen pals' letters and reading them aloud to one another. Moreover, many of the adults wanted to continue corresponding with their pen pals after the course was completed, and those who also were parents actively involved their own children as pen pals in the project. Understandably, then, extra mailings were needed to accommodate the unexpected outpouring of personal messages, gifts, and other tokens of friendship that pen pals wanted to exchange.

Teacher observations, together with both expected and unexpected project outcomes, constitute a body of evidence, a set of signs, attesting to the vitality

and transformative character of the dialogical learning that occurred in the con-
text of authentic human connection. Ranging from a fourth grader's radiant
smile and animated demeanor to Mary's caring note, the sentiments expressed in
decorated envelopes, the captivating videotapes, and extra class mailings, these
signs of connection construct a cultural narrative about close bonds between
people in faraway places.

Simple, yet profound, this story is persuasive, explaining how attitudes were
changed, writing was improved, an ethic of caring was developed, goals were
achieved, and "art's connectedness with the world" was restored. Far beyond
museum walls, the visual arts reach out, even as East Coast children and West
Coast adults grab on to them and to one another, co-creating knowledge through
this relationship. This is a colorful and holistic story of service-learning as pur-
poseful learning and the dynamic relationship among motivation, connection,
engagement, purpose, compassion, and transformation. It is a work in progress
with new and engaging chapters still to be written.

Endnotes

[1] These service-learning courses were developed as part of the project "Linking
Service-Learning and the Visual Arts," supported by a partnership between
the California State University (CSU) and the J. Paul Getty Trust.

[2] This project was supported by grants from the National Art Education
Foundation, the California State University, Los Angeles Innovative
Instruction Awards Program, and the CSU-Getty Partnership, "Linking
Service-Learning and the Visual Arts."

References

Furco, A. (1996). Service-learning: A balanced approach to experiential
 education. Introduction to service-learning: Readings and resources for
 faculty. Providence, RI: Campus Compact. Reprinted from *Expanding
 Boundaries: Service and Learning*. Washington, DC: Corporation for
 National Service.
Gablik, S. (1995). *Conversations Before the End of Time*. New York: Thames
 and Hudson.
Gilligan, C. (1992). *In a Different Voice: Psychological Theory and Women's
 Development*. Cambridge: Harvard University Press.

Honnet, E.P. and Poulsen. (1989). *Principles of Good Practice in Combining Service and Learning.* Wingspread Special Report. Racine, Wisconsin: The Johnson Foundation.

Liu, G. (1995). Knowledge, foundations, and discourse: Philosophical support for service-learning. *Michigan Journal of Community Service-Learning* 2, 5–18.

Root, S. (1994). *Service-learning in teacher education: A third rationale.* Michigan Journal of Community Service-Learning 1, 94–97.

Putting the Chairs in Place: Lina de Guevara and Transformative Theatre

Cameron Culhamoo

> We begin from the principle that we are all artists; playing, is one of the most powerful languages that you can have. To play is to use part of reality, to create and rehearse forms of transformation.
> –A. Boal

Drama in intercultural work is transformative. It can affect and activate entire communities. This chapter describes the work that Lina de Guevara, artistic director of Puente Theatre, has been doing with immigrants in Victoria, Canada. In this interview, using Puente's first production, *I Wasn't Born Here ("Historias de viajes inesperados")*, as a model, she illustrates how the stories we "bring with us can, through dramatic coloring, be shared as universal. The playbuilding process allows for expression of participants, individual struggles and triumphs, and at the same time it functions as the voicebox of the collective (actors) and the larger community (immigrants)." Lina's description speaks to the relevance of this form of drama and illustrates its efficacy as a vehicle for social change. With equity and justice its ultimate goals, as evidenced here, drama has the potential to create shifts of awareness within immigrant and host communities.

Lina founded the company in 1988 after her theatre career in Chile was interrupted by political events. Lina is a performer and director who also currently teaches at the University of Victoria. Her ideas are adapted in part from interactions with theatre practitioners Eugenio Barba and Augusto Boal, but her methodology is largely her own creative reaction to the needs of the immigrant groups with whom she works.

An Interview: August 2002

CC: Lina, please tell me about your background and how Puente came to be.

LDG: My starting Puente Theatre happened due to my change of situation. I became an immigrant myself in 1976. It was a shocking ordeal for a theatre person who is used to working with words and language. In Chile, I had had acting, teaching, and directing experience, but mostly performing. When I came here I found out that I couldn't perform or direct. I did not feel comfortable with the language, and I was just very confused.

CC: Can you describe some of your struggles as an immigrant?

LDG: Well, one of the main obstacles was that I was stunned as a result of "cultural shock." It is a critical time, one during which some people are able to cope, while others simply get stuck or overwhelmed. You lose your confidence. It is very difficult, especially in a field like theatre that is so hard to get into.

CC: Do you feel that this notion of "artistic transplanting" has been made more commonplace recently?

LDG: Well, I think in some places it is becoming quite fashionable, but still it is by no means easy. To do what I did came out of my own experience, out of what I was going through, a feeling of dislocation. At a certain point you ask yourself "What do I do now?"

CC: And what did you do?

LDG: I started by teaching theatre for children, which is something that I hadn't done in Chile. I discovered that I felt more confident when I was working with children. It gave me a lot of freedom, and I learned a lot from them, from their imagination and their spontaneity. In a way, it gave me a methodology from which to work when I started Puente.

CC: How has your own experience informed the work with new immigrants that you are doing now?

LDG: I wanted to do something that would serve me more in terms of self-expression, tell more about who I was, where I came from and what my background was. I suppose I wished to re-establish all those connections that had been severed by being an immigrant. I followed my own needs; perhaps this is going to sound selfish, but I believe that what roots the work is that you are doing it for yourself, not for the sake of philanthropy! I think that makes the work stronger. And then you do find other people who feel the same as you.

CC: In early Puente productions you worked with non-actors. Can you talk about that experience?

LDG: That also happened by chance, because when I finally decided to found Puente in 1988, the first project was to develop a play about immigrant women from Latin America, which we called "I Wasn't Born Here." That play was really telling my own story, and the story of others in the same situation as me. We shared the experience of being women, Latin American, and immigrants. Because I could not find any professional actresses in Victoria who were immigrants from Latin America, I had to undertake the play with women who were not actresses. I had a grant from Manpower and Immigration, so the people that I worked with had to fulfill certain conditions and they had to be unemployable. I met five women, none of whom had any theatre experience, and all were in need of work. And they turned out to be extremely talented.

CC: Did you select your cast by auditioning them?

LDG: It was sort of an intuitive process rather than an audition. I liked them from the start, and I thought we could all work well together. Most importantly, they needed to tell their stories, to express what had happened to them, and that was a strong feeling to which they all could connect. The project had many aspects to it. We created an integrated curriculum with a strong component of ESL (English as a second language). In addition to language building, they acquired life skills, employability skills, confidence in public speaking, and they also received movement, yoga, acting, and voice training.

CC: And did you bring in instructors for this?

LDG: We had many instructors, and I facilitated most of the theatre components. Once we had the training structure in place, we had to decide how to construct the play. For example, where would we find the stories? We decided that each actor had to interview 10 other women, also immigrants from Latin America. Rather than hear them talk about what they had experienced, we chose to re-create the interviews by acting them out. One person acted as the interviewer and another as the subject of the interview. We reconstructed the space where the interview happened, such as a living room, and, using the other actors, we showed who else was there at the time. For example, somebody would say, "Well, the immigrant woman's husband was sitting there, and every time I asked her a question, he answered." And so he became a character in the scene we were improvising. I had a saying to help us build up our play: "Maximum effort for minimum result." This meant exploring many scenes and choosing only a few or a few elements from different ones.

CC: I suppose those situations of the "others" that they had interviewed and re-enacted overlapped aspects of the actors' own experiences?

LDG: Yes, we were essentially building an understanding of the world of immigrant women through the interviews. One of the reasons I wanted to act out the interviews as opposed to hearing about them was that it meant we saw it all in a less "linear" form. This process showed us what had really happened, the lived experience, and as such, it was more emotional, less intellectual. Of course, it also gave the women a chance to practice their acting skills.

CC: I am curious about the research process.

LDG: We started to ask questions as a means of ascertaining what was really going on in their lives.

CC: Did you always enact the research together rather than simply read the interview responses out?

LDG: Yes, we always had the questionnaires there to access, but the first contact we had with the interviews was always through showing them dramatically to one another.

CC: How did you frame those interview questions?

LDG: Creating a suitable questionnaire was an important aspect of our work. We had a professional train us in techniques of empathic listening and asking questions such as: "What words do you relate to the word 'immigrant'?" "What objects would you bring from your homeland?" "When you were in your homeland, what words did you relate to the word 'Canada'?" We wanted answers that would be about images, feelings, stories that could be shown on stage. Other questions were: "What was your best moment as an immigrant, what was your worst?" I recall one woman said, "My best moment? I haven't experienced it yet!"

CC: It sounds like you were writing it collectively as you went along.

LDG: That's right. And eventually I wrote out the entire script, but only at the very end, just before we opened. One woman said she saw the word "English" like a huge word written in the sky, an oppressive presence that couldn't be avoided. We created a scene in which masked characters built a mountain of chairs to the tune of "Rule Britannia" and then placed a long pole with a flag marked "English" on top of the mountain. From under the backdrop, the women appeared, crawling like babies on the floor and saying "ba," "the," "sho"—all sorts of syllables in English—as they tried to climb the mountain. One woman finally arrived at the summit, grabbed the flag, and ran around the stage waving it and saying, "English...I got it!!"

CC: Where did you perform this play?

LDG: We opened at the Belfry Theatre here in Victoria and then performed at a number of festivals across the country. Also a video was made of the project, and it was broadcast nationally.

CC: Can you describe the reaction to the play?

LDG: It was very emotional. People were moved by the fact that the women they saw performing on the stage were really immigrant women and not actors. These women spoke with difficulty and struggled with the language, and that struggle touched the audience. Even though we had built the play from the interviews of "others" and created composite characters, there were aspects in all the stories that had happened to the cast members themselves.

CC: In this earlier production, was there a chance for audience "talk back" after the show?

LDG: Puente means bridge. In Puente productions, we always have a moment when a bridge is clearly established, when the stage is shared between actors and audience. For our first performances of this first play the women had set the table and invited the audience to come onto the stage and eat with us. They were so well attended that we had to bring in lots of food, and fortunately, there was a Chilean bakery in town that made delicious Chilean egg rolls (pan de huevo).

CC: That sounds like a welcome treat! Where were your actors from?

LDG: Two were from El Salvador, one from Nicaragua, and two from Chile.

CC: Are any of the women still involved in theatre today?

LDG: They all became employed after the project, whereas before it they were considered "unemployable". Building careers as actors wasn't really the goal. Our aim was to create and perform the play based on the conditions of the grant: to offer employment and to provide skills to make the participants self-sufficient. They had to learn English in order to perform and speak on stage, so that in itself was a big challenge. They had to learn to be actors. In the place where we rehearsed there were many folding chairs, which we started using as props in all of the drama exercises. We ended by making everything that we needed with them, in fact. But to bring these chairs onstage and to place them exactly where they had to go required careful and precise choreography; otherwise it took too long and became boring. It was difficult for the actors to put the chairs where they had to be in an economical and aesthetic way. The moment that they learned to put the chairs in the right place, they became actors. Overcoming this difficulty was very important, and time was a factor. For this type of project to have a truly life-changing effect, you need time.

CC: How much time did you have for this?

LDG: A project like this ideally takes up to a year, since a great deal needs to be covered. Because it was a full-time job for us all, we were able to give it the time that was needed. We worked from nine to five. Too often theatre doesn't do

what it could do if it were given the full-time commitment that it needs. It is a discovery process for everybody involved. As I say, "maximum efforts for minimum results." Theatre is not efficient, nor is it a machine. We are human beings; we cannot function like robots and give immediate results. This is especially true when you are working with people who are traumatized or getting through a period of adjustment in their lives.

CC: You need to work by "layering" in any theatrical process and even more so in this sort, I would imagine?

LDG: Yes, and a slow layering since it is a whole process of discovery. I think that the grants that we got were wonderful. They were an investment, not only in the actors but also in the members of the Latin American community. Many Latin American immigrants were fairly new to Canada. In 1988, a lot of the people had just come from Chile, El Salvador, Nicaragua, and Central America. We were a community that very much needed to feel it was being paid attention to, and this play expressed our issues. The experience established a link by saying, "There is a place for you here and you can belong." It affirmed that they had something positive to contribute.

CC: As a director, how did you help facilitate the telling of these struggles? How did you create an environment where such stories could be shared?

LDG: Well, there were some scenes that were very emotional. In particular, I recall one in which a woman tells how she crossed the border from Mexico to the United States as an illegal alien. Every time she told that story in rehearsal we cried. That story was understandably very powerful for her, but she wanted to tell it because she felt that she needed to relive that experience.

CC: And you certainly don't want to censor anyone.

LDG: We discussed this process with the actors and assured them that they would never be forced to share anything they don't want to, but when they do want to share something emotional, I am not going to say, "Oh, don't cry; we have to stop this because you are crying!" Crying is a natural reaction. Sometimes there is a great fear in our society of having people express their emotions—something that is perfectly okay and natural. Because they have gone through traumatic experiences, they need to express themselves. You can't expect people to be laughing all the time. The most awful thing is to be suppressed and to be told "No, don't talk about that." Besides, we had an unspoken agreement that we were all adults and responsible for ourselves.

CC: As director, did you ever feel that you had to shape the emotional content for the sake of balancing the play?

LDG: Yes, the play had many types of emotions and we had to balance the scenes. There were moments that were really funny, as well as some that were understandably heavier. One of the last lines of the first play was very hopeful. One of the women lifted her child in her arms, stepped forward and said, along with the other actresses, "We brought the best we have, and we want to share with you." A play about immigrant women could not be done without the children, and it was nice to see all the children there, celebrating with their mothers.

CC: To help create a picture for me of this play, can you recount some of the scenes that were memorable for you?

LDG: There was a very emotional scene of separation, where they were saying goodbye to the family before leaving for Canada. In another scene called "A Mirror on Marriage," the women explored the ways that immigration had impacted their marriages. I do remember a poem written for a scene we called "The English Lesson":

Magdalena (to the audience):
The English, you know,
Is very difficult for me.
I feel shame when I speak English.
My tongue is like wood
And my head too.
I don't speak English,
But I need to speak English
Because I like to live.
I like this country
Because is land of peace
And for my children is great country.
But this English feel me crazy!
Oh, my God, help my tongue and my head!
Why don't you speak Spanish?
It's very easy.
I want to speak with you.
I promise, in near future,
To speak English.
And pretty well!

CC: Might there be a danger of this work creating a certain degree of marginalization?

LDG: I believe you are marginalized if you are ignored, if your experiences are not heard. If you get a chance to tell your story to the mainstream, you are

becoming part of it. That is one of the reasons why I always wanted the plays to be in English. I wanted the stories to be told to everybody and not only to other immigrants.

CC: So this is about the audience as well as the actor/immigrants going through a transformation?

LDG: Right, most certainly the audience experiences a shift in awareness, partly because, as I said, they are seeing people onstage that they don't usually see there. And, in many cases, the audience members are recognizing their own stories. As for the actors, performing gives them a presence, a power.

CC: Why not just stop at the drama workshops you described earlier?

LDG: We were doing all this because we wanted to tell people who we were. Communication was a necessary part of the process. It was not only to acquire life skills for ourselves. We wanted to say, "This is who we are. We are not second class but we are here onstage hoping you enjoy our play. If you are able to empathize with us, you will understand." In one video documenting our work, a Latin American woman says, "I am so glad that there is this play that will make Canadian people understand us a little better." Because [as an immigrant] many times you feel misunderstood.

CC: This is about giving voice to experience and confronting misunderstandings, isn't it?

LDG: It is creating a much-needed dialogue with the greater community, and without the theatrical presentation you simply don't have that. Too often the larger dialogue does not occur because not all are prepared to listen. There are some who still don't accept completely the idea that Canada is a multicultural country and that we immigrants belong here. As an immigrant and as part of a minority, I strongly feel that we need to be legitimated. We need to be here without letting go of who we are, and to do that we need acceptance. You need to feel that you are here, that you have a voice, and that there are no misconceptions about who you are.

CC: Would you say that you were successful?

LDG: We just want to have our say. Of course, that first play is the vision of a very specific group of people. Another group of Latin Americans might have quite a different vision. We can only really talk for ourselves.

CC: Since that first play, you have directed many more. In what ways has your approach changed over time?

LDG: My experience shows me that each play creates its own methodology according to the theme, who the actors are, where it will be performed, and so

on. I guess that my main method is to keep myself open and prepared to be flexible and to follow what it is that each production needs.

CC: In terms of the future, in what direction are you steering Puente?

LDG: Next, I am planning to do a play that will look at stories of women who have immigrated from a variety of countries. I want to look at the whole of Canada because we are all immigrants. Those who are not first-generation immigrants have parents, grandparents, or great-grandparents who came from somewhere else. The First Nations people are the only ones that were originally from here.

CC: Have you ever encountered any resistance to this kind of work over the years?

LDG: There was an interesting episode during the production of *I Wasn't Born Here*. We had many outstanding reviews, but there was one (which was based on a rehearsal and not even our final production!) that was critical. To the participants it was nothing serious, since they believed so strongly in the importance of their work. You have to remember that these women had gone through hell. There was one woman who had been in jail in Chile, another who had been under bombing. These women are survivors.

CC: So a theatre critic isn't going to affect them all that much, I suppose.

LDG: They just completely dismissed his review as absolutely not important. I was the one complaining about it. In the end, we did use this incident by making his comments into a scene in our first play. When one of the women tells her boss in a factory that she wants to quit to participate in a play about immigrant women, she says to her: "Art is not for people like you!" In a sense, this was what that particular critic appeared to have felt. The stage was not for immigrant women who couldn't speak English properly. But he was wrong, and the reactions of our audiences proved it!

References

Boal, A. (1992). *Games for Actors and Non-Actors.* London: Routledge.

Bray, E. (1991). *Playbuilding: A Guide for Group Creation of Plays with Young People.* Portsmouth, NH: Heinemann.

Kao, S-M. and O'Neill, C. (1998). *Words into Worlds: Learning a Second Language Through Process Drama.* Westport, CT: Ablex.

Tarlington, C. and Michaels, W. (1995). *Building Plays: Simple Playbuilding Techniques at Work.* Markham, Ontario: Pembroke.

Teaching Art as a Subversive Activity

Beverly Naidus

Introducing an Old Strategy

The concept of art for social change has been around for many centuries. In my mind, it begins in the fifteenth century with the invention of the printing press. At that time, powerfully illustrated broadsheets were created and circulated to speak about the injustices experienced by the peasants at the hands of the feudal lords and the Church establishment. The history of socially engaged art has taken many forms over the centuries; sometimes it has existed as the well-crafted lines of a song that eventually seared off the façade of a corrupt regime or as the wickedly funny satire that could break the public's trance.

This particular history of art was hard for me to find when I first began looking for it in graduate school back in the mid-1970s. Nor was it easy to locate strategies for developing a personal and political voice as an artist. This sort of training was not commonplace in art schools or colleges where the dominant methods of educating artists were based in the world of form and technique.

By sharing what I have learned in the past couple of decades working as an artist, activist, and educator, it is my hope that some of my readers will be inspired to move beyond the role of artist as an entertainer or decorator. Maybe by reading this essay, some artist-educators will be inspired to expand the ways in which they teach and offer their students strategies for sustaining their practices with a new vision of how art can function in this world.

Finding Voice

It was the fall of 1976. I was a teaching assistant in a beginning painting class. The small art college sat on the edge of Halifax harbor in Nova Scotia. Cool gray light filtered through the many windows of the studio on the top floor of a renovated warehouse. More than 20 students were spread out at easels and walls, each working quietly and intensely on paintings of different sizes, shapes, and materials. I watched the instructor slowly move around the room, engaging in private conversations with each student. When I listened in, I heard her ask them questions about their work: What were they struggling with in this painting? Which artists inspired them? When did they know when a painting was finished? and so on. In a few cases, the questions became quite personal, and there was a strange intimacy about the dialogue, as if the instructor was facilitating a therapy session.

I wondered if this was the standard way to teach a studio art class. Whether in private conversation or in group critiques, the discussions revolved around the individual, his or her search for meaning in form, and the odd obsessions that defined their visions. Art seemed to be made by these students without any social context other than the art world. It was assumed that all the students felt alienated from society; after all, wasn't that why they were in an art school in the first place? With that fate, came no social responsibility.

Although I was only beginning my research on this topic, I saw this attitude as the legacy of the McCarthyism of the 1950s and the "art for art's sake" ideology of modernism. I had grown up in a family where doing work of social value was both implicit and explicit. My parents, the children of immigrants, were deeply engaged in the idealistic social movements of the 1930s. Despite suffering economically during the blacklists of the 1950s, my parents raised me to be a socially concerned person and to contribute my skills to make a difference in the world. This upbringing made me quite uncomfortable with an art practice that seemed to manifest totally as an upwardly mobile lifestyle or as a black-clad, bohemian pose.

The questions that went unasked by that instructor became a wellspring for me: Why were the students making art? Who did they feel was their audience? What were their intentions? Did they want to decorate the walls of the well-off? Did they aspire to have their names in the trendy art magazines or in art history books, or did they want to speak their truth with no goal of fortune or fame? During that first year in graduate school, I was blessed with a brilliant studio-

mate with whom I could have long conversations about these questions and the purpose of art. Soon I was reading John Berger, Walter Benjamin, Ernest Fischer, Arnold Hauser, Paul Von Blum, Lucy Lippard and many of the early feminist art writers who could be found in the brilliant but now defunct *Heresies* magazine. As a result of asking myself why was I making art and for whom, my art-making process began to change. Paper squares painted a Mediterranean blue and cryptically inscribed with graphite were abandoned and left in piles on a table. Typewritten text began to appear on translucent slips of paper. They dangled like price tags from hangers. The tags exclaimed "Buy One Now!" and "You Need This!" A pair of white pants was lightly cartooned on paper; a small red dot of paint placed politely on the crotch. Scrawled across the top was "the wrong day to wear white pants." My angst-ridden search for a private iconography was being replaced with a quirky sense of humor about the contradictions in everyday life.

Slowly I found images and words that could communicate my increasing sense of urgency about the state of the world and my place within it. I learned how to use art as a tool for consciousness raising and as a way to invite others to share their stories. I began to make site-specific, audio installations about my nightmares about nuclear war, my frustration with consumerism, and my questions about standard notions of success and propriety. When my pieces were effective they provoked an unexpected response and reward: audience members would offer me stories about their own lives, including their nightmares and dreams for the future.

Visitors to my audio installation, *This Is Not a Test,* which depicted the dwelling and inner voices of the last survivor of a nuclear war, were provoked to tell me stories about their terror during the Cuban missile crisis and their cynical responses to the official phrase "duck and cover." They talked about being numb and wondered how many missiles were targeted in our direction at that moment. I was amazed that my art had triggered such a generous outpouring of stories and began to see how art had the potential to turn what I thought were my personal anxieties into collective concerns. I was developing my artistic voice at the same time that feminist art was becoming visible as a movement. Within the context of that movement, personal story was profoundly important, especially as it referred to the politics of oppression. Along with the experience of gender politics, I began to see how economic class, cultural identity, geography, sexual orientation, and age could influence or frame an artist's point of view. As a teacher, I wanted to share these discoveries with others.

I assumed that there might be a few other students who had been affected deeply by the liberation movements of the 1960s and 1970s (civil rights, anti war, feminism, gay rights, self-realization, etc.) and who might be searching for a different path as an artist and looking for support.

During my last semester in graduate school (1978) I had the opportunity to create my own course and to find some of those students who wanted to explore different approaches to art making. The course focused on the assumptions we have about the world by looking at the meanings and connotations of "loaded" words. I had just finished reading *Teaching as a Subversive Activity* by Neil Postman and Charles Weingartner (1969). These two educators questioned an outmoded educational system that was not keeping up with the rate of change in our world. They offered new strategies for critical thinking that might give our society tools for confronting the problems that were and are threatening its survival. Their approach to making the classroom relevant by addressing political and social issues included a discussion of the shifting meanings of language. By focusing on the connotations and denotations of words, they exposed a method for examining the underlying values and assumptions of a culture. I wanted to expand their approach to critical thinking and relevance by adding images into the equation.

We started with the word "exotic." A loaded word to be sure. It was a particular favorite of mine because I had often been given that label (because of my dark skin, eyes, and hair) by well-meaning acquaintances. The students jumped into interpreting this word visually, producing a wide variety of artistic forms—from photocollage to painting to found object sculptures—to illustrate their meanings. We had a wonderful debate about the "right" or "correct" meaning of the word, what it means to be considered an outsider or an "other," and what it means to make art to communicate meaning. As the course progressed, students chose their own provocative words, and we brainstormed ways to share what we had learned with a larger audience. During the final week of the course, we had a public exhibition and dialogue about what it means to make art with a particular intention—in this case, to communicate meanings and look at the implications of those meanings in the broader society.

Whose Culture Has Value?

After leaving graduate school, I returned to New York City and found work teaching art in several museums. Every three months, we would focus on one sec-

tion of the museum—for example, the American Wing, the African Collection, or the Twentieth Century painting galleries. I knew from the moment I was hired that I was not going to follow the "party line," offering the "disadvantaged" and "culturally deprived" an experience of "high" culture. I was looking for a new strategy to make art in the museum relevant to my students, a strategy that would help the students develop critical thinking about the world, and give them more awareness of their values. My supervisor gave me a great opportunity: I could address the content of the collections in any way I saw fit, and I could develop whatever kinds of art projects that I felt were relevant to my focus.

The students came from public high schools all over the five boroughs and were mostly the children of the working poor and the lower middle class. I worked with the students at their schools for several sessions and at the museum twice. During one of my school visits, we looked at advertising as a visual and social message and discussed the values that ads promote. We wrote lists of what we were being sold aside from the product. From that list we were able to explore how the students' values contrasted with what Madison Avenue was promoting. In all cases, the contrast between the slick and manicured glossy magazine ads and the students' personal lives and communities was extreme. They could see quite clearly how the ads made them feel unhappy with their lives and how ads intended to make them buy products in order to feel better. Developing this kind of critical thinking was key to my process with them.

We also had long discussions about what they valued in their communities and cultures and whether they saw those values displayed on the walls of museums or in advertising. Our talks generated images and ideas about genuine needs and concerns, rather than ones the students felt they were supposed to have—based on what they saw in popular or "high" culture. We also looked at slides of art that raised questions about the world, which spoke to the truth of what it means to suffer and struggle, and that provided visions of better life.

The student art that emerged from all of this talk was multifaceted. They created papièr-machè masks that expressed each individual student's power. The masks were used to make plays about the community's stories and local hidden history. They designed ads to promote each individual student's strengths and talents. They made paintings of their dreams and nightmares. Some looked at the ways the crises in the economy and the environment were affecting their local communities. At the end of each semester, the schools were invited to display the student work at the museum for one evening and were given a special reception for this event.

While this series of workshops did little to subvert the museum environment, it certainly raised many questions for the students about how culture is transmitted and whose culture is given more visibility and why. During the five years I taught in NYC museums, I not only asked students to notice how little of the work on the walls was made by women and artists of color, but I encouraged them to find new venues for their self and community expressions.

At that time, New York City was filled with all kinds of alternative art spaces and collectives of artists doing socially engaged art. I participated in several activist artist groups whose collaborative projects on gentrification, reproductive rights for women, and nuclear issues entered the public realm in new ways—as site-specific installations, performance art, interactive carnivals, billboard correction, and other forms of street art. This was an exciting time and a desperate time. Reagan was the president; the Cold War appeared to be on the verge of hot, the economy had shifted dramatically, with housing costs becoming exorbitant; the environment was rapidly falling apart, and there was no shortage of subject matter for an activist artist. Still the huge shadow cast by the New York art world and the financial stresses we were encountering forced many of us to make choices. Some chose to promote their ideas through the mainstream gallery context; some found grants to work with communities as cultural animators, and others found educational contexts in which to promote their vision for social change.

Shifting the Discourse within the Ivory Tower

I was among the latter group and left NYC in the mid-1980s to teach art at a small liberal arts college in the Midwest. It was a time of ivory tower insulation with little visible student activism. Many students were focused on securing glamorous and lucrative careers and didn't want to be bothered with uncomfortable social issues. I remember being asked by a sarcastic student, "What are you gonna paint out here in the middle of the cornfields?" With local farmers losing their farms and committing suicide left and right and with nuclear missiles sleeping in underground bunkers down the road, ready and waiting for red alert phone calls, there truly was no shortage of subject matter for an activist artist.

Despite the dominant feelings of apathy on campus, there were many young students who had strong social consciences, and some of them found their way into my classes. Some were working to end apartheid in South Africa, some were trying to heal from dysfunctional family life, and some were looking to understand the epidemic of eating disorders among their peers. While it was important to share with these strongly motivated students how art could be part of

their vision for social change, I also felt a sense of mission to awaken the students who were asleep at the wheel, so to speak. Most of my assignments offered opportunities for students to find their personal voice, a voice that was informed by the place where they grew up, the economic class of their family, their cultural heritage, their age, and many other factors. So while strengthening their sense of artistic voice, the students could also broaden their understanding of their place in the world.

Using a social frame, the simple choice of placing objects in a still life had larger implications. Where did the objects come from? What natural resources were used to make them? Who labored to fabricate them and how much were they paid? Who purchased these objects, and how were they used in their new home? What meaning did the students derive from each object in their new context and how was the meaning expanded by this social lens? And how could we reveal these meanings in the actual art piece and communicate them to a less-aware audience?

When painting a landscape, could we observe the effects of development, farming practices, and ecological stresses on that landscape? How could we find an appropriate art form to share those revelations or concerns with an uninformed public?

And so on. Every formal tradition of teaching art could be analyzed and reconstructed using this lens, from assumptions made about the study of the figure and its objectification of the body, to the cultural imperialism often implicit in art history classes.

Engaging students in this kind of questioning was the only way I found it comfortable to sit in academia. During my two-year appointment at this college and my subsequent nine years teaching New Genres and Intermedia at a state university in southern California, I kept challenging the standard curriculum, trying to find ways to make my art classes reveal more about the world. Ironically, this questioning made my some of my colleagues quite uncomfortable. I saw this discomfort as healthy, giving us all the opportunity to grow. I was thrilled to see some of my more adventurous colleagues shift their practice and research to include a more socially conscious perspective. This was quite heartening.

Action/Research as a Strategy for Social Change

As time passed, I felt I needed more tools and role models to offer my students. After attending several national meetings of the Alliance for Cultural Democracy, an organization of artists who made their socially engaged art specif-

ically within community (rather than in the studio), I was inspired to offer my students new strategies for making art. Many ACD members saw themselves as cultural or community animators, artists who facilitate a creative process within the community rather than as artists making pieces for communities or directing the communities to make work based on the artist's vision. With this new insight, I encouraged my students to work collaboratively and to find new public contexts for their art.

When my students were designing a public art project, we would discuss the various strategies available to us. Would we create "plop art" that had no relationship to the community but had everything to do with our individual vision? Would we attend public meetings that gave us some notion of community concerns and then shape those ideas into an art piece of our own design? Would we invite specific communities to paint or perform in pieces of our design? Or would we bring our skills into the community and offer them up, encouraging the community members to collaborate with us and make the art about their lives?

In the summer of 1993 I had the opportunity to study cultural animation with founding members of the exciting and well-established community arts organization, Jubilee Arts, based in West Bromwich, England, since 1974. Jubilee is one of several groups that really defined cultural/community animation through their work. As the brilliant cultural activist and poet, Charles Frederick, theorizes:

> Cultural/community animation means to revitalize the soul, the subjective and objective, collective and personally experienced identity of a community in historical or immediate crisis. Using a plethora of art and performance forms, the community gathers in all of its internal diversity with autonomous democratic authority to explore critically its social and historical existence. The product of this cultural work is for the community to create new consciousness of itself and a renovated narrative of its imagination of itself in history expressed in a multitude of forms. This new narrative is created beyond the boundaries (while in dialectical recognition) of the previous, external and internalized narrative of oppression. Identifying itself within this new narrative of subjective and objective history, the community is empowered, while publicly expressing its presence in history, to make new history and a new destiny for itself, in an organized program of social and political action, thus adding new chapters to its historical narrative. While in the aesthetic project of composing its narrative, and while at the same time in the political project of acting from its new story, the community is re-composing itself, both symbolically and actually in freedom and with justice.

Jubilee had been invited to northern California to do art projects in the very polarized community of Mendocino County. The major tensions in the community existed between the people who relied on the logging industry for their daily bread and the environmentalists who were putting their bodies on the line to save the remaining old-growth forests.

Into this fray came a group of 30 or so activist artists and cultural workers from all over the United States and the Jubilee team. Our goal was to learn how to use art to create dialogue between communities in conflict and to make the narrative of invisible groups visible. We had a laboratory to learn about the process. Every day we participated in a series of exercises that are standard fare for Jubilee cultural workers. Action Research, a term to describe a way of gathering information and making art from it, was the most the important lesson we gained from our time together.

We broke into small groups and were asked to share a social issue that concerned each of us at that moment. We each discussed our individual issue for several minutes and shared a story with the group that illustrated our concern. We created a list of issues and discussed how our issues were interrelated.

After that, we were invited to make a skills inventory. The skills that we listed were very broad from "writes poetry" to "makes good soup" to "talks well on the phone." With this list and the list of social concerns, we began to brainstorm a form, an intention, and a context. In other words, we developed an art piece that connected many of the our social concerns and that could be made in the space of 24 hours using the skills that we had brought to the table. We thought carefully about who our audience was, what the limitations of our skills, materials, and exhibiting space were, and what we hoped to accomplish.

While the product of our efforts was not memorable, the process was. Within two days, we had developed new ways to communicate and create consensus with a group of strangers. We were ready to go out into the world and practice with these new skills.

Our group was assigned to the local senior center, where our intention was to collect stories about the elders' perceptions of both the tensions and the benefits of living in the area. We found different ways to start conversations, and once a little trust was established, we asked people if they wanted to photograph each other. The portraits and the stories became the substance of an exhibition at the local mall. Since the stories were gathered in the cafeteria, we decided to exhibit the portraits and the stories as place settings.

While not altogether successful, either visually or conceptually, this taste of action/research was a beginning. If they are to be effective cultural animators, all participants must make a commitment of time and resources. Trust must be built slowly. When one is not a member of the group, a bridge person must be found. An artist-facilitator who dips into a group for a short stay and exploits the group's talents for the artist's own benefit can create bad feelings all around.

The inspiration I brought home from my work with Jubilee was obvious. I was asked by my department chair to renovate and re-energize a course on "Artist Survival Skills" that had previously focused on resume and portfolio development and networking skills. My new course looked at social concerns that affected artists' lives and was a required course for all art majors. Students looked at how artists are educated; how the mainstream art world functions; how artists who work in communities facilitate their work; how sexism, censorship, homophobia, and racism affect artists; and how to survive in a society that is trained to be art-unfriendly. We had guest artists and art professionals come and give relevant lectures every other week. I put together a collection of readings to supplement the issues raised by the speakers and my lectures. Aside from an open-book essay exam at the end of the course, the only other assignment was for students to work collaboratively on a community art project of their own design.

This course became controversial for quite an interesting reason. One colleague was afraid that I was not preparing students properly for the outside world. He said, "These are working-class students who need to find jobs in the art world and in the industry. Your questions will make it difficult for them to fit in and accept the positions that are available." Perhaps this colleague did not understand the goal of social change. Realizing that most art students stop making art and looking for work in art-related fields after receiving endless rejections from employers, galleries, and granting agencies, my greatest desire was that these students would develop the confidence, resources, and smarts to create new opportunities, paths, and alternative institutions. Or, if they chose to work within the mainstream, that they could offer up their critical thinking skills to subvert the discourse and open up the minds of their colleagues.

Art for Imagining the Future and Envisioning Utopias

In 1991, I was invited to lecture on my work and activist art at the Institute for Social Ecology (ISE) (www.social-ecology.org). At the time, ISE was located on the Goddard College campus in the lush, green mountains of central Vermont (ISE has since bought its own gorgeous property in the same town and is now

accredited with Burlington College). During the month-long residency, I facili-
tated several art projects with the students, including a collaborative bookwork
filled with photo collages, drawings, and text of visions for the future. I call that
first summer at ISE my "introduction to utopian thinking." There I encountered
some of the most idealistic and visionary community activists that I had ever
met. The students came from all over the world, some working in communities
where their work in literacy campaigns or planning housing projects was life
threatening (because of the inhumane governments in power). Many of these
students had never thought of themselves as artists, but they had the imagina-
tions to fuel movements and to create bridges into all kinds of communities.
After that first summer, my husband Bob Spivey (who had received his master's
in social ecology with a focus on activist art) and I co-facilitated a summer course
called "Activist Art in Community" for many years. The course has changed
shape, size, and facilitators, but it has remained an essential part of the ISE sum-
mer diet and has also been offered at other colleges as a week-long workshop.

 We start the ISE course with an introduction to various strategies for mak-
ing activist art and community cultural work. I share a slide show about activist
art that has many threads: pre-McCarthy era socially engaged art; the first stir-
rings of protest art during the Vietnam War era; early feminist art and contem-
porary work that embraces women's issues; ecological art that ranges from proj-
ects that "reclaim" damaged pieces of the environment to work that addresses the
infiltration of genetically modified foods in our diet; art about racism and cul-
tural identity; art created as part of the antinuclear movement; art about the
AIDS crisis, homelessness, poverty, unemployment, and gentrification; commu-
nity-based art projects; and antiglobalization art.

 After viewing the slides, we begin a discussion that continues in different
forms throughout our time together. We look at satire as it manifests in the form
of "culture jamming," also known as "subvertising," and debate the effects that
it has on viewers. We look at the advantages of showing work in all kinds of pub-
lic spaces: college galleries, museums, shopping malls, city walls, subway cars,
billboards, magazine racks, storefronts, the Internet, beauty salons, laundro-
mats—basically anywhere that people gather.

 We talk about the many purposes of socially engaged art. Here is a partial
listing: to provoke thought, to wake up those who are in denial, to create dia-
logue between groups in conflict, to make invisible groups more visible, to
empower, to heal, to educate, to reveal hidden histories, to celebrate a commu-
nity's strengths, to document, to speak when everyone is scared, to enlighten, to

transform, and to speak to truth. We debate the necessity for strong aesthetics; in other words, does it need to be beautiful or visually seductive in order to attract the viewer?

Next, the students are introduced to a version of an action, research process that we learned from members of the Jubilee Arts group. I suggest that the students work with gut issues, things they have directly experienced. During the brainstorming process, we encourage students to focus on how their issues are interconnected (using some of the theories of social ecology), what their goals are for their piece, who they are trying to reach, and in what context they wish to reach this particular audience.

We also encourage students to continue a version of action/research in their home communities with a team of collaborators. Every community can benefit from this process—whether it is celebrating the creativity of invisible residents; working with the alienation between teens and adults; healing splits among newcomers, transplants, and old-timers; or sharing antidotes to consumer culture. After the students share their action, research work and give each other helpful feedback, they spend the rest of their time at ISE developing new projects (both individual and collaborative ones). In our many conversations, we try to distinguish the difference between many forms of activist art and make no judgments about which form is more important or valuable. Socially engaged art that is produced by individuals working alone can have a powerful impact on audiences. Cultural work that is a by-product of a movement can make a significant impression, especially when the media lens is focused on it. Projects that emerge out of a community/cultural animation process can also have an enormous effect on the public, but perhaps the most crucial aspect this particular work is what it does for the community itself. The key point here is that one form might be more appropriate for a particular intention and context, and each artist needs to evaluate those choices based on her or his abilities.

The two-week schedule of our current version of Art, Media, Activism, and Social Change includes many different components: social ecology theory, media theory, hands-on technical workshops, a practicum on media literacy, and lecture/demonstrations by visiting artists like the Beehive Collective (whose anti-globalization projects take many forms) (www.beehivecollective.org), Graciela Monteagudo (member of Bread and Puppet Theater and creator of her own street theatre projects concerning the Mothers of the Disappeared from Argentina) and Seth Tobocman (founder of World War III comics—a publication whose artists have focused on many social issues, including homelessness and the squatter movement of the Lower East Side).

We are continuing to learn how to teach this material. Our students are always giving us new ideas about ways to make the material more accessible. My great hope is that all of them will continue to find ways to make socially engaged art in a society that does not always welcome their work, and they will become educators in different capacities.

We have had many success stories, but I will only list a few here. A student from our weeklong course at Hampshire College recently co-founded the Cycle Circus, also known as Puppets on Bikes. This diverse group of cyclist performers and cultural activists based in Austin, Texas, focuses on border issues and looks at how the Free Trade Agreement affects the people who live there. Using puppet shows, comic books, and "cantahistorias" (they sing or chant a story with pictorial banners), their collaborative work looks at the life of sweatshop workers along the Texas-Mexican border (www.cyclecircus.org). A recent ISE student went home from our workshop to continue a series of video and audio projects that look at how patriotism is manifesting in the public sphere in Urbana-Champaign, Illinois. Two students from my southern Californian days are collaborating on political art projects in Seattle. They also teach in Art Corps, an after-school arts program. One of them serves as the Seattle Public Arts Commissioner, bringing his social consciousness into the public art sphere.

Widening Circles

After 20-plus years of lecturing on activist art, I am sometimes discouraged when audience members come up to me and say, "I had no idea that there was art like this. It is so inspiring." This feedback suggests to me that what little art education most people receive is not giving them a broad range of models. At a time when the most innovative frontiers of education are exploring the interdisciplinary, it would make sense that more art educators would be attracted to socially engaged art. Of course, as I mentioned previously, there are many institutions that are quite frightened by the idea of critical thinking. These art departments will continue to happily graduate students who stop making art within a few years of graduation because they can't find a way to survive in the art world as it is currently constructed. Sadly, many of these graduates think that it is their fault. What a benefit it would be to society as a whole to have more artists who feel a sense of social responsibility and who have the passion to continue making their work despite the obstacles.

Five years ago, I was invited to join the faculty of the new and innovative program, the MFA in Interdisciplinary Arts at Goddard College (www.god-

dard.edu). In many ways, this program manifests a part of my dream for a socially engaged art education. Students in this low-residency, long-distance program are asked to develop or strengthen their artistic voice and to look at their work in terms of personal story, social engagement, healing, and spiritual growth. Like other Goddard programs that are based on John Dewey's philosophy of learner-based education, students must develop their own study plan with an advisor each semester. Critical thinking is an explicit part of the program's goals. As part of the five semesters, students must spend at least one semester working on a community-based art practicum.

This program has attracted some of the most remarkable students and faculty I have ever encountered. One graduate is doing audience participatory installations and workshops in the local high schools about body image and eating disorders. Another former student is doing performance art and videos about newly revealed stories about the U.S. involvement in Korea. The graduates from this program are teaching, exhibiting, raising money, and facilitating projects all over the world. My excitement about the work Goddard graduates are doing could fill another chapter.

Just as this final draft is going to press, I am about to move across the country, again, to join the faculty of the Interdisciplinary Arts and Sciences Program at the University of Washington, Tacoma. I will be developing new curriculum in the arts to be part of an Arts, Media, and Culture concentration. With the collaboration of the progressive educators who will be my new colleagues, I hope to be able to shape a program that will be a model of how to teach the arts for personal and social transformation. And like the work coming out of the Goddard program, I would like to see our new program provoke resonating and exciting ripples to spread all over the place.

At this particularly challenging time in our nation's history, when civil rights are being curtailed and public dissent regarding the dominant political will is either being ignored or suppressed, the arts can play a key role in generating more democratic discussion of social policy. The arts can also give us a sense of hope and possibility in a time when many are losing their will to believe in a just and thriving future for the people of the world. I try to remain optimistic that more of us will use the arts to provoke dialogue, empower the invisible and alienated, raise questions about things we take for granted, educate the uninformed, to heal rifts in polarized communities and within individuals who have been wounded by society's ills, and provide a vision for a future where people can live in greater harmony with each other and the natural world. Perhaps the work I have been doing will inspire others and keep the passion for social change burning.

Endnote

To contact Charles Frederick, please email c.frederick@worldnet.att.net.

Reference

Postman, N. and. Weingartner, C. (1969). *Language in America*. New York: Pegasus.

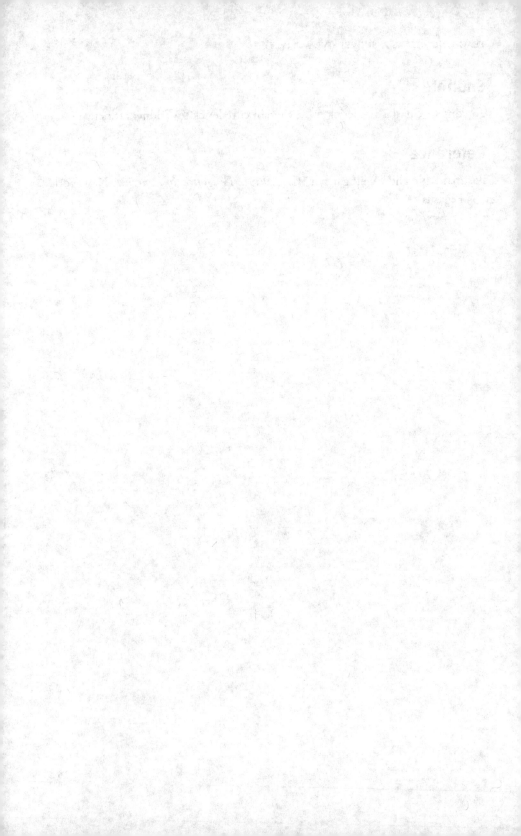

CHAPTER SIXTEEN

Theatre by Women: Development Projects in Rural Ghana

Shabaash M. Kemeh

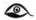

Waves of Change

The latter part of the 1980s ushered in the theatre for development concept in Ghana, and the Theatre Arts Department of the University of Ghana was the cradle for this. It all began with a group of instructors who had become disillusioned about the didactic theatre model used for community education and development. We felt that it was unilaterally packaged; the themes were too general, and it failed to meet the felt needs of target populations. We began to search for a more pragmatic, inclusive form of theatre. We found the answer to our quest in theatre for development (popular theatre), a new brand of theatre that began to emerge in the late 1970s in other African universities. It was based on the conscientization theory of Paulo Freire and the theatre of the oppressed of Boal. Kidd and Rashid (1984) referred to this type of theatre as theatre "of the people, for the people and by the people." In a nutshell, it is an intervention tool for raising the consciousness of the oppressed and marginalized people and has the power to challenge them to transform their socio-economic conditions. I was thrilled by this theatre concept as it resonated well with the progressive artist-educator spirit in me. As an adherent of Dewey's democratic education principles, equity, freedom, and social justice mean a lot to me. I feel passionate about championing the cause of the less privileged in society. I also believe in giving voice and empowerment to these folks to learn and solve problems for the betterment of their lives. Theatre for development was a perfect fit for my

aspirations to make a difference in the lives of others.

In 1987, my colleagues and I founded the Theatre for Development Collective, a small group of professors, teaching assistants, and students. The general process includes action research, data analysis and prioritization, play making, performance, and follow-up activity. We modified the techniques slightly to create our own version of theatre for development and experimented with it with do-able projects within and outside the university.

Three years after its inception, our collective reached the apogee of its operations and had become popular within the university community and beyond. We did numerous projects in inner cities, small towns, and villages on issues such as teenage pregnancy, functional literacy, child abuse, child delinquency, and primary healthcare. Our successes inspired me to get more involved in community organizing and social change activities. It also strengthened my resolve to take on the theatre-for-women-by-women project.

The Genesis of the All-Women's Theatre Workshop

In November 1991, the executive director of the Theatre Collective called me in to talk about a new project. I began to fantasize about where the next project would take us. In a state of excitement, I burst into the room without the usual courtesy of knocking on the door. My eyes instantly caught sight of an elegant woman in her thirties sitting on a chair a few feet away from the director's solid mahogany desk. She stared at my impolite entry. Just as I opened my mouth to apologize, the executive director said, "That's how young bachelors behave these days." He motioned me to sit down, and the three of us laughed at his joke. "The 31st December Women's Movement (31 DWM) want us to train a cadre of women theatre activists for them, and I need your input in the discussion," he said after he had introduced the woman as the project director of the 31 DWM. "This sounds interesting," I thought to myself. She spoke with a smile, "You know, most women in our towns and villages toil a lot, and yet, they gain nothing out of that. It's like… 'monkey dey work bamboo dey chop'…see what I mean? Their livelihood is deplorable. So our Movement intends to intervene. We want to use the women you'll train for us to mobilize and educate these poor village women." I kept nodding while I glanced at the project proposal, which the executive director gave to me. The three of us talked about the proposed workshop and logistics. "Hey, big bachelor, this is your last chance! Who knows…you might find a spinster there as a qualified candidate for the altar…it's long overdue," joked the executive director.

The project's purpose was to break the cycle of poverty of rural women in the country. Indeed, many women in small towns and villages in Ghana are small-scale farmers. They work more than men in the agricultural enterprise (Kaul and Ali, 1992). Unfortunately, they do not reap the cash benefits of their hard labor. Male heads of household have the power to make decisions on income expenditure, property, and family affairs. A double tragedy for the rural women is illiteracy, because the society prefers the education of boys to girls. Therefore, most women do not have formal education and the qualifications to be wage earners in public jobs.

These practices have marginalized and impoverished the majority of our rural women, who have become virtually dependent on men. As a result, they do not have adequate financial resources to afford decent clothes, good food, and healthcare. They are susceptible to stress and general and reproductive system diseases. They are abysmally submissive to male domination. All these factors have eroded the ability of women to fight for their socio-economic, marital, political, and educational rights.

Bukh (1979) saw the possibility of changing these deplorable conditions of rural women. She suggested that they should be mobilized by grassroots organizations of women by women. This was exactly what the 31 DWM had in mind. The theatre for development outreach collective accepted the invitation to run the workshop to help the movement realize its goal. For my colleagues, this might be business as usual, but for me, it was special. Why? I was a product of a rural upbringing by an illiterate mother. I had walked long distances with her in search of water in streams. I had traveled miles on foot with her to work on the farm. We would start at dawn and return at dusk with heavy loads of foodstuffs and firewood. She was a jack-of-all trades! My sweet mother did all this to get food on the table for the family, take care of our health, and to fund the education of me and my siblings while Papa was away working in the city. So I had witnessed firsthand the toils and sacrifices of women in a harsh economy and a male-dominated society. It was awful. I felt betrayed by the fact that some men in our society today still do not believe that women also need to enjoy the "goodies" of life. I always wanted to speak out against the socio-economic degradation of women, but I never knew how I would do that until this women's theatre workshop request came. I, therefore, saw my involvement in the project as my personal contribution toward the liberation of oppressed women.

Workshop Participants

The two-week residential workshop took place at the Post and Telecommunication Training Center in Accra. The participants were 20 women drawn from the Greater Accra and Eastern regions of Ghana. The average age of participants was about 30 years. There were six teachers, six traders, one hairdresser, four farmers, two secretaries, and one seamstress. They all had a basic education. Every participant could speak at least one Ghanaian language such as Ga, Twi, and Ewe. None of them had any acting experience.

One week before the workshop began, the theatre collective decided to use two villages for the action research and performance. The villages we selected were Keetasie in the eastern region and Oshieyee in Greater Accra region. We had a respectable insider in each community as our contact person. With their assistance, we went through the traditional protocol to gain access to the community. In Ghana, chiefs and community leaders are important gatekeepers for political, educational, economic, and social development programs. They cannot be bypassed by outsiders because they have the power to mar or make a success of programs intended for their communities.

The Workshop Gets Underway

On the morning of the first day, we had a brief orientation ceremony to outline the purpose and direction of the workshop. There were visible signs of excitement and trepidation on the faces of the participants. I overheard some of them brag that they would soon become famous like Mame Dokonoo, a popular star of vernacular television drama in Ghana. I also observed that some of them tried to hold back their emotions. I interpreted this attitude as the fear of the unknown. They were probably not sure if they had the talent to be great actors or the stamina for the long hours of rehearsals mentioned during the orientation.

Our introductory warm-up exercises were not the usual theatre games. Instead, we rallied the women to do traditional drumming, singing, and dancing. We sang popular patriotic, religious, love, and social songs. Drummers in the theatre collective provided the music. A convivial atmosphere gradually began to engulf us, and the women gyrated to the pulsating rhythm of the drums. Four women gravitated to the center of the dance circle and enchanted everyone with their graceful singing and dancing. Soon they led the singing and dancing, determining the songs and dances to be performed. Whenever I joined this small band of

women in the inner circle, the drumming, singing, and clapping would rise to crescendo. All the other performers would wave their handkerchiefs or raise their fingers in "V"s, yelling, "Go down on it!...Go down on it!" When the session was over, we were all intoxicated with excitement. The participants said that the "exercise" was therapeutic, helping them to loosen their bodies, throw off their inhibitions, and get energized. In an indirect way, trust and community building began to develop among all of us.

We told stories in small groups. Members in each group were asked to share Ananse stories or folktales from their localities. Then each group selected one story to share with the rest of the women. "Ananse and the Pot of Wisdom" story took the number-one spot among the stories told by the groups. In this story, Ananse, the spider, schemed to become the wisest person in his village by conniving with the fetish priest of the village to execute his diabolical plan. They used magic to collect the wisdom of all the people in the village except the son of Ananse, who was protected by the gods (without their knowledge). Ananse then sneaked out of the village alone to a remote, uninhabitable part of the forest. He made several painful (because he placed the pot between his stomach and the tree while he climbed) and unsuccessful attempts to climb a very tall tree, where he planned to hide his pot of wisdom. His son, who had secretly followed him and watched his father's stupid ordeal, shouted with glee, "Oh, Papa, you better put the pot at your back." Ananse was so frightened that the pot dropped and broke into pieces. And that was how wisdom became scattered throughout the world.

This simple story helped the women make use of what they knew from their culture to retool their skills in listening, concentration, imagination, creative interaction, negotiation, and decision-making. All this would be vital for the play making later on.

In the afternoon, we planned to visit two villages; none of the women trainees came from these villages. The idea was to have participants familiarize themselves with the people, the issues, and the environment. Before we took off, we briefed the participants about the general do's and don't's of participatory research. We invited their views about what we might do to derive maximum benefit from the initial visit for the research. They suggested visiting people in their homes, marketplaces, lottery kiosks, small stores, and the village plaza. They also suggested that they should observe and interview people about such subjects as economic activities, population, diseases, land issues, taboos, schools, social infrastructure, and personal likes and dislikes. It was agreed that participants should be friend-

ly and respectful. They should also try to interview both individuals and groups and cross-check information with different people.

The first village we visited was the farming community of Keetasie. We went to the chief's palace to introduce the workshop participants to him and his elders. We gave the participants a fixed time to meet at the palace. Then they dispersed in twos and threes to look around and get a general sense of the people and the community. I was in the company of two participants when we met a chatty seventy-year-old woman. "We knew you'd be coming. The gong-gong beater made the proclamation last night. You should have seen how women and children welcomed the news!" she exclaimed. "Will you people do me a favor?" she asked. "What's on your mind?" was the response from one of the women. "I want to be in your play...yes, I think I can act like the old lady in Obra's drama troupe which comes to perform in the village," she said. We all looked at each other in consternation. "Grandma, we like your wonderful offer, but the activities will be too strenuous for your aging bones," I pointed out respectfully. She led us to her home as she told us the history of the village. She gave us a basket full of oranges in appreciation of our mission in the village. She promised to let her daughter participate in the play instead of her.

We left the village at the appointed time. We traveled to Oshieyee, the second village, and went through the same process of touring the community with the assistance of our contact person, a teacher. When the tour was over, we had a debriefing session. The participants noted that the people in both villages were very friendly, but the women were more eager to chat and share stories about issues than the men were. Both men and women questioned our motives for the play, but it was the women who showed interest in participating in the play. I felt the greater interest of women in the play was a matter of gender alliance. The village women probably thought that the participants were their "sisters" with whom they could share personal stories. They did not hesitate to share stories about how they often worked hard for their husbands without adequate remuneration to buy beautiful clothes and other good things they wanted. We talked with the participants about the advantages and disadvantages of such an alliance with the village people. In the end, they agreed that it was important to maintain neutrality in the actual research process.

The second day started with playing traditional Ghanaian games. One of the games the participants liked most was "Tsye tsye kule." They formed a big circle with a volunteer at the center who chanted "tsye tsye kule" accompanied with synchronized movements of different parts of the body. Those in the circle

repeated the chant and mirrored the body movements of the leader. The participants enjoyed the rhythmic movements, vocalization, group interaction, and the general physical exertion from the games. We asked them to discuss and identify the benefits of the activity. They did not hesitate to mention trust, cooperation, problem solving, self-discipline, focus, self-confidence, and the release of mental juices. We discussed with them how these activities might be relevant to the village research, the play making, and performance tasks. "It's important for us to behave ourselves in a manner that will let the villagers trust us," volunteered a participant. Another remarked, "The activities made me smart. I was able to think, move, and act quickly on my feet." Someone else interjected, "Uh, huh...you're right. I felt the same. Very soon we'll all be acting like Adwoa Smart." This was followed by instantaneous raucous laughter from everyone, including myself. Adwoa Smart was a great star in vernacular drama on national television, and rumor had it that she always played those comic roles to compensate for her very insignificant physical appearance. From every indication, this particular phase of the process helped us to begin laying the foundation for the participants to sharpen their observation, critical thinking, creative imagination, and acting skills.

We introduced the participants to the basic theatre elements vital for play making. These include plot, characters, dialogue, conflict, suspense, music, props, costume, environment, mood, and feelings. We simplified the process by using folktales and the Ananse stories they had told the previous day. We divided them into four small groups. Under the leadership of members of the collective, they were guided to identify those simple elements. We went further and helped them to use tableau technique to capture the significant moments of the story or the beginning, middle, and end. This led to a discussion of feelings, thoughts, and creative interpretations of characters in a given situation. Finally we modeled how they could activate the tableaux pieces into very short improvisations. In "Ananse and the Pot of Wisdom" story, for example, one group worked on the scene between Ananse and the fetish priest. First, they retold the conversation between the two characters. Second, they analyzed the behavior of each character and what they said to each other in the situation where they plotted to collect the wisdom from all people. Third, they worked in pairs to create the tableaus of the two characters depicting moments of hatching the plot, performing the magic rituals to invoke the spirits, and the priest handing the pot of wisdom to Ananse. Each tableau represented a frozen image of the action. And fourth, the participants in the statuelike posture were given a cue to bring the

statues alive. This was the improvisation stage, where they moved, spoke, and behaved like characters they represented. At this stage, we had the group members reflect occasionally on the dialogue, role portrayal, acting skills, and the realistic nature of the vignettes. I noticed that the participants were improving their acting skills tremendously. It was amusing to hear these participants flatter themselves about becoming accomplished performers.

Research and Data Analysis

The third and fourth days were utilized for data collection and analysis of issues in Keetasie. There were more women, children, and elderly men in the village than educated young men, but there were no major public or private jobs for the population. The men were farmers and carvers; the women were farmers, traders, and sellers of pineapples and oranges. The women generated insufficient income from their farming and trading. There was no public latrine for men; there was no clinic and only one public latrine for women. The only pipe-borne water facility was not in good condition, so people obtained water from streams. Women had no interest in family planning.

Hamilton (1992) believes that empowering is a partnership process, in which the views and feelings of local people must be solicited and valued. My colleagues and I believed in such a process. We bused the participants to the village twice to share the list of what they considered issues. After long critical discussions with the villagers, one salient issue of women in the community was selected— job avenues leading to more economic power for women. The village women were forthright in arguing that with more money they could live better, as well as support their families.

The fifth and sixth days were used for research at Oshieyee, which had a larger population than Keetasie. The men engaged in fishing and farming; the women fried and smoked fish. There were more children than adults and more women than men. The issues here included malnutrition, overpopulation, lack of interest in family planning, no public latrine, truancy by children, women who were completely dependent on men, minimal cash flow, and poor personal hygiene and community sanitation. The general belief in this village was that children provided cheap labor and were financial assets in the sense that having several children was a guarantee that the parents would receive an appropriate funeral. The most important issue for women in this community was family planning.

Playmaking and Rehearsals

Since the second day, we had always started the day with dances and games. We now tried to incorporate additional drama exercises from the Ananse stories and tableau activities to improve their improvisation skills. At this stage, the participants were divided into two groups. Each group chose one of the villages and was guided to create a short improvised play based on the prioritized issue of the community they represented. The group that chose the Oshieyee village worked on family planning, and the Keetasie group worked on diversification of job avenues to bring in more cash income for women. The information gathered from the villages was used. The process involved intensive questioning, critical analysis, and discussion of the problem. The researchers asked the Oshieyee group probing questions: Why did the women in the village choose it as the most important issue of concern? What was the root cause of their ignorance or lack of interest in family planning? What shocking personal stories did you hear from the women? What were the specific problems encountered by the women through that experience? What was the attitude of the women at the center of the issue? What were the attitudes of their husbands, friends, and relatives? How did they address the problem? What other ways could they have addressed the issue? What were the implications for the women, their immediate relations, and the village community of not dealing with the problem? The analysis and discussions that ensued yielded a general storyline about a 25-year-old woman called Adjeley, who was married and had six children. After the birth of the sixth child, she suffered from protracted ill health. Her friend, Akweiley, who had only three children, advised her to go for counseling on family planning. She did not heed the advice because of her personal apprehensions and the vehement protests of her husband. She became pregnant again but lost the baby at birth and her own life, due to delivery complications as a result of excessive bleeding. This story was transformed into actable scenarios followed by rehearsals.

The rehearsals entailed constant stoppage, evaluation, and replay of scenarios to explore depth of characters, believable relationships, and multiple perspectives on finding solutions to the issue. Traditional music and dance, which were relevant to the plays, were also incorporated. It took four days to get the plays ready. Women from the villages who were interested in the plays were transported daily to the workshop venue. They got involved as actors, singers, and dancers. It was a wise move on our part to include these village women in the play-making process. During the freeze-critique-replay sessions of the rehearsals, these women were not afraid to voice what they perceived to be inaccurate representations of

the true feelings or behavior of the village men and women. They would boldly enter the scene to demonstrate the real picture of the experience. The end of such demonstrations were often greeted with joyous choral exclamation, "Ah, haa...that's it!" from the village women. The involvement of these local women really gave great authenticity to the issues enacted in the plays. They also helped to advertise the plays by word of mouth in their communities. This refueled the interest of those women who could not come to participate directly in the play-making process. Through their colleagues, they donated props and costumes that were needed for the play.

Play Performance and Discussion in Keetasie Village

The chiefs and their elders from the two villages came to preview the perform-ances on the 11th day. They were comfortable with the issues and talked about how they might help. We also invited some family planning personnel, commu-nity development experts, and a few representatives from the 31 DWM for the showcase. They gave us useful suggestions to enrich the two plays after the pres-entation. This chapter will share only information on the Keetasie performance and feedback.

On the following day, the group went to perform at Keetasie. Our contact per-son in the village worked with the chief to get the venue ready for us. There were approximately 200 audience members (twice as many women as men) waiting anxiously before we arrived at the village square. The chief and his elders were also present. The performance started at 4:00 p.m. and lasted about 30 minutes. Post-performance discussion lasted for another 30 minutes. Although seven women from this village helped in crafting the play, only five acted in the live performance with the workshop participants.

The play, *Had I Known,* was about the hardworking women in the village of Ahuntem who struggled to survive on the sale of oranges and pineapples grown in the village. They never made a profit in this business because traders from the big towns and cities always cheated them. They also suffered great loss when the fruit was exposed to the vagaries of the weather.

In the skit, a prominent businessman and his wife came to visit Ahuntem to survey the village in order to build a fruit-processing factory. The wife wanted to go to the toilet, and she was led to the house of a rich woman with a private latrine. The caretaker turned the wife and her guide away, forcing them to go to the public latrine. She was bitten by a snake on the way, and the national news-paper captured the story of the incident, noting that the couple then abandoned

Ahuntem and set up the factory in another village that became very prosperous. The news reached the chief of the village, who summoned all the people to his palace. The play's ending was left open ended so that the audience could discuss solutions to the issues raised. What alternatives should the women explore to diversify their cash income since they lost the opportunity to have a factory in the village? What would they do to address the need for a public latrine that was not far away in the bush? And how would they deal with the attitude of the caretaker?

At this point, the facilitator led the audience to find solutions to the issues raised in the play. These, of course, were the real issues of the women and the people of Keetasie. Despite the uproar and applause of the comic scenes, the people were quick to see that the play was about them. The women in the audience became more vocal than the men about the need to curtail the sufferings depicted in the play. The village women who collaborated with our participants throughout the entire process had greater confidence to speak on the issues than those who did not. Some of the men also made constructive suggestions when they realized the seriousness of the women's socio-economic conditions. The debate got heated as the women began to press for answers and action. When I stepped up to stop the discussion, the entire audience protested, "No...! No...! Don't stop it. Let's go on!" It was getting dark and there was no electricity, but the chief promised to coordinate another meeting for further discussion and action.

Performance Outcomes

The 31 DWM representatives in the audience used their own evaluation team, which later assessed the training workshop right from its beginning to the village performance and the post-performance discussion. They interviewed the women trainees, the village women who were directly involved in the play preparation and performance, and the chief and elders, including some men and women who were audience members. The evaluation revealed that the process succeeded in creating the awareness, especially for the women in the village. At the beginning, the village women did not know that if they organized themselves into cooperatives, they could get loans to diversify their one-way economic activity. They also did not know that they could use pineapples for local gin distillation or make jam from oranges and pineapples, but the performance and forum sessions brought this vital information to light for them. One week after the workshop experience, about two dozen women from the Keetasie village expressed interest in forming a cooperative. They contacted the 31 DWM district office in

Koforidua for monetary, educational, and organizational assistance about the use of oranges and pineapples in multiple ways for more cash income. The chief promised to give a piece of land for the latrine. A naval officer from the city who was present at the performance donated 10 bags of cement. A couple of young men in the audience volunteered to provide free labor for the construction of the latrine.

The report also acknowledged that the theatre experience had demystified male superiority for these rural women. It mentioned, specifically, that women in this village community were able to find their voice to participate in decision making on educational and economic matters that directly affected their lives. They were poised and unafraid to take proactive steps to find solutions to their problems. The report concluded that the workshop provided the expertise needed by the trainees to become effective theatre activists for the 31 DWM.

The success of the workshop was not as heartening for me as the 31 DWM's establishment of a theatre for development unit at the national office in Accra. A theatre for development professional, trained at the University of Ghana, was hired to head the unit. She paired the trained women activists to go to villages to work with women to identify and address their socio-economic problems through the theatre process. After some time, the 31 DWM found that the theatre by women, for women, and with women methodology helped them to mobilize women in rural communities in larger numbers than political rallies, radio broadcasts, or lectures did. The laissez-faire attitude of these women also began to change remarkably to a high-level commitment to issues that would improve their lives. For example, following the theatre experiences, there was significant enrollment in an adult literacy class by women in some villages in the eastern region. Those women realized that literacy was vital for greater self-esteem, knowledge, and power. In other villages, the theatre programs were the harbinger for small-scale cottage industries by poor women farmers and other dispossessed women to generate more money to elevate their livelihood. In other cases, women participated in reproductive health education and services because they had learned how important it was to maintain good health in order to use their creative talents for economic activities that would make them self-reliant and prosperous. I felt that these positive responses on the part of the village women began to evolve because they were not patronized. Instead, the inclusive theatre process in which they were equal partners in the decision making strongly inspired them, raised their consciousness, changed their attitudes, and galvanized them to take ownership of what they had to do to transform their living

conditions for the better (Epskamp, 1989). Once the theatre activists were able to achieve these initial objectives, the financial and other administrative sectors of the 31 DWM moved in to work with the groups to explore further assistance to bring their self-determined dreams to fruition. In most instances, credit facilities, technical expertise, educational, and other related logistics were provided by the Movement in collaboration with government ministries and international organizations like the United Nations Populations Fund (UNFPA).

It is no secret that rural women in other developing countries also live in abject poverty. They do not have equal access to land, capital, education, and technology in the agricultural economy. They are vulnerable to the exploitation of men and institutions. Rural women in India, for example, no longer have their traditional farming jobs. Devdas and Sundaram (1988) pointed out that these women have become unemployed and poor because men control the means of new farming technology. In situations like this, these women farmers and other marginalized women in developing countries need reliable channels to break the silent suffering they endure. They have to have the support of a sisterhood network, such as the 31 DWM, to fight for their rights and liberation. In my view, therefore, women's organizations in developing countries should take a second look at the theatre of women, by women and for women, model. If properly adapted, it could serve as a golden key among other strategies for sensitization, education, and empowerment of women for socio-economic advancement. Then, one day, we can all proudly sing a dirge at the funeral of the axiom "the place of women is the home!"

References

Bukh, J. (1979). *The Village Women in Ghana: A Study of Social Change*. Uppsala: Scandinavian Institute of African Studies.

Devdas R.P. and Sundaram P. (1988). Technologies don't happen. They have to be generated. *Indian Farming*, 38, 51–55.

Epskamp, K.P. (1989). *Theatre for Social Change: The Relative Significance of Different Approaches*. The Hague, Netherlands: CESO

Hamilton, E. (1992). *Adult Education for Community Development*. New York: Greenwood.

Kaul, R.N. and Ali, A. (1992). Gender issues in African farming: A case for developing farm tools for women. *Journal for Farming Systems Research*, 3, 35–46.

Kidd, R. and Rashid, M. (1984). Theatre by the people, for the people, and of the people: The people's landless organization in Bangladesh. *Bulletin of Concerned Asian Scholars*, 16, 1, 30–45.

CHAPTER SEVENTEEN

Rethinking Practices in Community-Based Arts Education

Jim Sanders

Practitioners who deeply reflect on the values they bring to the arts education set-
ting may be better equipped to rethink and revision pedagogical practices, cur-
riculum content, and policies within their institutions. This practice of inspect-
ing the often-unspoken messages embedded in arts programs and our agencies'
cultural histories may prepare teaching artists and cultural institutions to
respond to student experiences. In this chapter, I consider the policies and pro-
grams of a community art school, discussing and problematizing the institution's
efforts to serve a multiracial constituency throughout its 57 years of operations.
I encourage artist-educators and their institutions to join me in deconstructing
hegemonic practices, considering how arts curriculum and policies serve or limit
the possibility of equitable social change through the arts.

Arts education practices that reinscribe cultural orthodoxy must be revi-
sioned if we are to serve students in new and more meaningful ways. Through
dialogue and reflection with diverse rosters of artists, scholars, human service
agencies, and students, all may engage in the unlearning process: deconstructing
received cultural policies, aesthetic theories and working toward the ends of
redressing cultural and social injustice. This revisioning process echoes Patti
Lather's notions of research as praxis, "committed to the development of change-
enhancing, interactive, contextualized approaches to knowledge building"
(Lather, 1986, 260).

As well as academic arts agencies, community-based arts and craft organiza-
tions and non-degree-granting community schools of art need to reexamine their

institutional practices. This challenge extends to art education, the post-positivist's critique of the "inadequacies of positivist assumptions in light of the complexities of human experience" (Lather, 1986, 260). Post-positivism argues that the present orthodoxy in the human sciences is obsolete (Hesse, 1980, Reasan & Rowan, 1981; Rose, 1979; Schwartz & Ogilvy, 1979. I argue that questioning of orthodoxy in the visual arts is essential if art educators are to develop new visions for generating social knowledge among and between artists, students, and their communities.

Recounting one agency's change initiatives, I challenge readers to consider how traditional arts education practices and aesthetic theories must be re-adapted to address social problems facing our community's youth, including racism, elitism, homophobia, and economic injustice. Sharing lessons learned and problems faced while transforming an institution's engagement with critical issues and service to at-risk youth, I argue that (unintentionally or not) socially constructed cultural concepts, if uncritically taught, may lower (not develop) students self-esteem and foster (not discourage) their feelings of cultural inadequacy.

As I weave the story of my institution's[1] cultural and curricular change initiatives, I pull on threads of testimonies from teachers, students, and artists who have accepted the challenges and rewards of engaging students in art studies. As I draw on formal records of this community art school and transcriptions of its conference panels (1989–2001), I explore the ways the arts have been and can be used to serve at-risk students. I will describe how artists, board, community members and staff, in reflection on past and present institutional practices, policies, curriculum, and exhibitions, have supported our agency's revisioning process and supported the development and implementation of new programs and sites of delivery.

The interview questions posed to each subject challenged them to consider arts curriculum and pedagogical practices of the school as inextricably linked to social policies, governance, organizational culture, and economic politics of the day and the possibilities of service to students. The research process and the reflexive practices it demanded of researcher and informants have further shaped more recent institutional transformations. I hold that program and policy revisioning is a palimpsetic exercise and one that requires resilience and ongoing commitment to our change initiatives if they are to meaningfully serve those with least power and authority.

Reconsidering Social Practices of a Community Arts School in the Mid-1940s and 50s

While many arts and crafts instructors were actively engaged in supporting civil rights and social change initiatives, four of the first five I interviewed separated their discussions of art educational practices from their interests in social change. It soon became clear that most had never deeply considered how the cultural institution they served was a part of the maintenance and social constructions of race in this city. Thus, in subsequent interviews, I engaged subjects in reflection about this dynamic and, following the taped sessions, recounted recent initiatives designed to redress cultural inequity.

Well-intended founders of the Arts & Crafts Association[2] were committed to inclusive practices, and yet in its first decade, theirs was clearly the interest of a white middle- and upper-class elite. None of the artist-teachers were paid, and most were women with college art degrees who were married to middle- and upper-class professionals or men working in commercial art who taught others fine art in their nonworking hours. "How did we do so much with all those babies?" asks one instructor from the early 50s. "We had a ball. I had full-time help then—I paid $28 a week—it was disgraceful looking back on it." She, as other women participants, reconsidered how poorly paid black laborers enabled their voluntary efforts in the arts. Another artist active in that same period acknowledges, "I don't remember ever having a black student, but I don't recall any policies in place that segregated students."

The first decade of operation, the Association was housed in the city's first public school and later in an upper floor of a nearby central-city business. Collaborations with local hospitals, libraries, and the city's recreation department illustrated the founding mothers' concern with service to all—especially children in the town—but these were segregated programs as marketing literature from 1945–55 confirms: "classes for Negroes" were held on Mondays. Further inspection of Arts & Craft's minutes, however, reveals that its board of directors was racially integrated and that public meetings during the first decade of operation (1945–55) included the middle classes of both races,[3] denying Jim-Crow-legislated segregation.

Arts & Craft Association's early demographic tracking suggests the group's concern for providing programs serving African American residents. On November 23, 1948, "Mrs. Marsh, Director, reported…there were 361 registrations, with 94 Negroes registered."[4] This demographic mix represents an

unprecedented commitment to the city's biracial population. In those earliest years, all classes were taught free of charge—with memberships and corporate gifts covering the costs of operations. But as Arts & Crafts began levying membership fees for all participants and later added registration fees (increasing those charges throughout the 1950s and 60s), students with little ability to pay (a significant portion of minority participants) were left behind. This dynamic of economics, race, and participation was rarely, if ever, openly discussed at meetings of the organization's board—and even less frequently recalled by interview subjects who were active in the 1940s and 50s.

The October 10, 1952, board minutes recount a declining *Negro* enrollment and the strategies to increase black participation. In it, the board outlines actions that deny segregationist practice by inviting African Americans to their annual meeting and, concurrently, creating a space where black participants could assemble without white intervention. But it is black under-involvement, not white exclusionary practices that is framed as "the problem."[5]

The October 21, 1952, Annual Meeting Minutes, published less than two weeks later, notes:

> ...Negro work at the workshop had fallen off considerably since Mrs. Marsh left....[T]he Association sent letters to school faculty members and other interested Negroes asking them to meet at the Workshop to form plans. About 60 people came and as a result of an open discussion, five new classes were formed.

Recognition that black program participation declined with the departure of the workshop's director suggests an awareness of links between professional leadership and minority participation. It is acknowledged that engaging black leaders to address declining black enrollment resulted in a groundswell of support and the development of new programs. This illustrates how social discourse with those we serve can increase involvement, but it becomes clear that simply offering services and engaging minority communities in dialogue alone may be insufficient.

> There followed a discussion on the problem of attendance on Mondays at the Workshop. Mrs. Williamson...felt that if more Negroes were better informed about the Workshop there would be more interest. She also offered to visit churches and various organizations to solicit memberships into the Association if transportation could be provided for her. Mrs. Williamson said there was a great interest in weaving but the looms were usually full on Monday nights. Mrs. Alexander promised to see that the looms were available for use hereafter.

In these November 19, 1952, minutes, the lack of black participation is blamed on a lack of marketing within minority communities. Mrs. Williamson's (the sole black board member) offer to visit churches and organizations if transportation were provided, raises an issue facing all black students—transportation—for at this time, the group was meeting in a space that was clearly the territory of whites. Further, her access to equipment and materials is but part of a complex of issues regarding facilities shared across racial constructs. Honorably, the president's commitment to make looms available confirms the board's willingness to accept partial responsibility for declining participation.[6]

Roughly 45 years later, as I interviewed African American community leaders about Arts & Crafts' early history, none recalled or would at first believe that any sharing of equipment and facilities ever took place. Only after inspecting historic photographs, news articles, and meeting minutes did interview subjects acknowledge that Jim Crow had been denied. I note these encounters to suggest that reluctance to talk about past injustices may negate what gestures there were toward the denial of social injustice, again arguing that only through dialogue about policies and practices past and present can trust across communities be developed.

In the November 1954 "Report on the Effort to Improve the Monday Programs," the board acknowledges that the "location has proven unsatisfactory," thus suggesting an awareness that location has an impact on community involvement. In its earliest years the group had collaborated with the city's parks and recreation department to provide instruction at all of the city's playgrounds. However, the city board of aldermen's 1948 decision to stop funding arts programs effectively ensured that only an elite group would be served. Public funding (or lack thereof) continues to shape public perception of the arts as an elite endeavor and interest. Changing such beliefs requires ongoing advocacy in political debates about public investment in arts education.

In the late 1950s and 60s, Arts & Crafts classes were housed at the dividing line between the upper-middle-class white and black neighborhoods. "It was a big move" recalled one early educator, noting that the board questioned whether they could "afford to program the three-room facility and actually pay the instructors." Around the same time that a local paper's headline reports, "men take over classes at Arts & Crafts," the institution's faculty finally began to be paid. From 1954 through April of 1956, there is no mention of "the problem" of black participation in the organization's minutes, as the board's focus was on balancing budgets and paying instructors. Art class marketing brochures in 1956

and 1957 note only, "classes for Negroes scheduled upon sufficient demand." The shift from segregated classes to no regularly scheduled programming signaled that the group had largely dismissed any responsibility to serve black communities. During these years, demographics are not recorded in any of the formal documents, and no African Americans were serving on the board. This waning commitment to racial equity reaffirms a tenet of Marshall's cultural paradigm for analyzing education policies in the United States—that of equity, efficiency, quality, and choice—no more than three of these values may operate concurrently.[7]

Reflections on Sawtooth's Contemporary Efforts to Create Inclusive Arts Learning Practices

At Sawtooth's *1998 Congress of Educating Craft and Arts Communities*, strategies for addressing issues of access, inclusion, representation, and dynamics among cultural groups were discussed. One participant remarked, "We do a lot of taking art to the communities, because kids can't get there. Their parents are busy learning English in order to get a job." A second notes, "And the social difference too—of just knowing how to be with someone different. Even if they could get there, it's just awkward." A third describes programs "in transitional spaces...like the Boys and Girls Club, the rec[reation] centers...in housing authority communities. Working with the kids...trying to get to know the community members first...build[ing] a dialogue...supporting their learning and self-recognition as artists, rather than [our institution's] being perceived as the benevolent white organization coming in to do a service 'outreach'." These informants' insights remind us that a sense of trust and responsiveness to each student's circumstances is essential.

An artist-educator with 50+ years of involvement with Arts & Crafts/Sawtooth commented in 1999, "We had a group of people who would go to wherever art was being shown in town (an art appreciation class) and the library was one of those places. It played an important role as a safe space where everyone in the community felt they could meet." This same artist suggests, "I've never really known the difference between black and white....I knew a few people who stuck with a rigid view of society, but Mrs. Marsh (then director) was bright and capable for everybody, so prejudice wasn't an issue." While cultural institutions may seek to take colorblind positions, I argue they cannot ignore larger social practices, for how one "fits" in a program of art study continues to

be a rarely raised social issue. Our reluctance to confront histories of racism, classism, or homophobia limits our organization's ability to imagine or act on needed change, and somehow we must find the will to move through such difficulties.

What does it take to create environments in which difference may be openly discussed? An artist-panelist at two Sawtooth symposia in the 1990s shares his insights on this question:

> If I'm going to be talking about sexuality, being…a black male and GAY…there has to be some other individuals there…otherwise you feel like you are abandoned.… I think it's the same as racism—it's difficult for people to really sort of go there, because…a lot of individuals have not resolved those issues within themselves—heterosexuality or homosexuality or whatever.

In an interview with a second Sawtooth visiting artist, he relates:

> It bothers me. The people…who automatically say about my background…I'm a Mexican.…There's that difference of course that they define.…People often express, "Gee, y'know, uh, you are not at all what I expected."…They'll say, "Oh, you're not effeminate," or "you're not as stereotyped as the rest of them are."…Part of the general public's understanding about gay culture and gay life and illnesses are all viewed as being as one, and it is stereotyped.

Another arts educator with 40+ years of Arts & Crafts involvement acknowledges, "Simply stating that everyone is welcome is not good enough.…" I fully concur, asserting further that only by engaging artists from diverse backgrounds in our discussions of service, curriculum, and policies can we hope to create opportunities for cross-cultural understanding. This process demands that we not only listen closely but that we create multiple venues for such discourses—spaces where the traditional dynamics between majority and minority can be disrupted and stereotypical labeling can be erased. The (dis)ease and discomforts minority artist-leaders endure are problems our institutions must repeatedly reexamine. Resilient commitment to arts education for social change requires vigilant reflection on practices past and present—these are prerequisites for developing equitable programs of arts learning.

Connecting with Communities through Art Education—Rethinking Program Content

Arts & Crafts' quadrupled its physical space and program offerings following its 1982 return to the center city as Sawtooth Center for Visual Design. The first

seven years of operations in this renovated 1910 knitting mill were rife with eco-
nomic struggle as the group attempted to expand minority participation and
increase its professional stature. A sequential curriculum was put into place; ges-
tures were made toward transforming the agency to a degree-granting institution,
and, with local arts council support, the group was providing Art Is House cours-
es for minority students. This latter program, in some participants' reading,
marked a return to racially segregated programming, but for others, it was an
illustration of the area arts agency's equitable distribution of economic resources.
In 1989, Sawtooth initiated a decade of institutional change—one that moved
beyond simple inclusion of others, to a fundamental rethinking of its curricu-
lum. Midway into this initiative, a Lila Wallace/Readers' Digest Community
Arts Education grant (1993–1996), and North Carolina Arts Council Arts in
Education Partnership funding (1994–1998) further enabled full curricular revi-
sioning and a quadrupling of the number of students served. With adequate
funding, Sawtooth fully transformed a formerly Eurocentric approach and now
integrates and acknowledges artists, their works, and techniques from cultures
around the world into studio courses at every level. This revised approach has
broadened the base of involvement, at first through projects and classes that cel-
ebrated cultural diversity. Arts education programs for middle and high school
students have also introduced the concept of public art as a reflection of a com-
munity's values through artist-led slide lectures, writing assignments, gallery vis-
its, and a sculpture project. This unit was the seed of what would become a com-
prehensive plan for integrating the arts in the state department of public educa-
tion's standard course of study.

 In 1990, moving beyond classes and workshops, Sawtooth's faculty/staff
began to expand the school's slide library of visual references. A series of visiting
scholars from Latino, African, African American, Japanese, Chinese, and Native
American cultures was concurrently contracted to conduct training in-services,
working with staff and faculty in inventorying current and potential teaching
resources and program content. These dynamic artist-scholars worked with
Sawtooth's studio coordinators to concretely introduce multiple cultures through
studio art-making processes. This approach was then introduced to Sawtooth
instructors, who were commissioned to publish and present cross-cultural
research for and with educators across the region. This larger group further assist-
ed Sawtooth in refining its core-curriculum-integrated programs, based on their
responses and recommendations.

Curricular change and shifts in pedagogical approach were realized through dialogue with those who informed and reflected on our practices. These inter-personal exchanges—grounded in art making—provided a safe space for dia-logue and risk-taking, where artists and educators could cooperatively develop new ways of looking at and teaching art. Sawtooth sponsored regional curricu-lum development in-service courses, which further involved arts education pro-fessionals across the state, yielding even more relevant curricular reinventions. This process gestured toward a disruption of past top-down reform initiatives, creating spaces for all stakeholders in the construction of knowledge.

Professional Artist Symposia and Their Connection to the Education for K-12 Students

A series of regional symposia and conferences by and for professional artists informed Sawtooth's curricular revisionings between 1989 and 1998. At these annual events, visiting artists from across the United States and abroad led hands-on workshops in multiple media and traditions and led social interactions, group discussions, and panel discussions that engaged all participants. Visiting artist-leaders and participants identified issues for each year's panel discussions, often expanding the theme of the symposia and informing the subsequent year's assembly. Exhibitions of guest artists' works further created a space where stu-dents could reflect on the multiple artists' aesthetic and social concerns.

Symposia-aligned exhibitions served as the focal point of arts in education programs for area schools. Aligned with the North Carolina Standard Course of Study, these units featured syllabi developed by contracted craftspeople, cultural anthropologists, artists, and scholars. In-school segments of each unit included artist-led workshops for classroom teachers, slide lectures, pre-gallery visits, and language art and social studies research assignments. Students' gallery visits were followed by their writing critical reflections, and finally, assisted by Sawtooth artist-educators, students created works in the particular media or culture stud-ied. A broad range of media and social concerns were included in this series. In conjunction with the 1989 Paper Symposium, 2,000 Forsyth County public middle school students pulled Western-style paper and learned Japanese bindery techniques. The program reinforced students' core curriculum examination of Eastern and Western aesthetic and cultural practices, inciting students' develop-ment of critical thinking skills. Group discussions and gallery and studio tours inspired students' involvement and grounded abstract concepts.

In 1990, the *Fiber Art in the 90's Aesthetics and Technology* symposia examined the intersection of the arts and commerce. In-school slide lectures and hands-on activities linked social studies of fiber arts with women's roles in the Industrial Revolution and the development of child labor laws. A *Color Symposium* in 1991 examined cultural, commercial, and aesthetic histories of color through the eyes of racially diverse artist-leaders, who denounced notions of a universal language of visual art. Culturally specific color meanings and shifts resultant from cross-cultural interaction were central concepts in programs serving every seventh grader in our county's public schools. This theme was again considered in Endangered Cultures, a middle school program addressing international commerce, communications technologies, and globalization's impact on indigenous cultural practices and artistic expressions.

The identity problematic was repeatedly considered by Sawtooth in the 1990s. In 1992, *Cultural Foundations*[8] examined relationships among ethnicity, patterning and design, and cultural identity. African American, Native American, Japanese, Hispanic, Caucasian, male and female surface designers participated in exhibitions and presented hands-on workshops, lectures, and panel discussions. Beyond interrelationships between race and national identity, the group's discussions of cultural meaning considered their multiple identifications as feminist, gay, lesbian, and bisexual artists. These discourses challenged educators to reflect on the multiple ways identity is constructed within and across race, faith, gender, and sexual and economic boundaries. In 1993, at *Design and Content* (a symposium addressing the use of cross-cultural aesthetic and technical referencing in art production and teaching), racially diverse artist-leaders further examined how identity, cultural interaction, and economic policies have impacted artists and communities. Fifth grade teachers and students, who, in turn, considered how artists and agencies of art presentation reflected varied values and beliefs, viewed an exhibition of their work.

Challenging Public Conceptions about the Artist's Role in Building Communities

In the fall of 1993, Sawtooth hosted *Art and Ethics*, a conference and exhibition series that considered how artists and human service agencies collaborated to address issues of human need. Nearly 100 corporate and nonprofit leaders shared a day of museum and gallery experiences and participated in panel discussions and workshops. The program illustrated how arts education programs can

inspire community redress of poverty, racism, sexism, elitism, and homophobia. An exhibition entitled *Artist as Activist*[9] and an interactive workbook, *Making a World with Art in It/Making Art with the World in It*,[10] gave form to the ideas circulated at the conference. With local corporate and foundation support, the publication was distributed to all educators in 13 counties of the North Carolina Piedmont Triad, and follow-up in-service workshops were conducted to ensure its best use by classroom teachers.

In 1994, participants at *Craft and Ethics*[11] continued Art and Ethics' discourse regarding artists in communities. The five-day event provided an opportunity for national leaders to review conditions in the field and set goals and strategies for addressing critical issues. A summary of the proceedings, including goals and personal and institutional commitments for building inclusive institutions, was published in trade journals across the craft field. A half-dozen exhibitions, numerous workshops, and policy changes in craft agencies across the country resulted from this assembly.[12]

Expanding issues of meaning and representation to technologies, access, and voice, in 1995 and 1996 Sawtooth conducted research on computer and Internet technologies use within the nonprofit arts and education sectors of North Carolina. Assembling visual arts institutions from across the state in two working meetings, the disparities between schools and organizations in low-wealth and more affluent counties were identified. That same year, Sawtooth co-hosted Arts North Carolina's 1996 Conference, co-planning the technology day and hosting a discussion entitled *Resisting Technology*—a dialogue refuting the overreaching claims of some Internet theorists.[13] Addressing arts and technologies' shaping of social change, Sawtooth hosted *Building on Traditions* in 1997—a series of workshops on folk craft and at-risk technologies that considered how forms and physical and somatic histories are challenged by virtual communications. Later that year, the North Carolina Art Education Association meetings in Winston-Salem included three workshops on interdisciplinary curriculum development and discussions regarding art, technologies, and economies of children living on either side of an increasingly cavernous economic divide.

Reflections on the Revisioning of Social and Cultural Practice in Art Education

A national *Congress of Educating Craft and Arts Communities* was held at Sawtooth in 1998. Conceived as a laboratory for artists, students, faculty, and

administrators to explore practices in pedagogy, governance, and curriculum, 60+ participants from a dozen states shared their agencies' programs, policies, and evaluation methods. Participants reflected on the roles of leaders of arts institutions committed to social change. Congress conferees reconfirmed the arts' role in developing and sustaining healthy and productive communities while grappling with issues of accountability, program success, and inclusivity. Artist-leader Joyce Scott challenged administrators to create assessment tools that could raise social and cultural awareness among student populations—designing evaluation forms that challenged students and artist-faculty to consider their role in the construction of social problems. Others, like the artist Rev. Charlie Newton, shared strategies for entering and working with inner-city neighborhoods. His grasp of the support children needed in both developing disciplined study and articulating their visions of hope for the future (especially in refutation of larger media representations) were illustrated in "bus-sized murals" at each of the city's four neighborhood's recreation centers. Rev. Newton led a tour to his most recent mural at the Twin City Ball Field, later engaging the largely white participants at the conference in reflections about their racial, economic, and cultural assumptions.

In more recent years, Sawtooth has expanded its work for preschoolers, working with a state-sponsored *Smart Start* program to help childcare providers and students appreciate the diversity that surrounds them. Storytelling, dance, and music were integrated into these multicultural visual arts programs—each unit adapted to fit the learning capabilities of four- and five-year-olds. This curriculum openly addresses cross-cultural sensitivity and was lauded by childcare providers for its social, developmental, and artistic value. But in the new millennium, "early readiness" programs in the state increasingly are focusing on preschoolers' capacity for reading and writing, and state funds for the arts have nearly evaporated. Sawtooth staff has necessarily refocused its energies to grant writing to secure support for arts-based programs addressing children and their families' creative, interpersonal, and social development—struggling amidst poor economic times for survival.

Sawtooth's year-round after-school and summer arts programs for K-8th grade students continue to involve more than 2,000 students annually. But with decreased local funding of the center's work,[14] class fees have again risen in an attempt to balance the budget. Concurrently, declining economic conditions resulted in a 25 percent increase in Sawtooth scholarship requests for fiscal year 2001–2002. Sawtooth, with increased private investment, continues to provide arts learning for students regardless of economic capacity, with one in eight students receiving aid.

Conclusions

Sawtooth participants' reflections continually shape the agency's direction and programs. Convening fertile minds from the fields of the arts, the community, and cultural development and engaging students in reflection about studio art and historic practice, Sawtooth has sustained its community-based critical change efforts. In governance and program policies of Sawtooth, dialogue is essential, but in times of seeming economic crises, such discourses are difficult to sustain. The agentic voices of others have been encouraged in critiques of the organization's work and its service to individuals and the political and social interests of communities it serves. Sawtooth acknowledges that constant adjustment and revisions are required to better serve communities (un)involved in the program, and, with that acknowledgment, change may always be possible.

Sawtooth's collaborative revisioning of the arts' role in social and cultural constructions is a process involving curriculum, economic policies, and physical space and the evaluative instruments and measures used to inform improvements in the quality and relevance of programs and services. The school's pursuit of change includes a concern for building appropriate technologies and providing training for staff and program participants in their use. Continual retooling, however, is needed if broad-based engagement in art-making processes, curriculum development, and the "coming together" of multiple communities in the (re)writing of our cultural history is to be sustained.

Sawtooth's work with major educational institutions, museums, and cultural resources has capitalized on the collective intellectual, instructional, and aesthetic practices of culturally diverse artists and participants. Funders of Sawtooth's change initiatives in the 90s have acknowledged our interest in community support, tripling local participation, and corporate and individual support. But with reduced public and foundation support in the early years of the twenty-first century, the center's efforts are now at risk. With financial catalysts for change all but evaporated, our agencies must now redouble their commitment to equitable social practice or risk repeating our past.

While service to underserved audiences has been stabilized thanks to state support, cross-cultural approaches to teaching are still insufficient to address the widening divide between the haves and the have nots. Students' use of signs and symbols, shared or unique to varied communities, and their ability to speak with voices of difference and see the world in new ways cannot change the context from which these students emerge.

Schools in North Carolina are increasingly racially divided, with fewer sustaining an interest in building cross-cultural understanding, one of the hallmarks of mid-90s curriculum efforts. The divide between rich and poor widens, and students are shortchanged as dialogue across these communities focuses on end-of-grade test results, the war on terrorism, and economic recovery. With unimagined obstacles potentially presenting themselves at every turn, resilience and commitment are essential if our work for social change is to be sustained. Through ongoing social dialogue, deep critical reflection on existing social practices, and imaginative reconstruction of our institutional policies, practices, and curriculum content, our agency and others may truly serve at-risk students and communities and begin to treat rampant social dis-ease, and not just its symptoms. Relinquishing our privileges and working toward empowerment of those we serve are challenges now, as they were in the past, and likely will be in the future. It is difficult and challenging work, but it is work worth doing.

Endnotes

1. As Executive Director of the Sawtooth Center for Visual Art since 1987, I refer to this southeastern urban community art school as "my institution," to reaffirm that all within an institution must take personal responsibility for their agency's social as well as aesthetic and educational policies and practices.

2. The Arts & Crafts Workshop (1945–1948), Arts & Crafts Association (1948–1982), and Sawtooth Center for Visual Design (1982–1990) are all earlier names for Sawtooth Center for Visual Art (1990–).

3. For a more in-depth discussion of early racial practices at Arts & Crafts Association, see "Founders: Reconsidering Racial Policy in a Community Art School" in Kris Sloan and Jim Sears (Eds.), *Democratic Curriculum Theory & Practice: Retrieving Public Spaces.* Troy, NY: Educator's International Press. (pp. 165-190), 2001.

4. Minutes of the Arts And Crafts Association Board of Directors Meeting of November 23, 1948.

5. In the 1952-53 fiscal year there was only one African-American serving on Arts and Crafts board, whereas in the first years of operation, 20-25% of the board was of African-American descent.

6. A feature article in the Winston-Salem Sentinel that was published a few

months after this meeting included a photograph of Mrs. Williamson with woven draperies that she had created at Arts & Crafts.

7. See Marshall, Mitchell, and Wirt's 1989, *Culture and Education Policy in the American States* for an in-depth discussion of educational policy priorities and their cultural paradigm for policy analysis.

8. Cultural Foundations was a Sawtooth co-sponsored conference with the Southern Region Assembly of the Surface Design Association—an event supported by grants from the National and Endowments for the Arts and Humanities and the North Carolina Arts and Humanities Councils.

9. The *Artist as Activist* exhibition was curated by Paula Owen, at that time, executive director of the Hand Workshop in Richmond Virginia. Ms. Owen also served as a panelist and panel moderator at this and the subsequent *Craft and Ethics* conference.

10. The *Making a World with Art in It/Making Art with the World in It* text was edited by Karin Pritikin, based on Jim Sanders' summary of panel proceedings and visual images documenting the Artist as Activist exhibit and other exhibitions collaborating visual art institutions across Winston-Salem.

11. Craft and Ethics Conference was co-sponsored by the National Craft Organization Director's Association, the American Craft Council's Southeastern Assembly, and *1993: Year of Craft in America* National Steering Committee with support from the North Carolina Arts Council and the Z. Smith Reynolds Foundation.

12. Six goals were formally established at the 1994 Craft and Ethics Assembly. These follow:

> *Embracing Diversity:* To stretch the vision of the American craftsperson to i n c l u d e previously marginalized or ignored traditions, to expand the aesthetic/artistic premise in American crafts, and to create awareness, appreciation, understanding and inclusion of racial, ethnic, and geographic diversity among craftspeople and their diverse methods, materials, and techniques.

> *Developing Audiences:* To "take down the white rope", making craft more accessible, touchable and appealing to a broader audience--inclusive of youth, seniors, the differently abled, the full range of socioeconomic labels represented in this country and beyond, and the geographically isolated.

> *Building Alliances:* To enhance relationships within the field among craftspersons, curators, editors, promoters, professional organizations, museums, galleries, communities,

government agencies (NEA, NEH, state and local arts councils); to look beyond stereotypes and to overcome any lingering attitudes of competition toward the fine arts.

Educating Practitioners: To increase opportunities for personal and professional growth among all players in the field through additional conferences and workshops in communications skills, the history of crafts, marketing and merchandising techniques, time management, self-documentation, public relations, contractual relations between promoters and craftspersons, and juror standards.

Enhancing Community: To foster an ethic of reciprocity among craftspersons and our organizations, encouraging all to serve as educators, curators, volunteers, mentors, organizers, innovators, and collaborators in order to give back to the community and to honor those who have paved the way.

Preserving the Environment: To accept responsibility for the environmental impact of our work, to consider alternatives that produce a sustainable environment (e.g. recycling, conservation and wise use of resources) and to promote environmental stewardship among the industry and the consuming public.

13. See Neil Postman's 1993, *Technopoly* for a critique of the overarching claims of internet culture.

14. A summary report of *Congress* findings was posted on Sawtooth's website, http://www.sawtooth.org for a year (1998–99). Key recommendations of participating artists and students included:

15. The major underwriter of Sawtooth's work for over a half century is the Winston-Salem Arts Council. Their support represented 54% of the Sawtooth's budget in 1985-86 and 22% of budget in 2001–02. At the time of this writing the Council has determined to sell the building in which our community art school resides, without offering any guarantees for support in the future.

References

Hesse, M. (1980). *Revolution and reconstruction in the philosophy of science.* Bloomington Indiana Press.

Lather, P. (1986). Research as praxis. *Harvard Educational Review,* 56, 3, 257-277.

Reasan, P., & Rowan, J. (1981). Issues of validity in new paradigm research. In Reason, P. and Rowan, J. (Eds.), *Human Inquiry* (pp. 239-252). New York: Wiley.

Rose, H. (1979). Hyper-Reflexivity: A new danger for the counter-movements. In Nowotny H. & Rose H. (Eds.), *Counter movements in the sciences: The sociology of the alternatives to big science* (pp. 277-289). Boston: Reidel.

Schwartz, P. & Ogilvy, J. (1979). *The emergent paradigm: Changing patterns of thought and belief.* In Values and Lifestyles Program Report No. 7. Menlo Park, CA: Stanford Research Institute (S.R.I.) International.

From the Inside Out: Playback Theatre at Bedford Hills Women's Prison

Lori Wynters

Note: All names have been changed to honor privacy.

Stories from the Inside Out is an educational theatre arts project developed and implemented by Washington Heights Playback Theatre, collaboratively funded and supported by Open Meadows Foundation and the College and Community Fellowship at the Graduate Center City University of New York. The project integrates methods from playback theatre and a broad range of expressive arts as vehicles for dialogue, learning social skills and self-awareness, exploring societal issues, leadership development, and community building. The program is implemented in two parts, addressing the experiences of women who have lived through the New York State prison system. The first part is addressed through a series of playback theatre workshops facilitated by members of the Washington Heights Playback Theatre Company, who meet regularly through the Family Violence Program. The issues addressed include education, domestic violence, healthy relationships, alternatives to violence, substance abuse, conflict resolution, communication skills, parenting skills, community building, leadership development, and spiritual nourishment and nurturance. The second part provides a forum for community dialogue and support through playback theatre for those women who are in the post-release program, now completing undergraduate and graduate degrees through the College and Community Fellowship at City University of New York Graduate Center. Playback theatre and other expressive art modalities are implemented to continue to foster a community of support, connection and community building. The project has offered courage, education, and guidance to its participants and has helped to end the cycle of violence and despair through an ethic of care, using improvisational theatre art as a transformative practice.

Here we stand again at the first check-in point at Bedford Hills Women's Correctional Facility, a maximum-security prison in an affluent suburb of Westchester County. It's an institution filled with 800 women. More than 75 percent are there for nonviolent, drug-related crimes, serving time under the Rockefeller Drug Laws established in the 1980s. The minimum sentence is 10 years. Some of them are girls as young as 16; some are mature women living in prison beyond the age of 70. Most of the women are African American. Many of them have children living outside the barbed wires.

We enter as artists, knowing that historical context, access to wealth, social conditions, socialization, and the politics of race in the United States have cultivated and continue to feed this situation. We believe in the transformative healing power of art making, specifically improvisational theatre. We believe that art making has the potential to open the heart, liberate the individual and social groups, facilitate social processes, and even reform societal institutions. We know this in our cores. Can our seemingly small contribution as Playback Theatre artists open the door for some shift to occur in us, in the women with whom we are honored to work, and in the institution of the prison in some way that will open a door to greater freedom?

Washington Heights Playback Theatre is a small and tightly knit multiracial, multiethnic, intergenerational playback theatre company. We are artists who are young, old, Puerto Rican, Cuban, Irish, Dominican, English, Russian, Polish, Austrian, Christian, Jewish, Sufi, Catholic, Buddhist, gay, straight, black, white, agnostic, able to speak Spanish, English, Hebrew, and American Sign Language, and are always working with the complexity of our own multiple identities. We have been invited to provide a series of workshops with the women in the Peer Adolescent and Survival Skills group (PALSS) program. Every Thursday evening, for two hours, we visit and offer a playback theatre workshop, where we tell and perform stories and moments from each other's lives, moments from the past, the present, and dreams and visions of the future. We begin each session with a series of improvisational warm-up activities using voice, movement, drama games, ensemble activities, gesture, music, and spoken-word exercises. We make meaning together, engaging in the reciprocal process of teaching and learning together, constructing knowledge, and offering witness to each other's experience.

The First Visit

There is no visible interest in our presence at first. It feels like they were gathered by the director to come to yet another "program" that would "help" them. All

my years of dealing with my own resistance and working with resistance in treatment centers, mental health clinics, and classrooms remind me to take a breath and say, "It's just resistance. Enter into it. Honor it. It's here for a reason."

A group of women sit, sliding down in broken-down chair/desk combinations in the back of a classroomlike space. A few broken cafeteria tables with attached cracked benches are piled in a corner. This is our space. The women are not particularly interested in the beginning, but the moment we go "into action," the attention shifts, and we work together for the next hour and a half. I'm not sure where we will go, but it feels like there is a vital energy opening and moving forward.

In our workshops and performances, we use pieces of fabric and a variety of percussion and flute instruments. Any piece of fabric that is close to the color green is confiscated upon our arrival, as that is the color the inmates must wear. The guards wear blue, and we are not to wear or bring that color fabric in either. At the first entry place, the guard goes through all our theatre bags. As the guard lifts each instrument out of the bag, the weapon qualities of each are evaluated. He only takes out a few—the rain stick, the bamboo flutes, and the drums. Clearly, they could all be used as weapons, and the cloth could be used to strangle, but somehow they pass the inspection each time we visit. Here are the props we use to bring life to our enactments, seen from the perspective of violence.

We get up and stand in performance position for a fluid sculpture, a playback theatre form that captures the feeling quality of the teller's experience. Fluid sculptures are designed to warm the audience up to each other and to the theme of the workshop or performance in this transparent form of theatre. The playback actors do a series of short abstract aggregates of sound and movement that express the audience members' responses to the conductor's questions. In my role as conductor, I ask how everybody feels tonight, on our first visit to Bedford Hills. One woman, Lana, who is pregnant, says her back hurts her and she's tired. That was enough to work with. "OK, Lana, let's watch." One of the actors steps out of the line she has been standing in with the other actors. She steps into the middle of the created stage, and her body curls over as she holds her back in pain. She moans a note. The musician plays a slow heavy beat on the drum. After a moment another actor joins the first one, verbally expressing the discomfort Lana described. Two more actors add their contributions, linking their actions to what is already there. By the end there is an organic, kinetic human sculpture that expresses Lana's experience.

One by one, we each step out into a created stage space embodying a sound, gesture, and movement that captures the teller's experience until we have an

amalgam of sound and movement reflecting the feelings she has shared. We stop. The women are with us and we are with them, beginning to shift the boundary of us/them. We are all present in this moment. "Lana, is it that bad?" I ask. "Yes. Actually it's worse," she answers.

"Does someone have a different kind of experience?" I ask. One by one we play back through various playback theatre forms what each woman has shared. The hour is filled with moments of many varying experiences that particular Thursday. In my role as conductor I follow up on themes as they emerge. Before everyone tells a moment, they ask us to share a moment from each of our lives. We do. The reciprocity deepens, as does the shift in power in terms of leadership; guide and artist shift, and we collectively share these roles. A particular kind of trust begins to emerge. Trusting another to hold and honor your feeling state is a rare experience and a deeply freeing one. To be fully heard without judgment allows the self to breathe more fully. Some of the women took our places as actors and played back what they heard us say. They had never done anything like this before and noted that it felt easy, like they had all felt that way at some point in their lives.

The group turns to the director of the program, a woman who is deeply loved. She is a light at that prison. They asked her how she feels. She looks at each of them when she responds. She said she feels hopelessness because she feels like they don't want to help themselves. She said she feels sad seeing her sisters here and wonders how to inspire self-love. No one clapped after what she said; there was just the still silence that comes with deep feeling.

The evening is coming to a close. A woman who has been quiet all evening raises her hand hesitantly. She tells us that she "does hair" and that she's so popular that there is a waiting list for her to do hair. The others smile and nod. Immediately the ritual of "doing hair" is felt in the room, a collective experience of the group. She does African American women's hair. "A day in the life of Karina" is the last fluid sculpture of the evening. We sit with the women for about another half an hour talking about how we do this work and ask if they are interested in learning it. The response is a genuine "please return."

The Next Visits

The women are amazing. We begin with 15 women and 8 leave at the option bell. The option bell: This bell goes off in the middle of our workshop, and they have the option to leave, I guess. We're in the cafeteria room again. Before we enter the room, a bunch of the young women are sitting in that room with the

broken-down school chairs and the cafeteria gate is down. There are four women in there with one man, who is standing and clearly reprimanding them. I ask the director of the Family Violence Program what's going on, and she says that there's some kind of judiciary procedure taking place. They tell us to wait a few minutes. The gate opens and we go in. The women sit down again, leaning against the wall, trying to get as much body support as they can. You can tell they're always ready, ready for something. They are always self-supporting. The wall provides a relief from the strain of constant readiness. The guard who escorts us around says there have been a number of stabbings. He gently reminds us that, while we might be having fun, laughing, telling our stories, doing fluid sculptures, playing sound ball, pass the gesture, etc., we should remember where we are. There are murderers here. Maybe in this room, maybe not, but they're here and the women definitely have to watch their backs all the time. We have the privilege of a constant escort service.

Each week brings new stories, stories of love, mistaken love, confusion about love, mothering, being a mother, learning what that means, self-mothering, abuse in all its forms, abuse of power, loss of control, violence, lots of violence, protection, joy, God, questioning God, belief in God, racism, sexism, power, money, love, God, love, God, love, violence, love....

After a period of workshops, the women are more comfortable taking on roles as actors, and they perform for each other, exploring different moments from their lives. If art is a form of making meaning, then art is inherently healing and therapeutic. Making art in this way, through witnessing each other's stories, through collective construction, through a shifting of the balance of power between performer and audience member to collective teller, as one who is revealing an aspect of the human condition, is a social form of therapeutic encounter or healing encounter.

What makes this form of theatre unique is that it acknowledges private feelings, feelings that are usually only revealed in intimate relationships or in the individualized Western therapeutic encounter. Playback theatre provides a method to hold these feelings in sacred space, offering a container and offering them as a public shared experience that may be unique to the particular teller yet also a universal experience of what it means to be human. It is a form of public intimacy.

What distinguishes it from the often-voyeuristic confessionals on talk show television is that it is offered as a public form of intimacy, where we can provide a holding ground for each other in a relationship, melting through the isolation

and alienation that makes us feel alone in our stories. Playback theatre in this workshop series opens the space for connection to each other. While the specifics may be different, we come to discover that we are more connected than alone when we begin to listen with a sacred listening to each other's stories.

A Return

We know what to do, but this time there are lots of kids in the initial check-in room at the jail. We have been there many times before, and the routine is familiar to each of us, but we are typically there in the evening for the playback theatre workshop. This time, however, it was a one-day event, "Violence Awareness Day." It is 8:00 am on Friday morning. As we enter, there are at least six kids, probably no more than 10 years old, visiting mothers, grandmothers, aunts, and sisters. They are waiting to go through the first check-in procedure and the electronic detector. The guard scans our bodies with the thick black rectangle while we stand in the surrender position, arms and legs out waiting to be declared "weapon free."

One of the children is taken with our musician, whose conga drum sits on his back as if it were another one of his limbs or an extension of one of his dreadlocks. We start singing in this room, awaiting the guard's attention. We are supposed to have a group clearance, but it seems as if they are never ready for us. We go through the ritual of asking them to call the director of the Family Violence Program to tell her we are here. We understand that there are several hundred women in the gymnasium waiting for us as we are the next presenter/performers scheduled for this day. Another guard arrives to escort us up the hill toward the gymnasium. He tells us to be careful. He is quite stern with a tone of voice that really is saying, "These are animals here so you have to treat them that way." Instead he says, "Do not get too close with the inmates. Do not fraternize with them. They're dangerous. Don't forget where you are."

I don't disregard what he says or romanticize the women in here, and yet his thought leaves humanity outside of the barbed wires. He continues with this speech until he realizes that we all seem to know what to do, regarding getting the infrared stamp, where and how we need to sign in, and how to obtain the visitor pass. He asks us if we've been there before, and we say yes. We pass through three gates that open and close behind us, passing our left palm under the infrared light as we travel through each checkpoint. We go through a sunlit corridor; very different from the ones we went through last November on Thursday evenings. We enter into a decorated gymnasium. For the first time, I

find that it's hard to distinguish whether we are in a maximum-security prison or in a university gym. The guard once again warns us not to get too close to the inmates. Several of the women immediately recognize us from several months earlier, and we naturally embrace, breaking all the rules he has carefully laid down for us, aware that we are in a maximum-security prison. Our thoughts move in and out of the complexity that has created these conditions for all of us.

They are ready for us. We set up in a very transparent way, as the audience is sitting and waiting for us to begin. They watch us set up while the director of the Family Violence Program continues to tell them about the rest of the day. She is speaking into a microphone in a gymnasium. Her voice is about as clear as the guy on the number 1 train in New York City telling you, "Next stop Christopher Street," which usually sounds more like, "exop hister feet." I like the transparency. I like how we take an ordinary public space and transform it in front of the audience into a place of art-making and inspiration, a sacred space delineated by the way we place cloth, instruments, and our bodies. It seems that the entire group is attentive to the transparency, a part of the performance that is about to happen. Perhaps it has now shifted into ritual, where the "supposed" audience is part of the experience, part of the collective art making and transformation that is already happening in the setting up of the space. The collective space where story emerges is shared, is witnessed, and that helps to open to the collective connection that we all share in the midst of the fragmented conditions that create the illusion of separateness. This is the power of art making, of playback theatre, which keeps us nourished as artists, opening us to the divine in ordinary day-to-day life.

We do some sounding behind one of the large plants tucked in a small stairwell behind the raised portable platform stage and come out singing a spiritual, "Keep Your Lamps Trimmed and Ready."

Then two of us break off into "Lord, I know I been changed, the angels in the heaven done signed my name." Both these lines are sung simultaneously in a haunting harmony.

The tellings begin.

> "Who is going to help our children through this, how can I help them when I'm in here?"

> "I have a son who is now in Afghanistan."

> "I want to tell her how much I'm going to be sending my love back here even though I'm leaving soon."

" What do you do when he provokes you to beat him up, but you don't want to, but he keeps egging you on?"

"What do I do about dealing with the bullshit of the system when I get out of here and they won't let me have my kids?"

"What I want to know is how come I hear about all this love and good will that is being extended to New Yorkers since September 11, but none of that seems to be happening in here?"

"Can you know what it's like for me being here when I'm coming off of crack?"

"How do I not keep blaming myself when they did that to me?"

"Sometimes I feel like I want to hurt her even though she's my mother."

"Where's this war going to lead us?"

"How the hell can I feel American when I'm in here?"

The tellings can go on for hours as we breathe in the stories and breathe them out through poetry, spoken word, dance, melody, song, theatre improvisation, scenes, and monologues and soliloquy.

This was our last visit. It was only a month after the events of September 11th. The weekly Thursday program had been discontinued due to budget cuts. At present we are invited back each year in October for Violence Awareness Month. Unfortunately, many of us experience violence more than one month a year.

In this brief time at Bedford Hills, our collective work as artists using play-back theatre helped to develop witness consciousness—the ability to be totally present for each moment. This particular improvisational theatre form doesn't attempt to treat, cure, fix, or solve. It doesn't try to make something out of nothing. It allows for the truth, the essence of the moment to rise with honesty, a faith in the world, full breath, totalness, and the intention of our human connection to each other and to the spirit, leaving room for each individual's experience of the divine connection. It helps create space for clarity, acknowledging the complexity of the human condition, of multiple identities, of social conditioning, of historical context, and its impact in the present. It allows for artistic witnessing that encourages us to reach out across the alienation in contemporary culture that keeps us from knowing each other and ourselves, a culture that focuses on consumerism, dogmatic religion, and anything outside of ourselves that seeks to control us.

This form of theatre brings to the public space everyday issues, questions, celebrations, dreams, and concerns about what it means to live in the human

condition rather than making these everyday experiences and feelings subjects for therapy. It releases the need to pathologize the individual's response to an environment and condition that is out of balance. It brings us back to the wonder of the present, helping to illuminate the extraordinary in the ordinary and makes the statement that our day-to-day lives are worthy of art making.

When we are involved in the process of making art, we are simultaneously involved in the process of making meaning or, in pedagogical terms, of being fully alive to the present moment. Joseph Campbell speaks eloquently of this when he says,

> I think that what we are really seeking is an experience of being alive so that our life experiences on the purely physical plane will have resonances with our innermost being and reality, so that we actually feel the rapture of being alive. (Campbell, 1988, p. 159)

In pedagogical terms, we are engaged in the process of constructing knowledge, constructing the text of our own life rather than ingesting or introjecting what is imposed or influenced by those outside of oneself. We are in the process of being present to the divine in ourselves and each other.

Change begins with a seed of desire within the self for love and radiates out. Through story, we can embrace self-understanding, self-compassion, and potentially transform our lives. Sharing personal stories in this way is both relational and communal. It acknowledges private truths in a public way, allowing the healing power of witnessing to organically emerge. Our desire is not to solve or fix but rather to be deeply heard, through a sacred listening. Perhaps our collectively creating space for vision, imagination, spontaneity, and creativity in this particular relationship may have nurtured and given birth to something in all of us that plants the seeds for inner freedom.

Reference

Campbell, J. (1988). *The Power of Myth*. New York: Doubleday.

CONTRIBUTORS

Nancy Beardall, ADTR, CMA, LMHC, is a dancer, educator, and dance/movement therapist. Her work involves bringing dance, dance therapy, and comprehensive wellness and prevention programs to the public schools. Her publications include *Creating a Peaceable School: Confronting Intolerance and Bullying* and *Making Connection: Building Community through Gender Dialogue in the Middle School* (co-author), as well as several video films about her work in the public schools. Her experience includes teaching K-12 in addition to being a senior lecturer at Lesley University. Currently, she is the Wellness and Prevention Counselor for the Newton, Massachusetts middle schools and is involved in the Ph.D. program at Lesley University in Expressive Therapies.

Judith Black is a nationally renowned artist whose traditional and original stories have received standing ovations on stages as far ranging as the Montreal Comedy Festival, the Smithsonian Institution, the National Storytelling Festival, and the Disney Institute. She is the recipient of awards from the *Parents' Guide to Children's Media, Parents Choice, The Cable Ace,* and *Storytelling World* and was nominated for the New England Emmy. She has been awarded a Springfield Cable Endowment and won the Fifth National Invitational Storytelling Championship, storytelling's most coveted Oracle: Circle of Excellence, and many other awards. Her award-winning original stories have been commissioned by the U.S. Department of the Interior, The Museum of Fine Arts, Boston,

National Public Radio, The Artist's Foundation, The U.S.S. Constitution Museum, The U.S. Department of Forestry, the North Shore Symphony, Massachusetts Foundation for the Humanities, Connecticut Emergency Room Nurses, and many others. She has taught the fine art of storytelling at Lesley University and other schools and institutes throughout the nation for 25 years.

Dr. Karen E. Bond is an associate professor at Temple University, Philadelphia, where she coordinates the Master of Education program in the Department of Dance. She teaches graduate courses in dance curriculum, pedagogy, and qualitative research methods, and an undergraduate core course entitled "Dance, Movement, and Pluralism." She has published widely on these subjects and presented papers, workshops, and short courses in Australia, Brazil, Canada, the Northern Marianas Islands, Finland, Japan, New Zealand, Singapore, and the United States. She has just begun a three-year term as chair of Dance and the Child International, the only organization devoted specifically to the advocacy of dance for young people on a global scale.

Judith Beth Cohen, a professor at Lesley University, Cambridge, Massachusetts, has been teaching in innovative programs for adults for more than 20 years. She helped found Lesley's Learning Community Residency, an innovative, interdisciplinary master's program for students from all parts of the world. Cohen has taught at Goddard College in Plainfield, Vermont, a pioneer developer of adult programs. She has taught writing at the Harvard Business School, Harvard College, and Bard College. Cohen is the author of a novel, *Seasons* (The Permanent Press), as well as many short stories. Before coming to Lesley, she taught writing for 10 years at Harvard University. She's a contributor to *How Writers Teach Writing* (Prentice-Hall, 1991), *Rethinking American Literature* (National Council of Teachers of English, 1997), and *Education as Transformation: Critical Perspectives on a Theory in Progress* (Jossey-Bass, 2000). Her chapter "The Mermaid's Legs, The Artist's Hands, The Professor's Assumptions" is in *Educators, Artists and Therapists on Reflective Practice* (Peter Lang, 2003). She's at work on a memoir, *Shocking Mother: A Daughter's Story.*

Cameron Culhamoo, a museum theatre performer, children's entertainer, and co-founder of Théâtre Cabale, a francophone Victoria theatre company, has seen firsthand the potential of the arts in language teaching. He is currently completing his M.A. in drama education at the University of Victoria, where he teaches

ESL at the English Language Centre. He is currently researching the integration of theatre as a conduit for intercultural and second-language learning, and has presented papers at several national theatre research conferences in Canada. His work was recently published in a series that investigates innovations in theatre and language, called "Body and Language," in which he explored silence as a means of communicating in the theatrical frame. He has also published an article this year in the Canadian drama education journal, *Drama Contact,* in which he examines drama in ESL as a means of affective discovery with his students.

Alev Danis was born and brought up in London, England. She moved to Boston in 1990 and began to be involved in the plight of the homeless. She has worked and volunteered in a number of shelters and programs to help homeless and at-risk women. Her professional background includes sales for a computer research company, running her own craft business, and a decade of teaching adult education. Her educational achievements include a degree in history and economic and social history. For many years, she was on the board of the Women's Lunch Place, a day shelter in Boston. She is currently living in London, running a training and resource center for homeless, asylum seekers, and refugees.

Lisa Donovan has worked as an arts administrator and/or arts educator in a variety of arts organizations including: Jacob's Pillow Dance Festival, the Berkshire Opera Company, University of Massachusetts' Department of Theater, as well as Boston University's Theater, Visual Arts, and Tanglewood Institutes. She currently oversees professional development programs for faculty and teaches in the Creative Arts in Learning Department at Lesley University. She was formerly the Executive Director of the Massachusetts Alliance for Arts Education. Lisa is a doctoral student at Lesley University researching how theater education can develop a sense of voice and identity. Lisa lives with her husband Rick and sons Alexander and Jack in Lee, Massachusetts.

Indira Etwaroo, Ph.D. candidate in dance studies at Temple University, is currently conducting her dissertation fieldwork in Ethiopia under the auspices of a Fulbright Fellowship. As a future faculty fellow at Temple, Etwaroo was the 2001 recipient of the Congress on Research in Dance (CORD) Graduate Research Award and a 2002 American Association for University Women Community Action Grant. Etwaroo continues to present and perform her work on the intersections of gender, race, class, and sexuality, as signified through the dancing body.

Ephrat Huss, M.A. certified art therapist, practices art therapy at Telem, the Kibbutz center for family therapy in Beer Sheba, Israel. She also teaches social workers, early childhood professionals, and teachers (both Jewish and Muslim) introduction to art therapy, and developmental psychology in Beer Sheba, and works on developing and supervising early childhood programs in her area using creative interventions.

Carol S. Jeffers, Ph.D., is a professor of art education at California State University, Los Angeles, where she teaches a variety of graduate and undergraduate courses in art and art education. Research interests include visual metaphor, visual culture, and aesthetics of the everyday. She is the recipient of the 1999 Outstanding Art Educator of the Year in Higher Education, Pacific Region award (National Art Education Association), and has been nominated for the Thomas B. Ehrlich National Service-Learning Award. She is widely published in journals and books in the field of art education.

Shabaash M. Kemeh is a core faculty member in the Creative Arts in Learning Division, Lesley University, Cambridge, Massachusetts. He teaches a number of arts in education courses including Integrating the Arts into the Curriculum, Drama for Empowerment, and Early Childhood Arts, History, and Social Science. He had previously taught in the Theatre Arts Department of University of Ghana, Legon, Accra, in Ghana. He coordinated several theatre for development outreach projects related to health, adult illiteracy, and women's issues in inner cities, towns, and villages throughout the country. The University of Ghana, international organizations, and nongovernmental organizations jointly sponsored most of these community projects. Shabaash holds his M.A. and Ph.D. from Kansas State University, Manhattan, Kansas.

Vivien Marcow Speiser, Ph.D., ADTR, LMHC, NCC, is a professor in dance therapy and director of international and collaborative programs in the Graduate School of Art and Social Sciences at Lesley University. Marcow Speiser is a dance and expressive therapist who has taught across the United States and internationally and has used the arts as a way of communicating across borders and across cultures. She believes in the power of the arts to create the conditions for personal and social change and transformation. Her interests and expertise lie in the area of cross-cultural conflict resolution through the arts, and she has worked extensively with groups in the Middle East and in South Africa. In addition, she

is an expert in the creation and performance of rites of passage rituals and in the use of dance and performance in expressive therapy practice. Her current area of interest, research, and teaching is the arts and healing. She has been working with expressive therapies as a support for cancer patients… She has also been involved with the Living Tree and Healing Arts Project, which uses the arts to facilitate the expression of feeling following September 11th.

Margaret Read MacDonald teaches storytelling at the University of Washington Information School and Lesley University. Retired after 30 years as a children's specialist with the King County Library System in Seattle, MacDonald now tours the world performing and offering storytelling work-shops. Drawing on her background in folklore (Ph.D., Indiana), education (M.Ed.Ec., Hawaii), and librarianship (M.L.S., University of Washington), MacDonald has written more than 33 books on folklore and storytelling topics.

Dr. Morna McDermott is currently an assistant professor in the Elementary Education Department at Towson University, Maryland. She received her Ph.D. from the University of Virginia in May 2001. Her scholarship and teaching center on the various relationships between arts education, arts-based inquiry, democracy, and social justice, while working with pre-service and in-service beginning educators.

Beverly Naidus has been using art as a tool for raising consciousness and heal-ing (with humor) for more than 25 years. She has a core belief in the power of art to positively transform communities and individuals. Her work has been exhibited and reviewed internationally, but what interests her the most are the stories shared face to face with others. Her nomadic career has allowed her to experience a diversity of lifestyles in many communities, including New York City, Halifax (Nova Scotia), Northfield (Minnesota), Venice (California), and Shelburne Falls (Massachusetts). She has recently relocated to Vashon Island, Washington, with her partner and son and is developing curriculum for and teaching in a new interdisciplinary studio arts program at the University of Washington, Tacoma.

Mary Clare Powell is a professor at Lesley University, in Cambridge, Massachusetts, where she teaches teachers in a graduate program how to inte-grate poetry, music, drama, storytelling, visual arts, and dance into their

curricula. She teaches in sites all over the United States and in Israel and is direc-
tor of the Creative Arts in Learning Program. She is the author of *The Widow,* a
study in photographs and words of her mother alone (1981), *This Way Daybreak
Comes: Women's Values and the Future* (with Annie Cheatham, 1986), *Things
Owls Ate* (2000), her first book of poems, and now *Academic Scat* (2002), poems
from academia. She has published poems in a variety of journals and has written
several articles about integrated arts in learning, creativity, and social change, the
artist-teacher, and women's creativity.

Angela Rackstraw was a nursing sister, midwife, and practicing artist in Cape
Town, South Africa, before going to the United Kingdom in order to gain her
PGDip in art therapy. She is one of eight registered art therapists in South Africa
and has initiated numerous community art therapy services. She is founder of
"the CATh progamme," which focuses on work with marginalized and trauma-
tized communities in the Western Cape. Angela has recently completed her M.A.
in art therapy, exploring the establishment and efficacy of Art Therapy in a third-
world setting while working with children affected by extreme deprivation,
abuse, and HIV/AIDS.

Eleanor Roffman is a faculty member at Lesley University. She holds a profes-
sorship in the Counseling and Psychology Division of the Graduate School of
Arts and Social Sciences and teaches in Lesley's Israeli Extension Program. She is
a feminist activist, both on and off campus, and is involved in many communi-
ty projects that integrate issues of race, class, ethnicity, and sexual orientation.
She has worked for more than 25 years in the Israeli/Palestinian peace and jus-
tice movement. Her focus has been on the international concerns of women.

Jim Sanders has served as the executive director of the Sawtooth Center for
Visual Art in Winston-Salem, North Carolina, since 1987 and is concurrently
the superintendent of the Arts-Based Elementary (charter) School. Dr. Sanders
has 26 years of experience in nonprofit management, is on the board of the Arts
North Carolina, and is an independent organizational consultant. He holds a
Ph.D. in education (curriculum and instruction) from UNC-Greensboro
(1999), an M.F.A. in fine art from SIU-Carbondale (1976), and a B.F.A. in fine
arts from Arkansas State University (1974), and is an active fiber artist.

Phillip Speiser, Ph.D., LMHC, is executive director of the Boston Institute for Arts Therapy, a community-based nonprofit mental health agency serving more than 3,000 children and families annually. Speiser is a family therapist and expressive arts educator and therapist who has been developing and implementing integrated arts programs since 1980. He is an adjunct professor at Lesley University in Cambridge, Massachusetts, and has taught and lectured extensively throughout Scandinavia, Europe, Israel, and the United States. He is the former chairperson of Very Special Arts, Sweden, and of the International Expressive Arts Therapy Association.

Barbara Summers has been involved with social justice issues for more than a decade. She co-founded and directed the Women's Craft Cooperative at Rosie's Place, a homeless shelter in Boston, Massachusetts. At Rosie's Place, she also started the Women's Choral Group and Kid's Act, a social action program that helps link elementary school children with community service. She has been involved in developing fund-raising events involving other groups to engage their talents in efforts for the Women's Craft Cooperative at Rosie's Place and the First and Second Church's of Boston Social Action Committee. Summers has received numerous grants and awards for her work with the Women's Craft Cooperative, such as the Edwards E. Phillips Award for Outstanding Citizenship from Metropolitan Life.

Frank Trocco is an associate professor at Lesley University. He has a particular interest in looking at science as it is applied in areas of popular culture, and the conflicts between popular and orthodox conceptions of science. In 1978, he co-founded the National Audubon Society Expedition Institute, which created degree programs in environmental education for undergraduates and master's students. Since the summer of 1989, he has participated every fall in the nine-night Nightway ceremony with traditional Navajo Chanters. He has recently completed a book, with Trevor Pinch, on the social history of technology and electronic music, *Analog Days: The Invention and Impact of the Moog Synthesizer* (Harvard University Press).

Lori Wynters, M.F.A., Ph.D., an interdisciplinary artist, national faculty in the graduate program in Creative Arts in Learning at Lesley University, adjunct faculty in the doctoral program at Union Institute, and Playback Theatre School graduate, is a teaching artist, and an arts integration curriculum specialist. She

performs and conducts theatre/dance workshops in playback theatre and dance improvisation, honoring the transformative and healing power of personal stories. She lives in Asheville, North Carolina, with her truest love, Wylie, and daughter, Hannah, and is inspired by bell hooks' call for an "aesthetic revolution."